LANDSCAPE
PHOTOGRAPHER OF THE YEAR

COLLECTION 01

Managing Editor: Paul Mitchell
Senior Designer: Kat Mead
Image retouching and colour repro: Sarah Montgomery
Production: Lyn Kirby
Indexer: Hilary Bird

Produced by AA Publishing
© Automobile Association Developments Limited 2007

Published by AA Publishing (a trading name of Automobile Association Developments Limited, whose registered office is Fanum House, Basing View, Basingstoke RG21 4EA; registered number 1878835).

A03369

ISBN-13: 978-0-7495-5224-4

A CIP catalogue record for this book is available from the British Library.

The contents of this book are believed correct at the time of printing. Nevertheless, the publishers cannot be held responsible for any errors or omissions or for changes in the details given in this book or for the consequences of any reliance on the information provided by the same. This does not affect your statutory rights.

Colour origination and printing by Butler & Tanner, Frome, England

www.theAA.com/travel

The Automobile Association cannot be held responsible for the content of the external internet sites listed in this book.

STEEN DOESSING

Right: Keyhaven Marshes, Hampshire, England

This location is one that I have had in the back of my mind for many months but the light and conditions were never quite right. On this particular morning I had driven to Hurst Spit to take another scene but the weather was completely wrong. I remembered this idea and didn't want to return home empty handed and this is the result.

DAVID CLAPP

Page 5: Saddle Tor, Dartmoor, Devon, England

Dartmoor has a micro weather system all of its own that can deliver a drama and desolation that drives my photographic intrigue on a regular basis; but I have returned home with nothing more times than I care to mention. This is my most dramatic shot yet of one of Dartmoor's most evocative locations.

LANDSCAPE
PHOTOGRAPHER OF THE YEAR
COLLECTION 01

CONTENTS

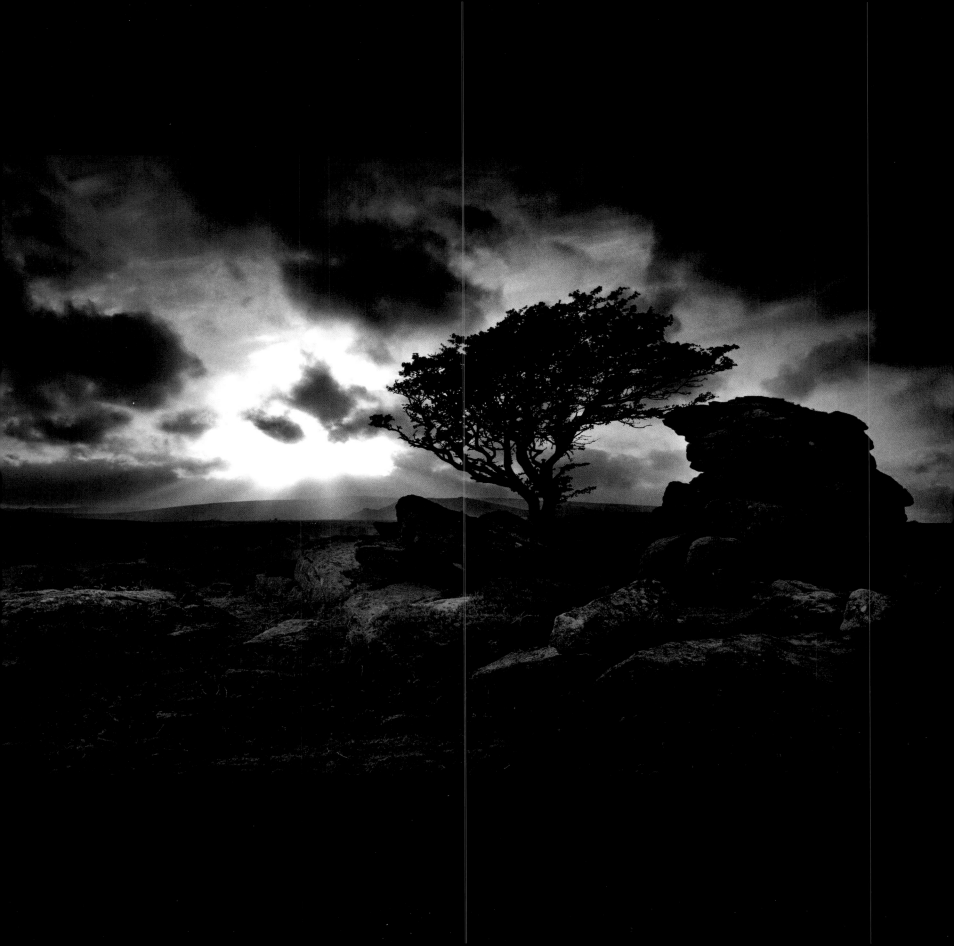

INTRODUCTION

THE COMPETITION

Take a view, the Landscape Photographer of the Year Award, is the brainchild of Charlie Waite, one of today's most respected landscape photographers. Together with AA Publishing, Britain's largest travel publisher and a division of The Automobile Association, he has created this prestigious award to showcase the very best photography of the British landscape.

Open to photos of the United Kingdom, Isle of Man and the Channel Islands, Take a view is divided into two main sections, the Landscape Photographer of the Year Award and the Young Landscape Photographer of the Year Award. With a total prize fund exceeding £20,000 and a six-week exhibition at the National Theatre, Take a view is set to become a desirable annual competition for photographers of all ages for years to come.

www.landscapephotographeroftheyear.co.uk
www.take-a-view.co.uk

THE CATEGORIES

Classic View

The images in this category capture the beauty and variety of the UK landscape. The rugged cliffs and sprawling beaches of the coastline, the majestic mountains of the highlands, and the verdant splendour of the national parks – all are here. Recognisable and memorable; these are true classics.

Living the View

This category features images of people interacting with the outdoors – working or playing in the UK landscape. From the peaceful tranquility of an early morning fishing trip to the thrills of kite surfing and the urban acrobatics of parkour, these images illustrate the myriad ways we connect with our outdoor environment.

Your View

What does the UK landscape mean to you? Sometimes intensely personal and often very conceptual, the parameters of this category are far-reaching, with images illustrating a whole range of emotions and perspectives. Subjects covered include the destructive effects of an angry sea on a deserted clifftop village and the simple pleasure taken in a sunset over a distant horizon.

Phone View

The key to this category is spontaneity. There may be no tripods and telephoto lenses, but the great advantage of the camera phone is that it is always with you, so there are plenty of chances to capture the unexpected – as these images show.

SPONSORS

National **Theatre**

THE SUNDAY TIMES

SUPPORTERS

OLYMPUS
Your Vision, Our Future

coo**tide**
INTERACTIVE

Campaign to Protect
Rural England

FUJIFILM

B+W

Manfrotto

BBC
Homes
&ANTIQUES

OUTDOOR
PHOTOGRAPHY

visit**Britain**

CALUMET
PHOTOGRAPHIC
IT'S WHERE THE PROS GO

Photographer

SPECIAL PRIZES

The Lowepro Environment Award

In its 40th Anniversary year, Lowepro, the market leader in protective camera bags, is proud to support the Landscape Photographer of the Year Award. The Lowepro Environment Award has been devised to celebrate the amazing landscapes that we have on our very doorstep within the UK.

Lowepro maintains a long heritage of supporting environmental and wildlife protection programmes worldwide – it's the planet's precious landscape and wildlife that continues to supply photographers the world over with awe inspiring images.

The standard of photography within the competition has been truly impressive and we wish the Award even greater success in years to come.

The Páramo Mountain Award

Often considered to be one of the most innovative brands in the mountain and travel market, Páramo Directional Clothing Systems have recently been discovered by photographers – both professional and leisure – who know that it's often when the weather gets interesting and the environment is extreme that outdoor photographs become spectacularly special.

The Páramo Mountain Award, given as part of the Landscape Photographer of the Year Awards, represents the coming together of Páramo's appeal to mountaineers, explorers and outdoor photographers.

PÁRAMO
DIRECTIONAL
CLOTHING SYSTEMS

With special thanks for the kind generosity of

hocking
associates

and

fame factory uk

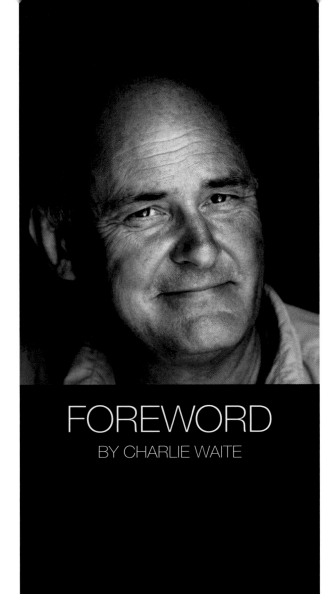

FOREWORD
BY CHARLIE WAITE

LANDSCAPE PHOTOGRAPHER OF THE YEAR 2007

Some thirty years ago, when I first began to understand how enriching landscape photography could be, I wondered whether there might be other like-minded photographers who could relish simply being outside, photographing at every available opportunity and using their camera as a vehicle to express their response to the world around them. British people have enjoyed a long legacy of great landscape painting. Since the birth of photography in the mid 19th century, photographs have been taken of the British landscape that have recorded both rural and urban changes and celebrated the beauty and diversity of these islands.

The widespread social and rural repercussions resulting from the industrialisation of Britain in the 18th and 19th centuries contributed greatly to the individual's slow dislocation from the natural environment, as road and rail were laid down, linking rapidly expanding cities and factories. Within one generation, hundreds of thousands of folk with a hundred generations of allegiance to the land had little choice but to answer the beckoning, clamorous call of the cities and machinery.

Landscape painters of the time were painting pictures to satisfy the urban middle classes' need to be reminded of the bucolic life that they had left. By the 1850s much popular landscape painting was sentimental and unashamedly nostalgic, perhaps suggesting a wish to escape to how life once was and an inference that the present was worse; an equation that from many people's perspectives prevails today.

When the first seed of an idea to launch Landscape Photographer of the Year emerged, I had little idea that there are indeed very many kindred spirits who in equal measure are passionate about their landscape photography and the beauty and diversity of the British Isles.

As each year passes, my love of landscape photography grows ever greater and I find myself more deeply immersed in it and all that it brings to me. Whilst my own work is very important to me, over the years I have developed an enthusiasm for others to become the beneficiaries of this same enrichment that comes first with 'seeing', and hopefully followed by the 'making' of images that will both resonate and evoke the experiences they had at the time of releasing the shutter.

I have always been convinced that landscape photography is good for us. There are those who might argue that the mechanics of exposure, filtration and technique precludes appreciation of what is there. I refute this and contend that landscape photography deeply engages us and connects us to a world of wonder and reverence. It enables us to see subtle nuances and enhanced dimensions within the image to be made that greatly add to our understanding of ourselves and other things outside ourselves that may be not be so easy to quantify.

Further, I would suggest that the landscape photographer is acutely conscious of colour, form, design, geometry, dimension, balance, the air, the sky, and of course the great fundamental catalyst to the making of an image; light. It strikes me that

these 'awareness credentials' qualify the landscape photographer for seriously knowing all that is going on in 'that place' and at 'the moment' that the image is made. It is the case that the photographer's antennae are fully extended and in maximum reception mode. The camera therefore has the dual roles of creativity and reflection. It is arguably a very creative tool; able to express our artistic intention, yet often never used to its full potential. In our 2007 Landscape Photographer of the Year Award, it most certainly has been.

From the first moment of approaching the Automobile Association with the idea of the award, they showed great enthusiasm and have been by my side throughout in championing the project to find the 2007 Landscape Photographer of the Year. The beauty and variety of the British landscape holds a unique place in the hearts of many and it has been enormously gratifying for me to see how this variety has been so comprehensively embraced in the first year of the award.

Crucial environmental issues have been conveyed with much of the photography that has been entered and whilst we celebrate the great diversity of the British landscape, landscape photographers are however well qualified to express environmental anxiety. It is predicted that in a few short years 20 per cent of British agricultural land will be devoted to the production of bio energy crops. Perhaps then we will see much more of our countryside turning briefly yellow than we have seen hitherto. It is very probable that in years to come we will see an increase in cereal crops grown more for industrial energy than human diet. No doubt miscanthus, willow, poplar and sugar beet will soon be visible in quantity across our landscape, all in the name of renewable energy. Reconciling the nation's energy requirements with the sensitivity needed to preserve our landscape for future generations is for our governments to ensure; let us pray they do so with prudence.

The eight judges have been presented with what must surely amount to some of the finest photography of the British landscape ever to be seen. The very democratic judging process has been often agonising and controversial but at the same time stimulating and informative. There were works from devotees of the classical British landscape where images of the English uplands and Scottish Highlands reminded us of the reasons for people's huge affection for the UK.

Our vast and dense historical forests have been well represented with images lit so mysteriously as to suggest the presence of phantoms wafting amongst the trees. Landscape images have been made from every corner of the British Isles; some with people engaging happily within their community of friends and surroundings and others which are both humorous and disturbing.

There have been images conveying the bleak beauty of North Country moorlands and images of standing stones in theatrical lighting that are reminiscent of long past rituals. Magnificent images have been made of our great rivers, along with intimate works such as a simple, wild garlic-flanked brook flowing through a Devonshire valley.

I have been struck with entries of some magnificent industrial and urban landscapes, all of which are of course significant and integral to the fabric of the British landscape. Some of these works have looked back to the great textile mills of northern England, others to the slate-mining quarries of mid Wales.

There was competition between images of a complex puzzle of lichen living on its host rock since the ice receded thousands of years ago, in the wildest of the Scottish Western Isles, and 200ft-high Cornish granite cliffs standing firm after millions of years of raging Atlantic pounding.

Being a series of islands, inevitably, there were numerous thrilling images of our nation's coastline. On occasion the photographer has chosen to look out to sea, as many of our great mariners would have done as they departed our shores towards battle or discovery. We are often referred to as a 'seafaring nation' and accordingly, it is entirely appropriate that any image of our waters is as relevant to this award as any photograph made inland.

The 2007 Landscape Photographer of the Year Award has been the greatest celebration of landscape photography of Britain that I could possibly have wished for. This first collection showcases the very best of the thousands of entries received and all are commended by the judging panel. The British are photographing their landscape like never before.

THE JUDGES

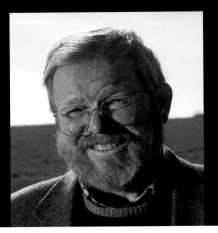
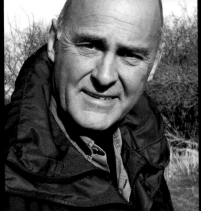

Bill Bryson

Best-selling Writer
CPRE President

Bill Bryson's love of the British countryside is well known and is celebrated in his books, including *Notes from a Small Island*. He is the President of Campaign to Protect Rural England (CPRE) and his passion perfectly supports their cause to protect and enhance the countryside for the benefit of everyone.

Born in Iowa, America, Bill visited England in 1973 on a backpacking expedition. After working for *The Times* and *The Independent* in the 1980s as a sub editor, he became a full-time author living in North Yorkshire. He and his family returned to America for several years and then moved back to England once more in 2003 to live in Norfolk. He has written books on travel and language as well as the autobiographical *The Life and Times of the Thunderbolt Kid* and his latest book – *Shakespeare: The World as a Stage (Eminent Lives)*. Bill is also Chancellor of Durham University; a Commissioner for English Heritage and, in 2006, was awarded an honorary OBE for services to literature.

Photo:David Rose/CPRE

Charlie Waite

Landscape Photographer

Charlie Waite is firmly established as one of the world's most celebrated landscape photographers. He has published 28 books on photography and has held over thirty solo exhibitions across Europe, the USA, Japan and Australia, including three very successful exhibitions in the gallery at the OXO Tower in London, each visited by over 12,000 people.

His company, Light & Land, runs photographic tours, courses and workshops worldwide that are dedicated to inspiring photographers and improving their photography. This is achieved with the help of a select team of specialist photographic leaders.

He is the man behind the Landscape Photographer of the Year Award and this ties in perfectly with his desire to share his passion and appreciation of the beauty of our world.

Ben Fogle

TV Presenter and Writer

In 2000, Ben volunteered to be marooned on Taransay, a remote windswept island in the Outer Hebrides as part of the BBC's big millennium project *Castaway 2000*. Since then, he has become one of our best-known television presenters, fronting such programmes as *Animal Park* and the BBC's adventure series, *Extreme Dreams*.

Ben has travelled extensively in South and Central America and has toured the world for various broadcasting assignments. Constantly meeting new challenges, he rowed across the Atlantic Ocean with double Olympic oarsman James Cracknell in 49 days, setting the British pairs record.

Now married to Marina, with two dogs, Inca and Maggi, the adventures continue – Ben and Marina recently set the world record for sailing from Portsmouth to Cork in the Big V sailing race in just 49 hours.

Janet Ibbotson

Association of Photographers
Managing Director

Janet has had a long career in the visual arts and in copyright. She began in the 1970s working as an advertising agency art buyer, before joining the Association of Photographers in the early 1980s where, amongst other things, she campaigned successfully for changes in UK copyright law. In the 1990s, Janet joined the Design and Artists' Copyright Society (DACS) to set up the collection and distribution of royalties for photographers now known as 'Payback'.

She became a consultant in 1998, amongst her tasks being Secretary of the British Copyright Council and, since November 2005, Janet has also returned to the Association of Photographers as its Managing Director.

Raised in Sheffield and now spending her leisure time in rural Norfolk and the Greek islands, Janet has always loved landscapes and landscape photography.

Keith Wilson

*Outdoor Photography magazine
Founder and Editor*

Keith Wilson is a successful editor, author and photojournalist and the founder of *Outdoor Photography* magazine. A former editor of *Amateur Photographer*, Keith has written three books, including *The AVA Guide to Travel Photography*.

In 2002, he edited *In My Mind's Eye*, the first book devoted entirely to Charlie Waite's black and white photographs. Keith is also the editorial director of *Black & White Photography* and, when not spending hours looking at other people's photographs, likes nothing more than capturing his own panoramic landscapes, preferably in the Scottish Highlands, Italy or his native Australia.

John Langley

*National Theatre
Manager*

John is the manager of the National Theatre, on London's South Bank. Alongside its three stages, summer outdoor events programme and early evening platform performances, the National has become renowned for its full and varied free exhibitions programme. Held regularly in two bespoke spaces, these exhibitions are an important, ongoing part of the London's art and photographic scene. John is responsible for these shows and has organised over 300 exhibitions and played a significant role in presenting innovative and exciting photography to a wide and discerning audience.

When escaping from the urban bustle of the capital, John particularly loves the coastal scenery of the United Kingdom, with the north Norfolk coast and Purbeck in Dorset being particular favourites.

Monica Allende

*The Sunday Times Magazine
Picture Editor*

Monica started her career in publishing; commissioning travel photography where sourcing idyllic landscapes was the objective. For the last six years, she has been picture editor for *The Sunday Times Magazine*.

Although she sees images every day of her life, she still gets excited about the variety and creativity of photography and likes to encourage up-and-coming photographers. She is interested in the increasing accessibility of photography and the changing attitudes of young people towards the art.

She likes extreme landscapes; raw nature that gives a feeling of infinity and appears unchanged by the human hand. Her favourite element is water and so the coastal landscape, particularly of North Devon and Cornwall, has provided unforgettable visual images, but as an urbanite, born and bred among concrete, the urban landscape speaks to her in a familiar language.

David Watchus

*AA Publishing
Publisher*

David took over as publisher at the AA at the beginning of 2006 having worked in a variety of roles within the business. His vision is to build on AA Publishing's strong base in travel, lifestyle and map and atlas publishing, in which areas the AA has many market-leading titles, whilst increasing the presence of the AA in the wider illustrated reference market.

A strong personal love of photography in general and the British landscape in particular, coupled with his vision for AA Publishing led to the AA's involvement in the extraordinarily successful launch of this new competition.

PRE-JUDGING PANEL

The pre-judging panel had the difficult task of selecting the best images to go through to the final shortlist. Every image entered into the competition was meticulously analysed, before the final list was put through to face the main judging team.

Jasmine Teer

After training as a large format photographer and working as a photographic technician in Portsmouth, Jasmine graduated from the London College of Printing in the late 1990s. She launched a freelance career but was then given the opportunity to re-vitalise the picture library, Britain on View, owned by the British Tourist Authority (now VisitBritain). Over the past four years, Jasmine has managed and art directed shoots throughout the UK to assist in building awareness of Britain for both international and domestic visitors. Since January 2005, Jasmine has managed the library Britainonview.com, a commercial online library covering the UK that represents some of the country's best landscape photographers.

Trevor Parr

Trevor's lifelong love of photography started at Art College. He became an assistant to a number of fashion photographers before setting up on his own in a Covent Garden studio. In the late 1980s, he started the Parr-Joyce Partnership with Christopher Joyce; an agency that markets conceptual, landscape and fine art photography to poster, card and calendar companies.

Robin Bernard

Robin is the founder-owner of Bayeux, a professional imaging company that opened in 2001 and is now the largest in London's West End. With an extensive background in the pro-lab industry, Robin has experience in many technical areas. Once a colour and black and white printer, he printed for photographers including Adam Woolfitt, Charlie Waite and Storm Thorgersen. He was a director of Ceta in the 1980s and went on to be responsible for photographer liaison at Tapestry during the 1990s. Although very much attached to a London lifestyle, he escapes to the country at regular intervals, particularly the English Lakes.

Liz Allen

Liz is the manager of the World Travel Library at AA Publishing. She has worked in the AA's picture library for the past 17 years, initially as a picture researcher, then picture research manager. She moved into her current role in 2006. Liz loves the diversity of the British landscape, particularly the sweeping views of the coastline.

and **Charlie Waite**

DAVID CLAPP

Right: Bantham Beach, Devon, England

Bantham Bay is a surfing mecca for many, but for me it is an ongoing photographic challenge. This particular section is aptly called 'Bay of Dismay' by surfers and, with so many jagged shapes and a huge rip, it is no wonder.

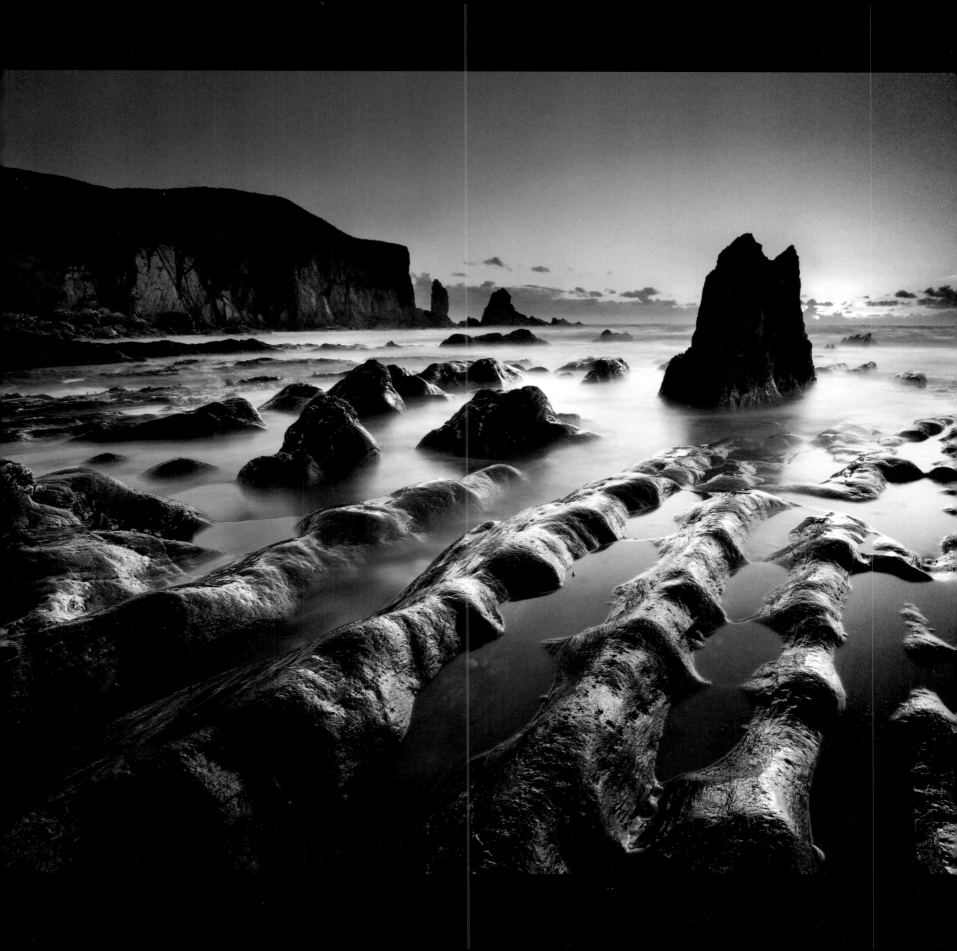

LANDSCAPE
PHOTOGRAPHER OF THE YEAR

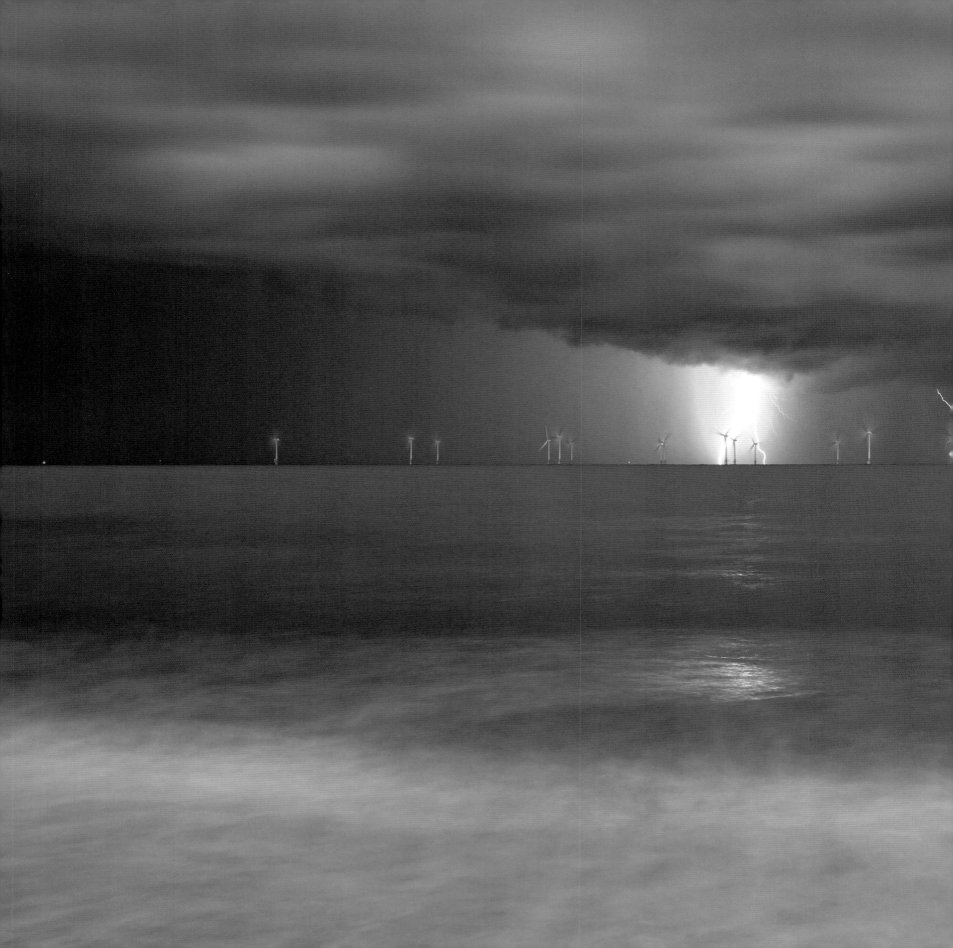

LANDSCAPE PHOTOGRAPHER OF THE YEAR 2007

ADULT CLASS WINNER

JON GIBBS

Storm over Scroby Sands wind farm, Great Yarmouth, Norfolk, England

Gazing out of my kitchen window, I could see some amazing clouds forming in the sky to the west. Something made me head towards the sea, which was actually to the east, and I was lucky enough to witness a storm brewing out to sea to the north of the wind farm. The lightning started to appear directly behind the turbines – enabling me to capture two very different power sources in the one shot.

Judges' Choice Ben Fogle and John Langley

17

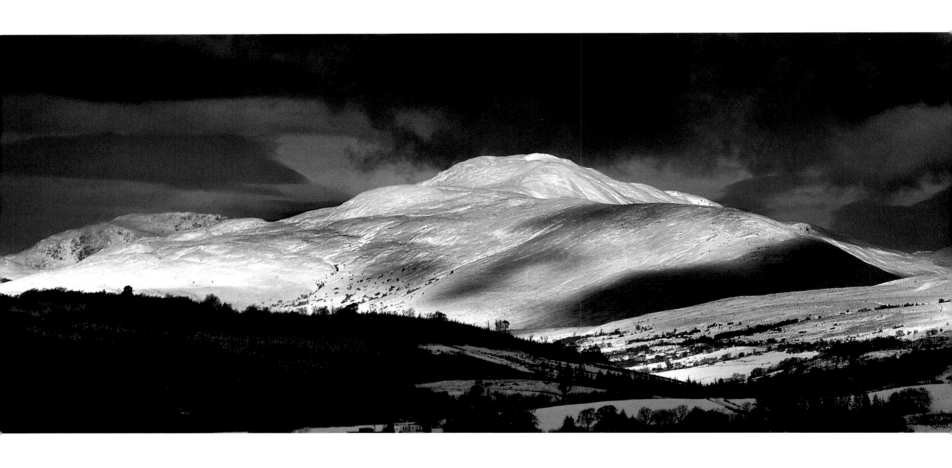

LANDSCAPE PHOTOGRAPHER OF THE YEAR 2007

YOUTH CLASS WINNER

LOWEPRO AWARD YOUTH WINNER
BEST ENVIRONMENTAL IMAGE

LIAM LESLIE

Ben Arthur, Darroch Park, Gourock, Scotland

I walk past this view every morning on my way to school and have often thought about photographing it. One day, after a heavy snowfall, it seemed like the perfect opportunity to do so. It must have looked an odd sight though, with me standing at the top of a hill, camera tripod-mounted in front of me, waiting for the right cloud patterns across the mountain. All around me were people having fun in the snow – snowballs flying through the air! I think it just shows the lengths you have to go to for the perfect picture.

CLASSIC VIEW
adult class

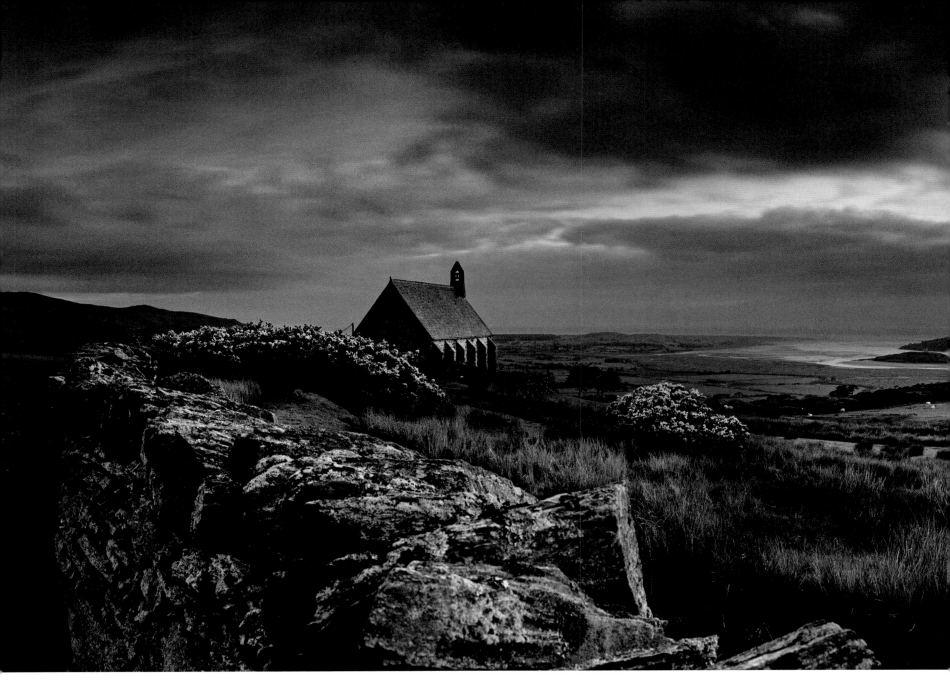

CLASSIC VIEW ADULT CLASS WINNER

JAMES CALLAGHAN

Hillside Chapel near Talsarnau, North Wales

I happened upon the location while on a car shoot, and knew that I had to return in the evening. After taking a few different angles, I 'homed in' on the final, then waited for a cloud to soften the light. It was a beautiful evening, evoking a sense of peace.

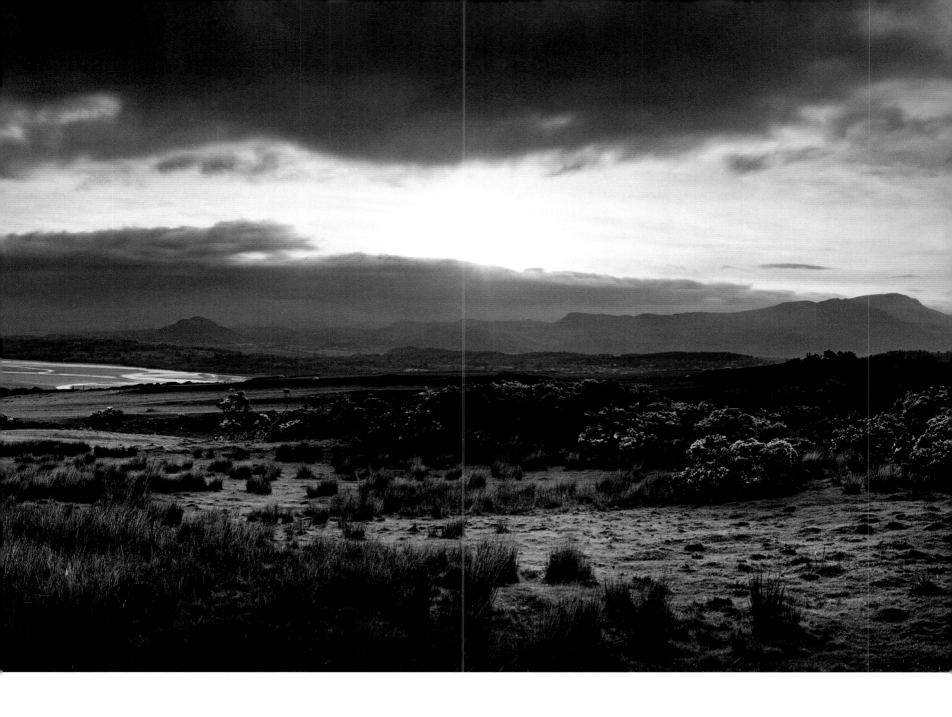

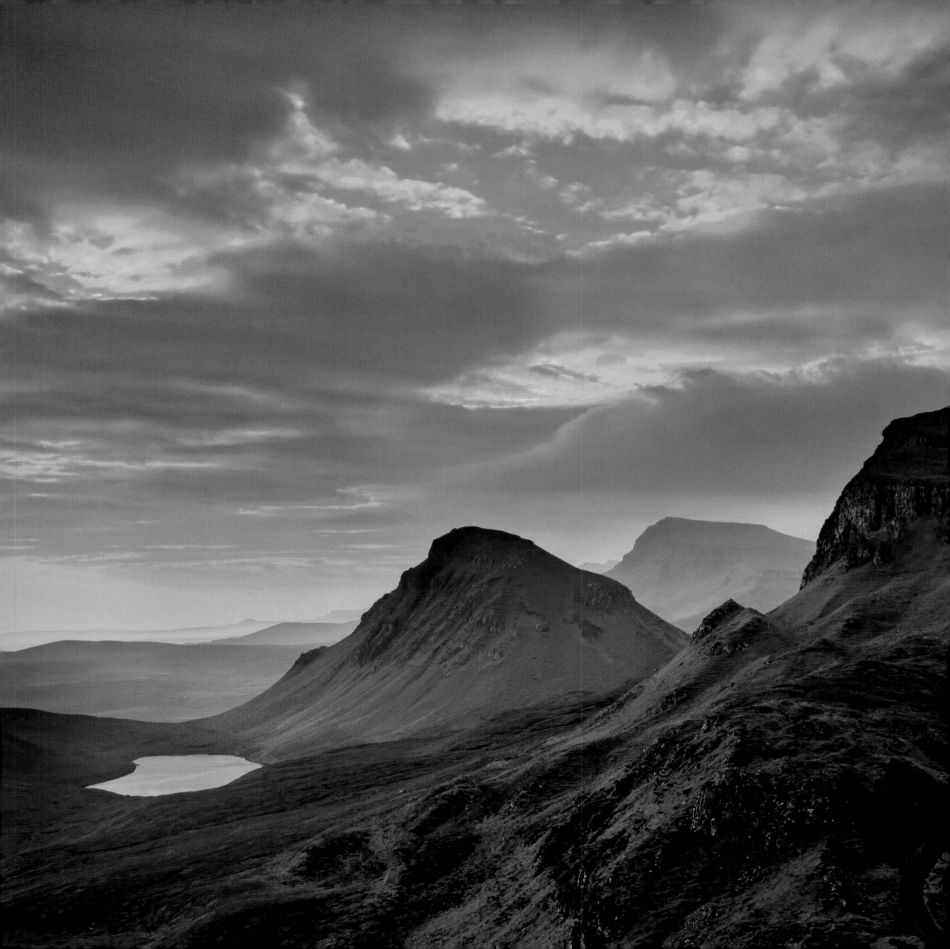

CLASSIC VIEW ADULT CLASS RUNNER-UP

IAN CAMERON

The Quiraing, Isle of Skye, Scotland

Skye is a wonderful island with many diverse opportunities for the photographer. The east side in particular has some of the most amazing rock formations. The views are straight out of *Jurassic Park*, only needing a few pterodactyls wheeling overhead to complete the illusion. The Quiraing has always been one of my favourite places, even though the best time to be there is undoubtedly dawn – or preferably just before.

On a summer's morning, I arrived at 4.30am to a beautiful dappled sky. I climbed to this viewpoint, just a few hundred yards from the road and searched around for the best spot to set up and fine-tune my composition. As anticipated, the sky began to colour up and honey-coloured light started to creep up from the eastern horizon.

The speed at which the light changed, as the sun painted colour and texture on the slopes, was phenomenal. Once again, landscape photography proved far from the slow, relaxed pace with which it is usually associated.

Judge's Choice Janet Ibbotson

25

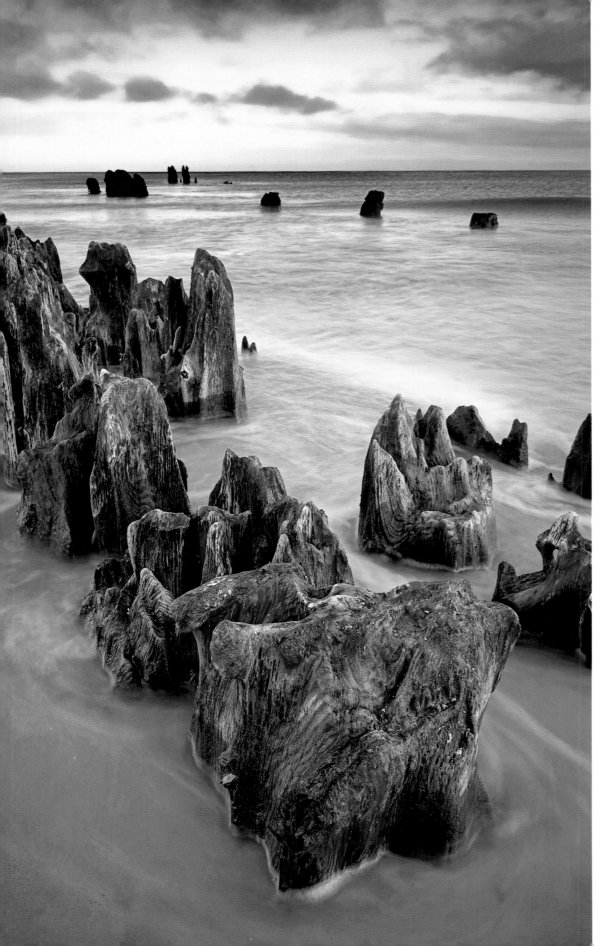

HIGHLY COMMENDED

IAN FLINDT

The Old Pier, Walberswick, Suffolk, England

Little remains of the old wooden pier at Walberswick, a quiet and quaint Suffolk village that appears to be otherwise untroubled by the process of time. The pier posts, dressed in their glamorous coats of rusting metal red and algae green, have been reduced to spiked stumps by the incessant onslaught of the tide. In this photograph a low angle and vertical format were used in order to allow the posts' fascinating shapes and colours – or their resemblance to British teeth, as one Canadian friend remarked on seeing this image – to dominate the scene.

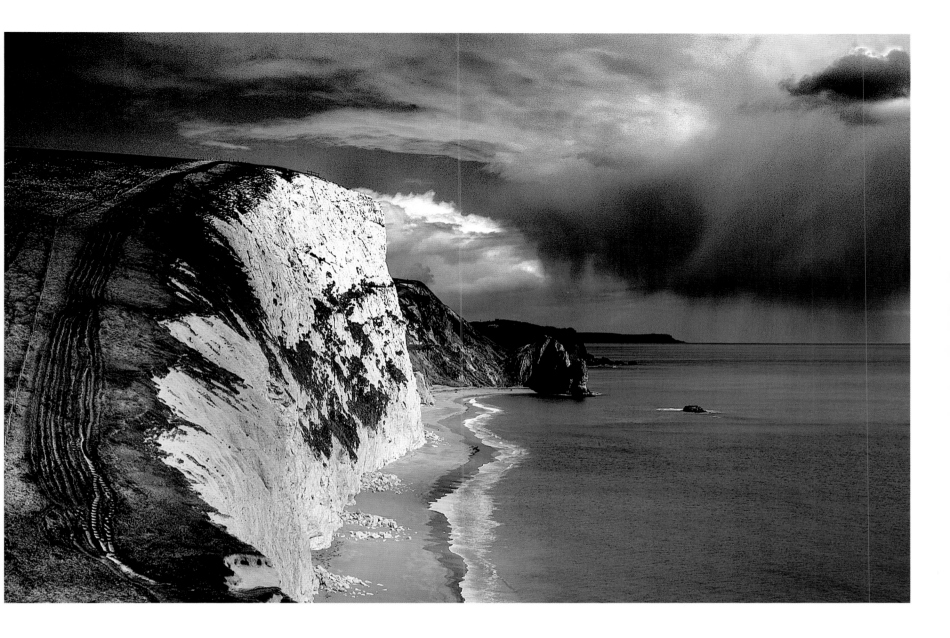

HIGHLY COMMENDED

SEYMOUR ROGANSKY

Looking to Durdle Door, the Jurassic Coast of Dorset, England

This was taken on a hike between Lulworth Cove and Weymouth, on the Jurassic Coast of Dorset. It was one of those early spring days when one can experience every type of weather the British climate can throw at you. I wanted to capture the drama of the interplay between the landscape and the elements.

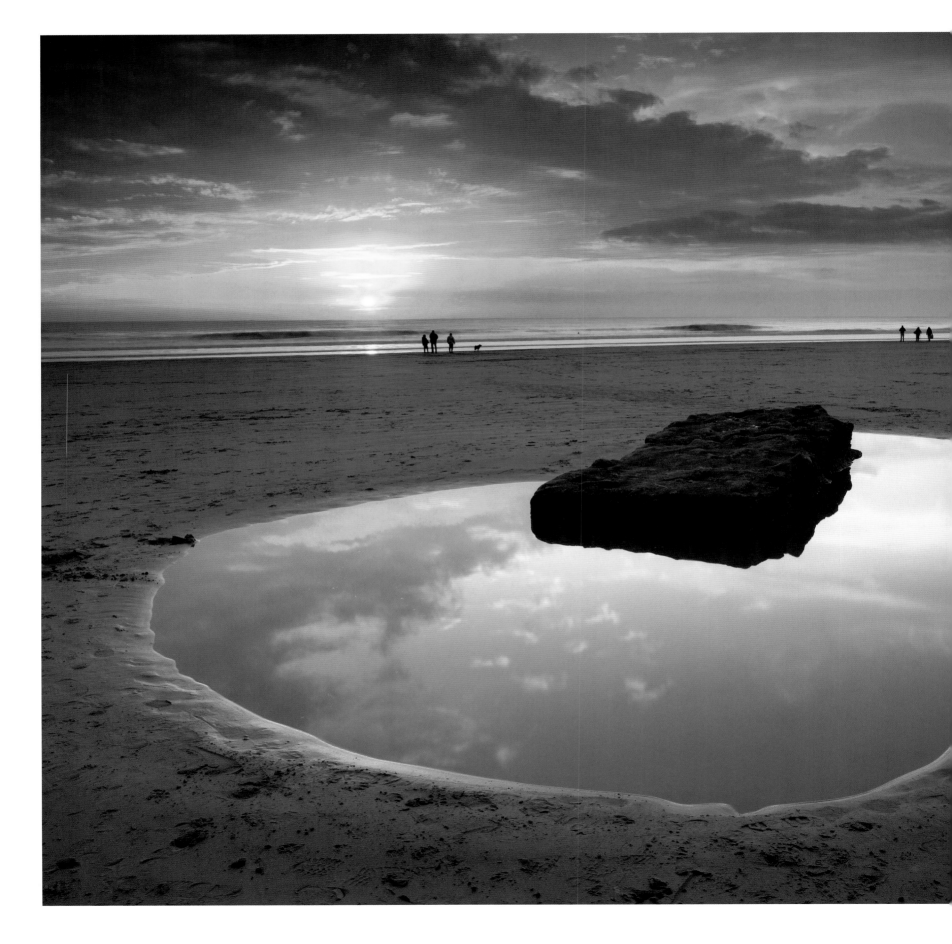

HIGHLY COMMENDED

ADAM BURTON

Dusk at Southerndown, Dunraven Bay, South Wales

A perfect sunset at spectacular Southerndown in South Wales. I was drawn to the rock in the pool, but was initially hesitant to take the shot because of the people on the horizon. I try to avoid photographing people or man-made objects whenever possible as I love to capture nature in its purest sense. I nearly walked away, but then I noticed the position of the people – three on either side of the rock, creating a wonderfully balanced composition and adding great interest and another dimension to the image. I decided to break my self-imposed rule there and then and was very glad I did.

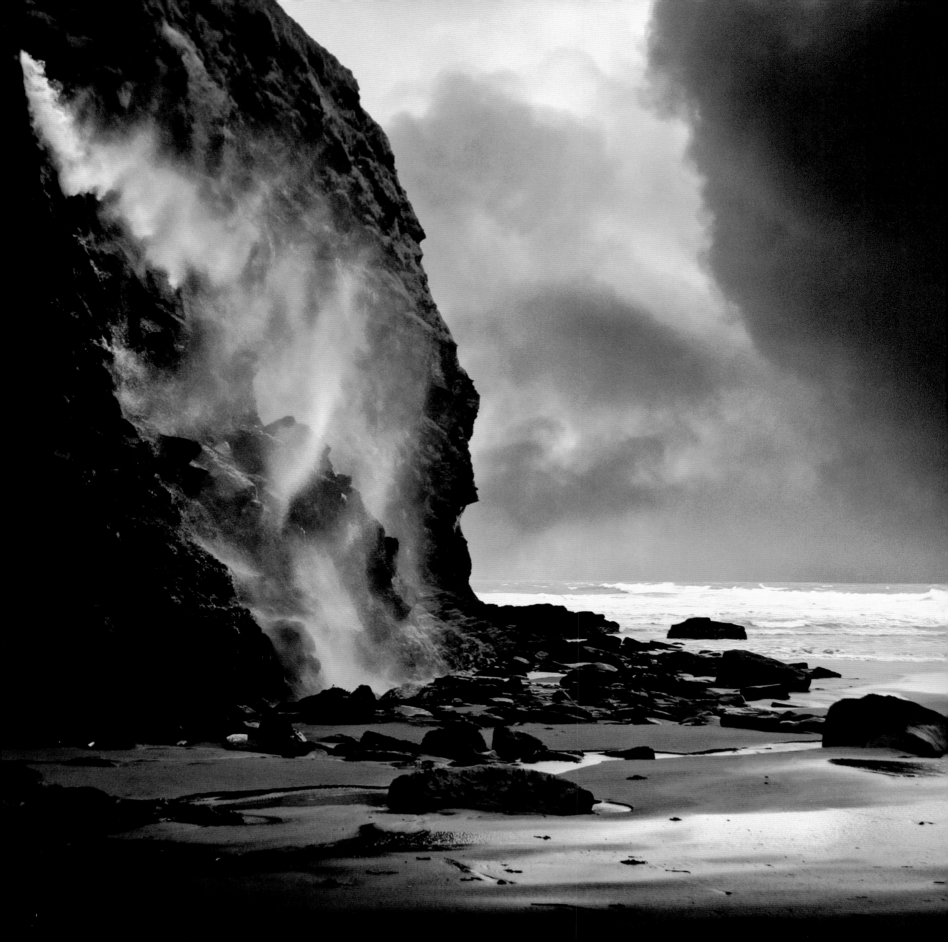

HIGHLY COMMENDED

CHRIS TANCOCK

Left: Druidston Haven in winter, Pembrokeshire, South Wales

On this day we had really high winds blowing out to sea. The waterfall was falling about six feet and then blowing at right angles for about five feet before cascading away. It was so windy I had to add pebbles to my rucksack and hang it on the tripod.

Judge's Choice Keith Wilson

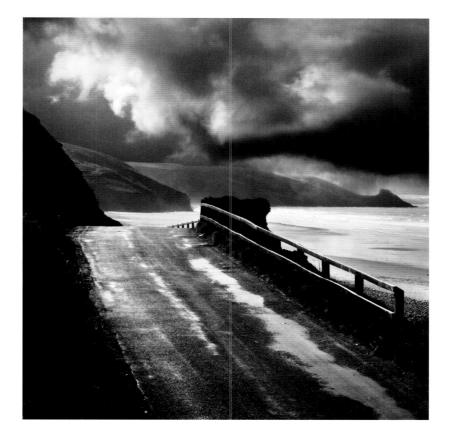

Newgale in winter, Pembrokeshire, South Wales

We were driving home when I saw that the road and the lighting were perfect. I just had time to jump out of the car, get in position and grab this image before the clouds went behind the hill and the storm broke up. It was one of those fortunate, chance moments when I was actually there at the right time – just!

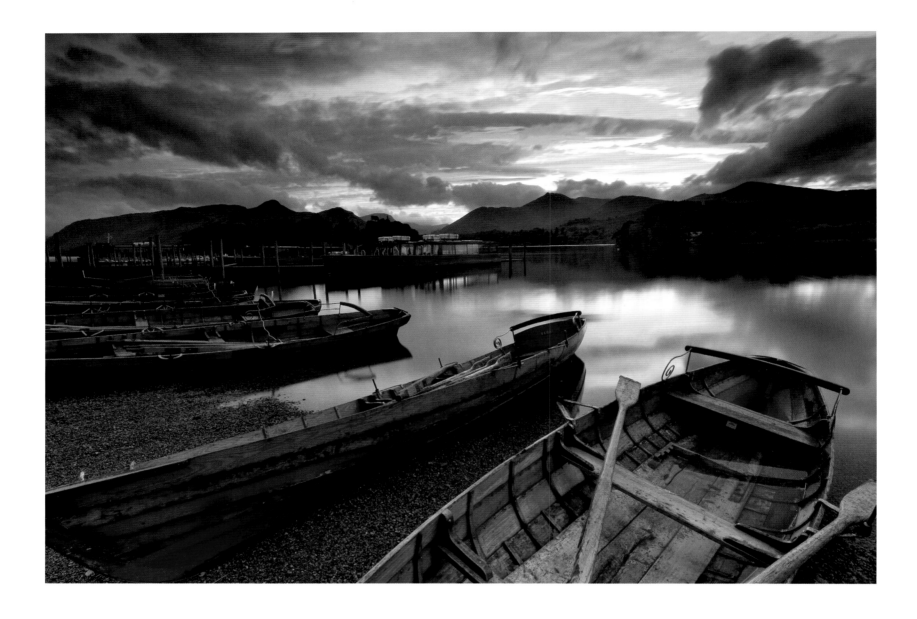

ROBIN WHALLEY

Derwentwater at sunset, the Lake District, Cumbria, England

This image was taken whilst on a photographic holiday in the Lake District. It had been raining hard and the day had been spent photographing rivers and waterfalls in a local wood. As sunset approached, the clouds lifted and we raced down to the landing stage at the Keswick end of Derwentwater. What can't be seen on this shot are the 16 other photographers crowded around either side of me. The ultra wide-angle lens allowed me to virtually climb into the boat to capture this shot.

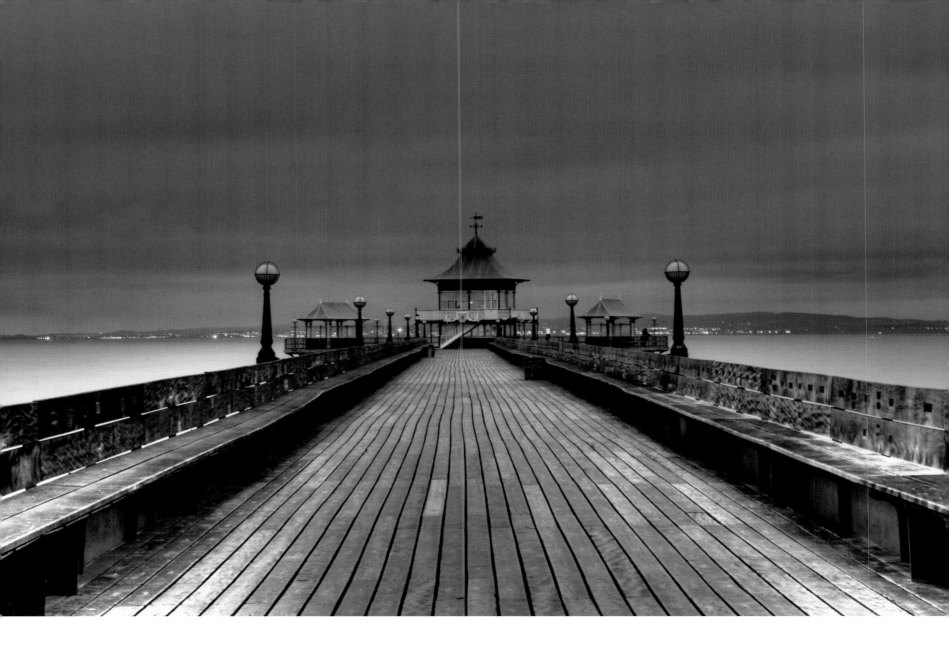

TONY HEPBURN

Winter morning, Cleveland Pier, Somerset, England

The shot was taken very early on a cold winter morning in January. I chose an early start because I didn't want the pier crowded with people. The pier is the complete focus of the shot and the dramatic sky, just before daybreak, adds a huge amount. It's a very evocative and special place, where the weather can make or break a picture like this. I still remember the biting wind, blowing in off the sea.

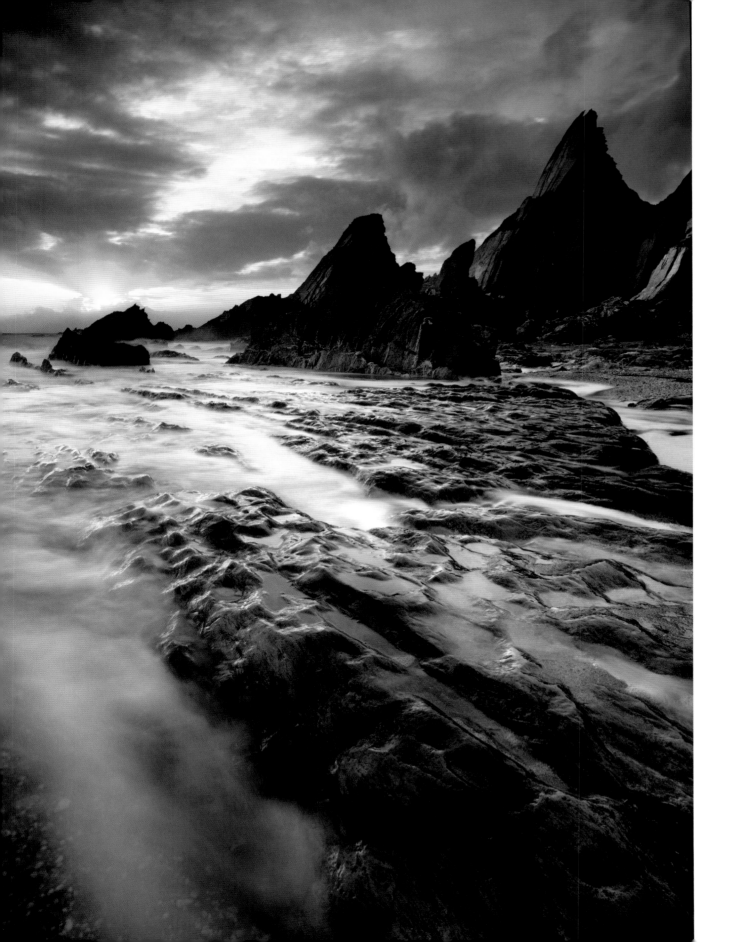

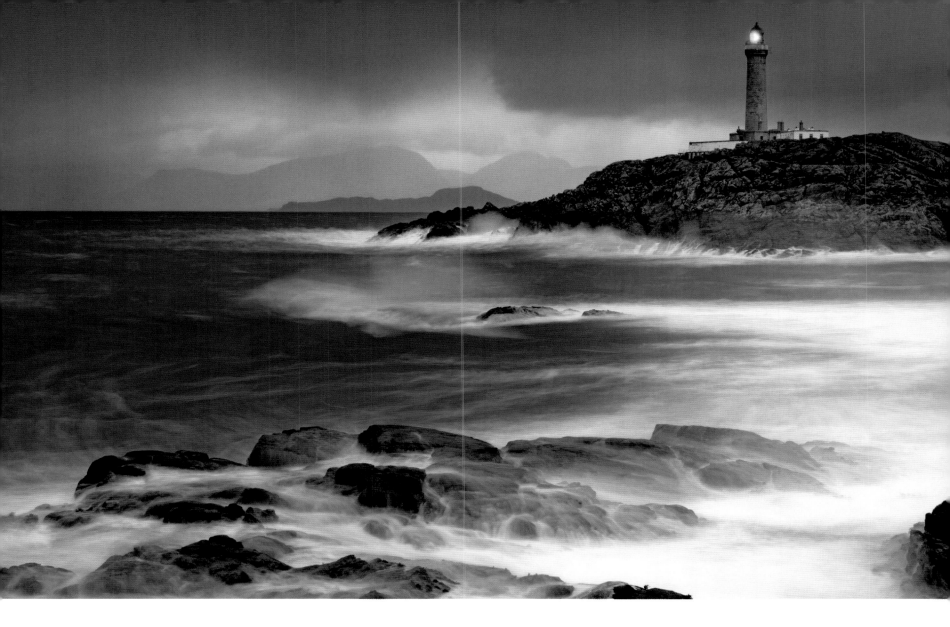

DAVID CLAPP

Left: Westcombe Bay, South Devon, England

Such repetition in geography is rare, but this interpretation of 'big, bigger, biggest' is something that captured my imagination long before I ever picked up a camera. The streaking lines of this unmistakeable knife-like geology are inherent in South Devon on a number of beaches, but I have never found a beach with such cathedrals of rock, exhibiting such character and form, as Westcombe Bay. It is grandiose and formidable.

Ardnamurchan Lighthouse, Scotland

A prominent landmark such as this is best accompanied by huge westerly Atlantic swells, and that is exactly what I got on this particular day. With a huge golfing umbrella covering the camera and tripod, the wind belted the rocks all around me and the low grey cloud came racing inland. Smoothed by a long exposure, this image represents a calmer moment perhaps; the lighthouse filaments beginning to glow above the power of the elements.

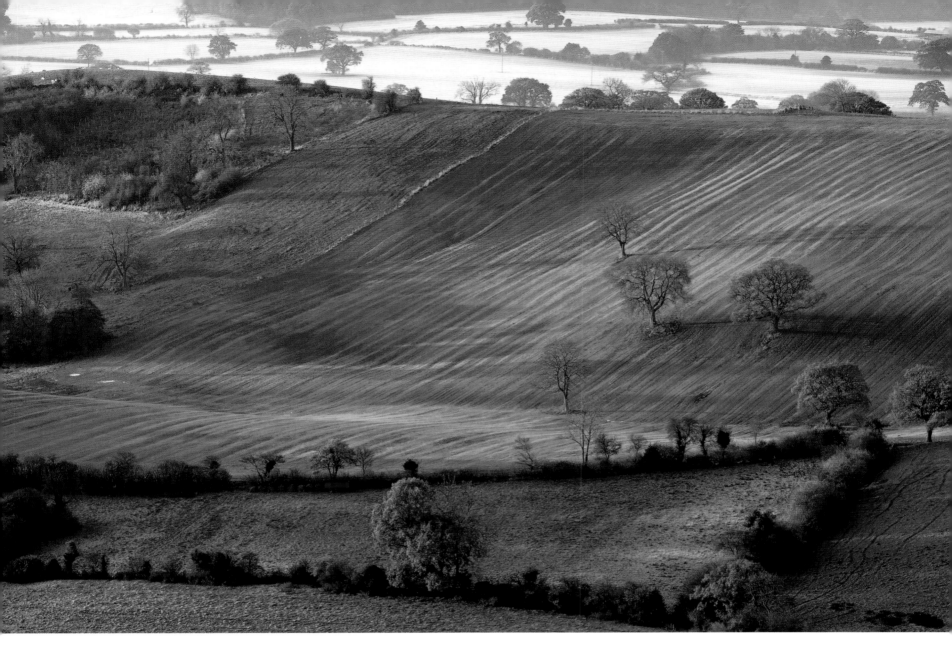

PAULA GRAHAM

A cold autumn morning in Yorkshire, England

This was taken from a vantage point on Sutton Bank at sunrise, overlooking the Vale of York – a well-known local beauty spot. I arrived early on a very cold November morning and conditions were just glorious; cold, misty, but with a clear sunrise that burned the mist off very quickly. Standing on the viewpoint, all alone; no traffic, no noise, just this glorious late autumn sunrise made me feel very content and in awe of such beauty.

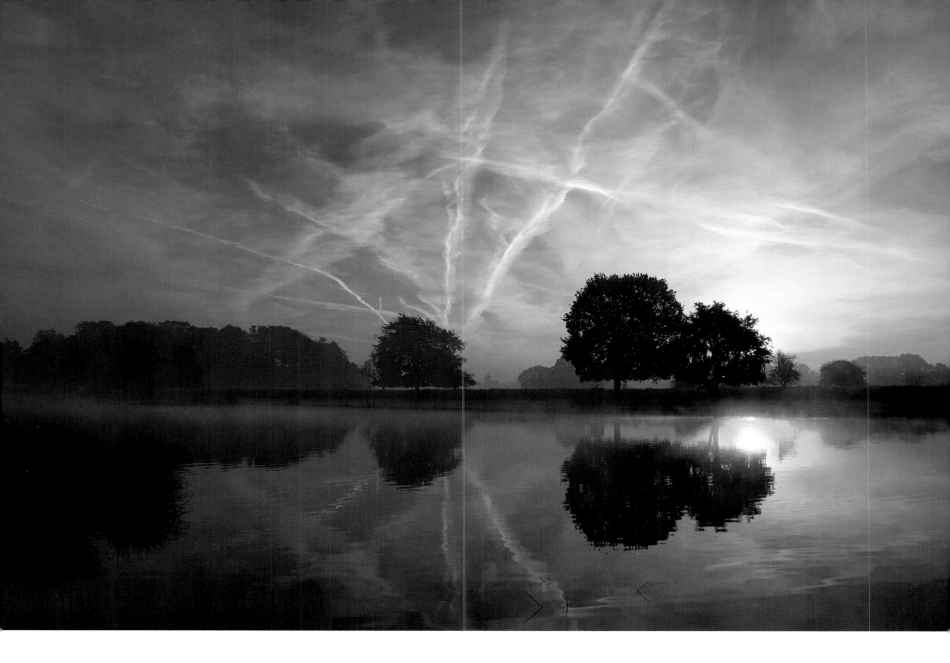

ALAN RODERICK

Bushy Park at dawn, Hampton, West London, England

This picture encapsulates the feelings I had whilst Lorraine, my wife, was dying of cancer in 2007. She liked to see pictures of our local park and remember our early morning walks. The contrails are both beautiful and deadly – representing people's holidays as well as pollution and illness. The dawning sun gave me hope and faith to face the difficulties of those final days. The brisk, autumnal morning managed to give a feeling of spring waiting to burst forth once the dark days of winter were over, and that life would go on.

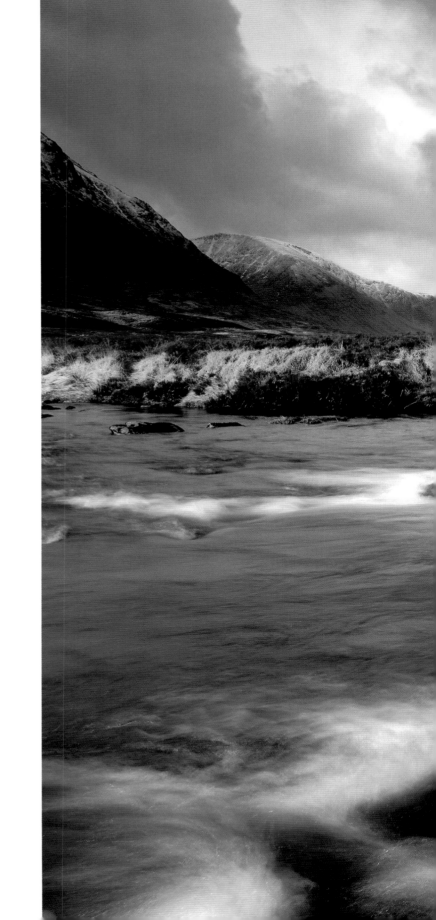

ANDREW CRAGGS

Approaching storm, Buachaille Etive Mor, Glencoe, Scotland

The weather on the afternoon I arrived in Glencoe was magnificent but soon closed in. After following the forecast closely, a break in the weather seemed possible around sunrise on the day I made this image. A blanket of low cloud greeted me that morning, so I headed out with equally low expectations. I walked to my chosen vantage point, with high winds buffeting me and very few breaks in the cloud but, just after sunrise, shafts of light began to appear. Then one break in the cloud lit the foreground, so I quickly took this image (with an umbrella shielding the camera from wind and rain). It's a good thing I did, as the fleeting light disappeared as quickly as it had arrived.

38

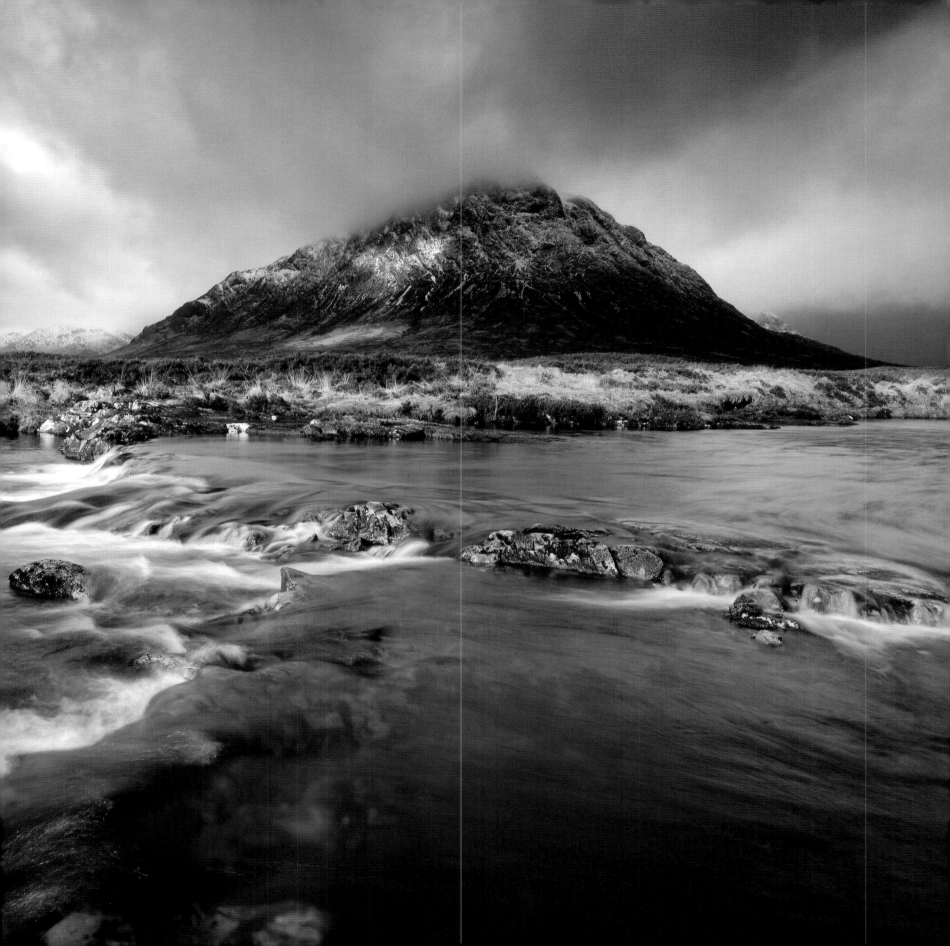

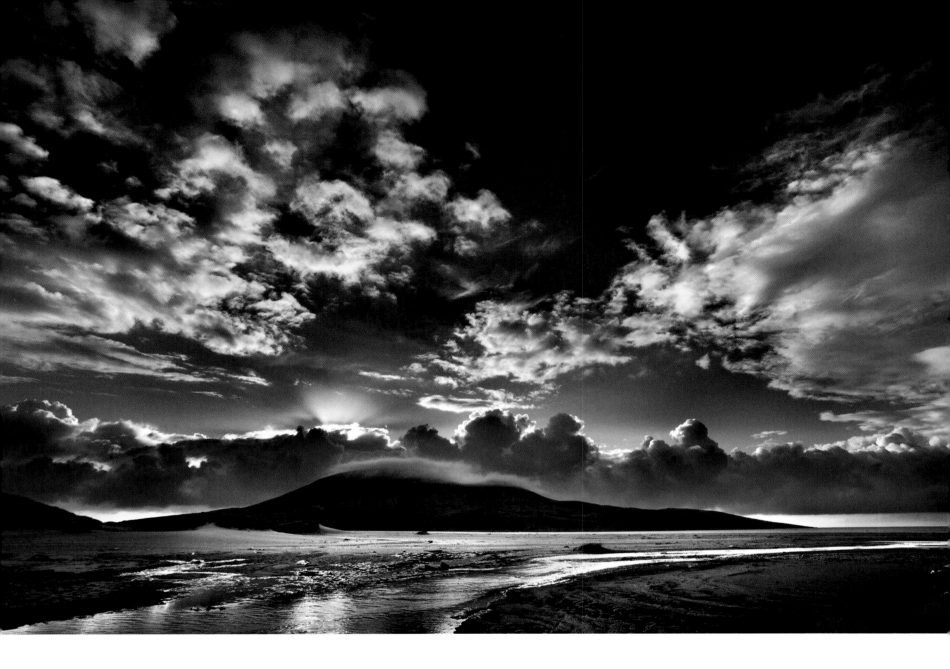

TRISTAN CAMPBELL

Scarista Bay, Isle of Harris, Scotland

Standing alone in such a beautiful place and watching nature put on such a fine show was an awe-inspiring experience. The cloud formations are simply stunning.

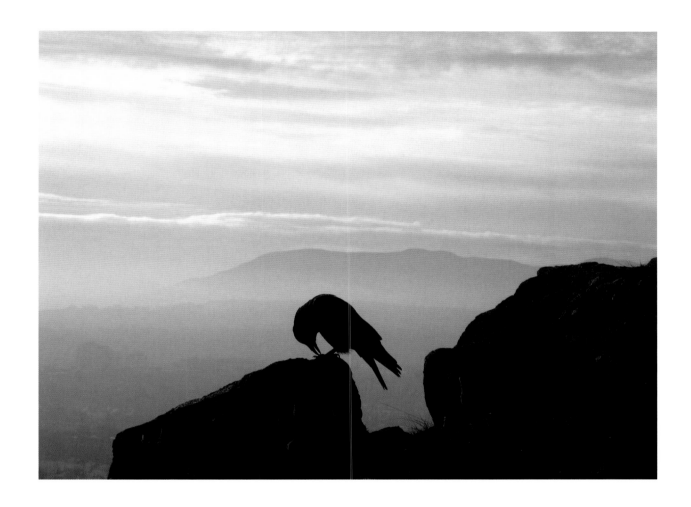

ROSEMARY BOWMAN

Mist rising from the Pentland Hills, Midlothian, Scotland

This image was taken at the end of December, on a day when Edinburgh was submerged in mist. As I walked on Arthur's Seat, the Pentland Hills emerged in smoky light, with ribbons of mist running through. The image, which had seemed still and tranquil, almost ethereal, formed an instant contrast when the bird landed on the dark crags.

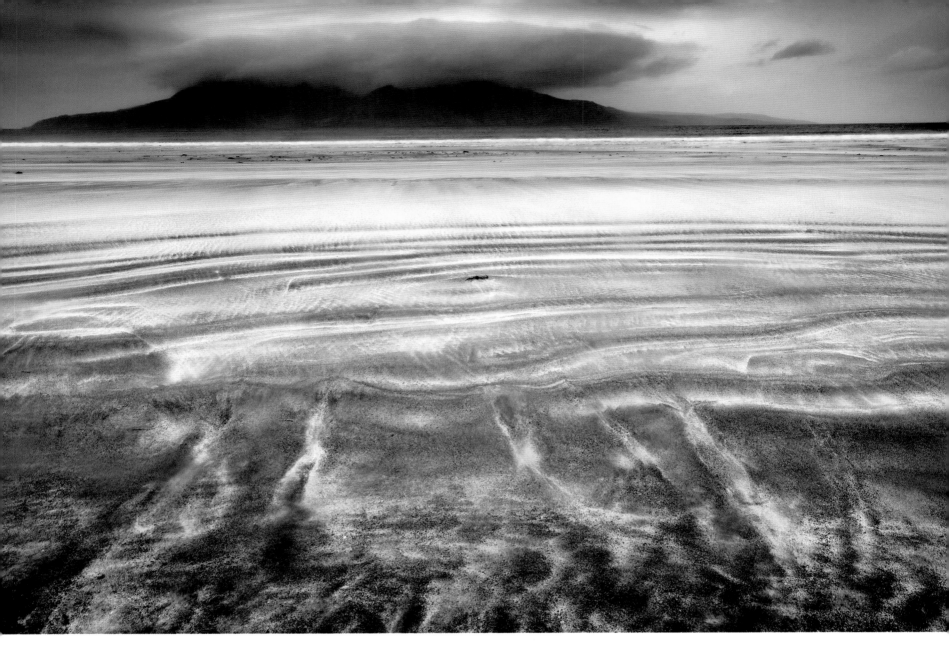

PETER PATERSON

Laig Bay, Isle of Eigg, Scotland

The picture was taken on a wet morning at Laig Bay on the Isle of Eigg. I was particularly interested in the cloud formation that was hanging over the mountains of Rum which adds a bit of drama to the scene along with the sand patterns in the foreground. I processed the image so that it gives the viewer the same emotions that I felt at the time.

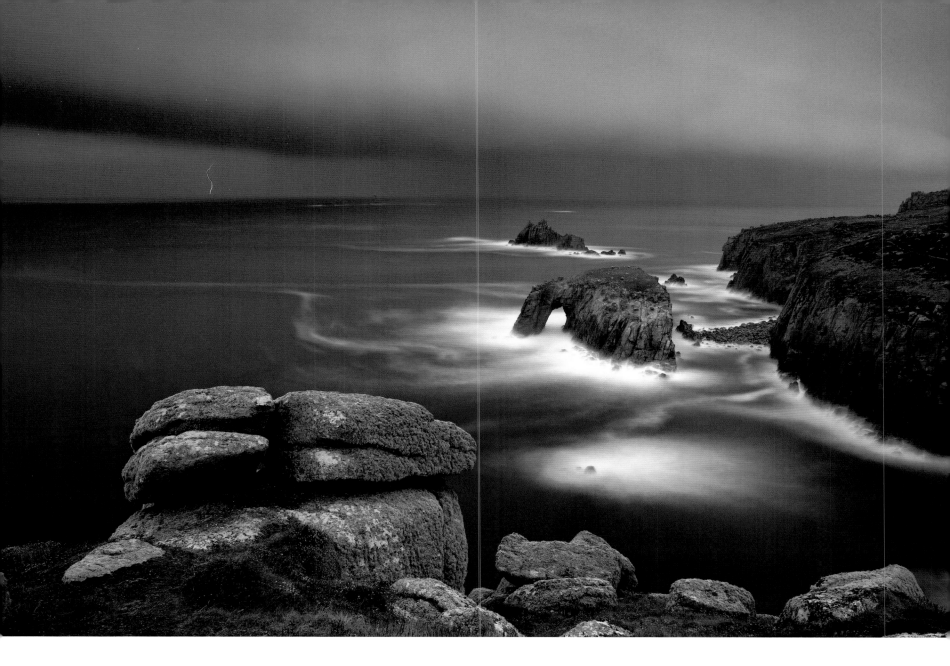

ADAM BURTON

Land's End, Cornwall, England

Despite the gloom of an approaching Atlantic storm, I decided to make the most of the situation with the conditions available. As the light levels dropped ever further I noticed occasional lightning bolts striking over the sea on the horizon. I set up my camera for a long three-minute exposure – once the exposure ended and the preview popped on screen I was so happy not only to have captured the bolt, but in exactly the ideal position.

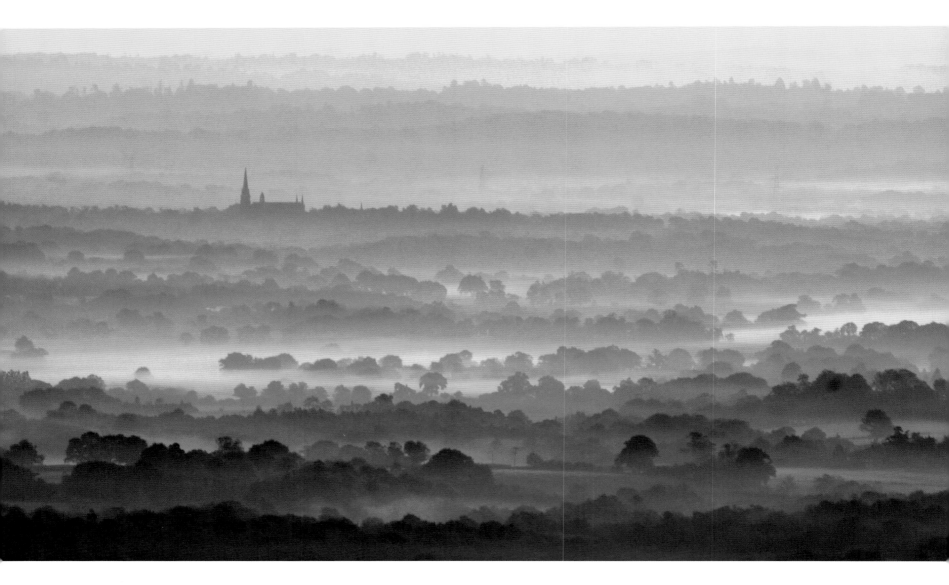

GEOFF GOODWIN

View from Chanctonbury Ring, West Sussex, England

Getting up in time to be at the top of the South Downs for sunrise on a June morning requires a lot of willpower. Once you arrive though, it becomes very worthwhile. The sun had been up for about 20 minutes and, together with the mist, gave the Sussex countryside this wonderfully atmospheric look.

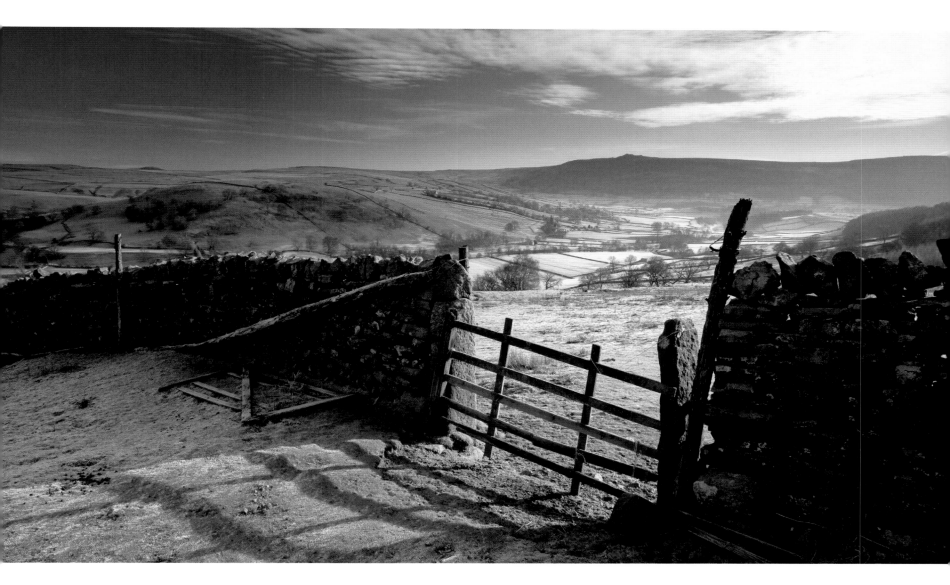

JOHN POTTER

Simon's Seat, Wharfedale, North Yorkshire, England

This location is a favourite of mine, especially in winter, as the sun rises to the right of Simon's Seat. Conditions, if it is frosty, are often favourable about an hour after sunrise.

STEEN DOESSING

'Transience', Hurst Spit, Hampshire, England

Initially, I was not sure about this image and didn't do anything with it for months, but now it has become one of my personal favourites. I used a 4-minute exposure, during which time the luminosity of the light and the ambience changed dramatically, hence the title. The light around Hurst Spit and the Solent is magical during spring and autumn.

CHRIS TANCOCK

Right: Ricket's Head in winter, Pembrokeshire, South Wales

A very stormy day with torrential rain. This is a colour photograph, but my lens must have been looking through gallons of water, as all the colour has been drained out of it.

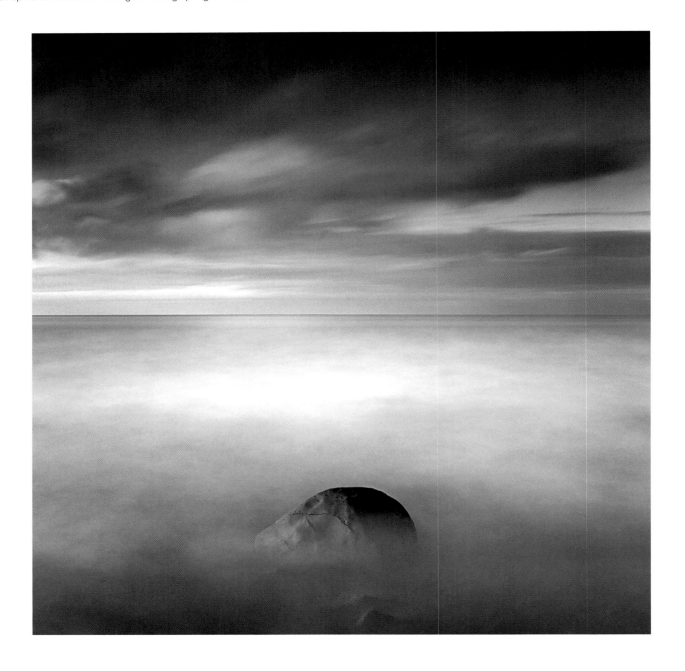

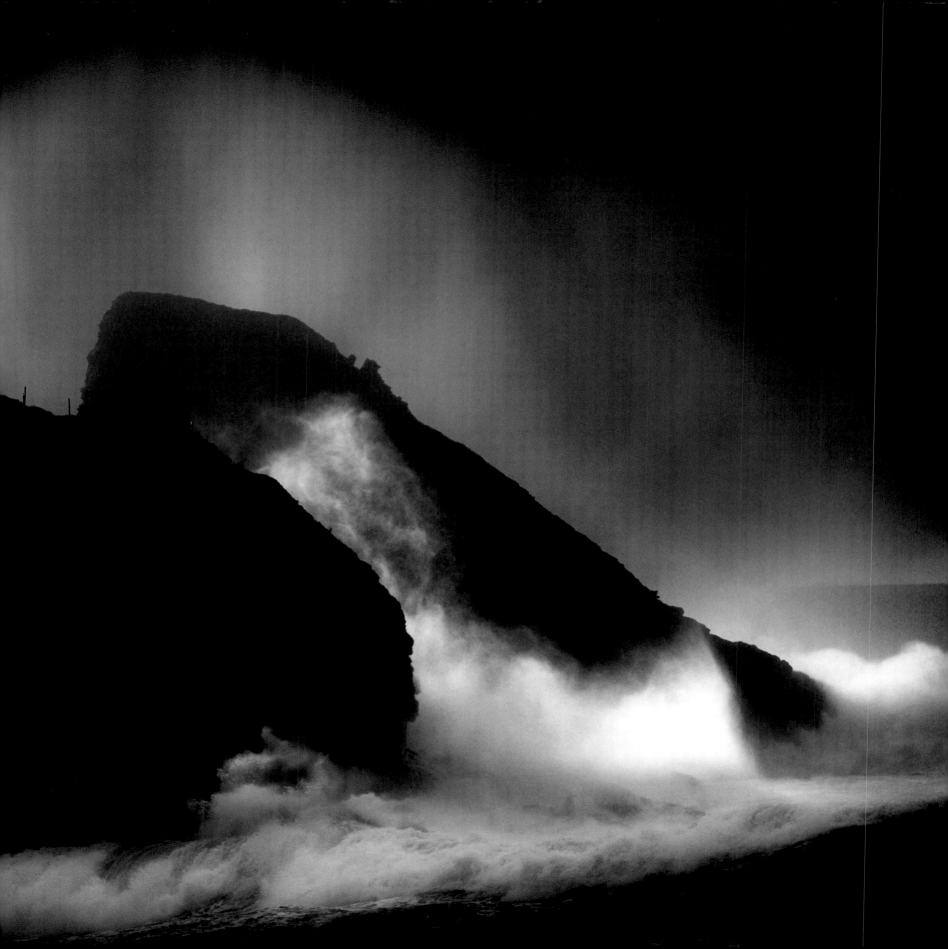

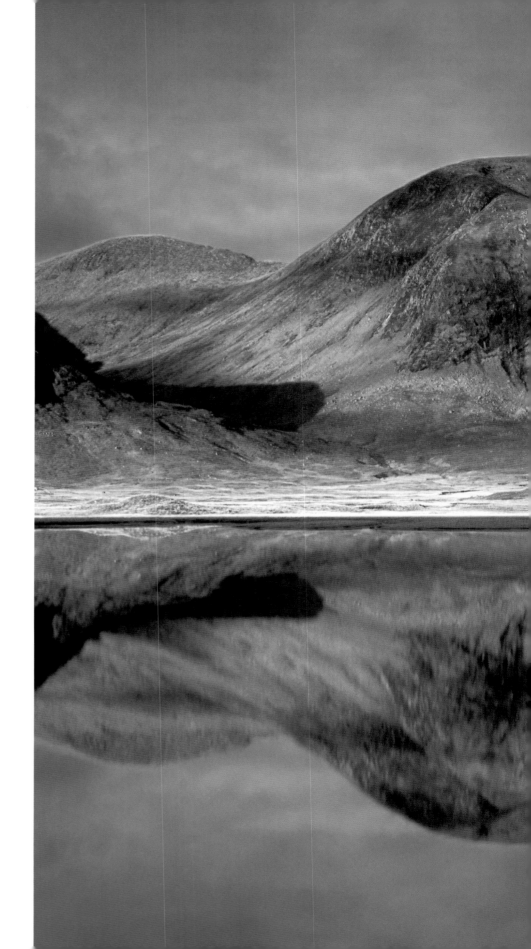

SIMON BUTTERWORTH

Loch Dochard, Northwest Highlands, Scotland

This image, silhouetting a dead tree against the calm reflections of
Loch Dochard, was taken on a very cold winter morning. Meall nan
Eun can be seen in the background.

Judge's Choice David Watchus

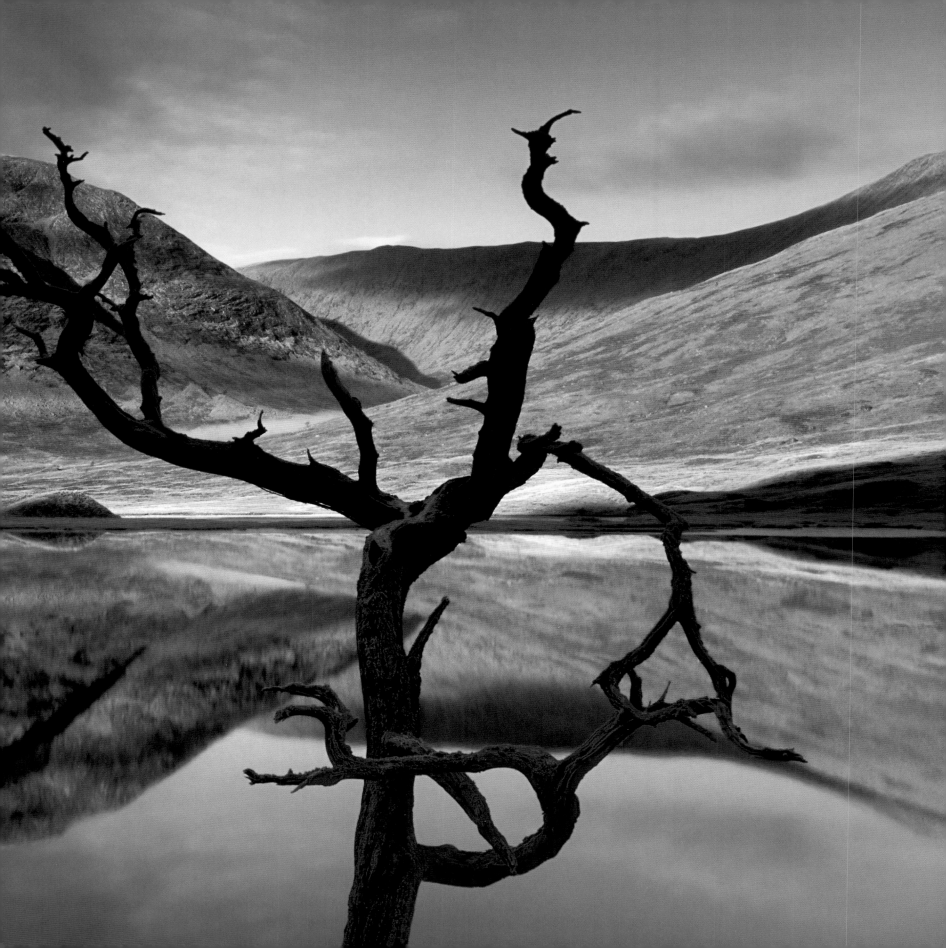

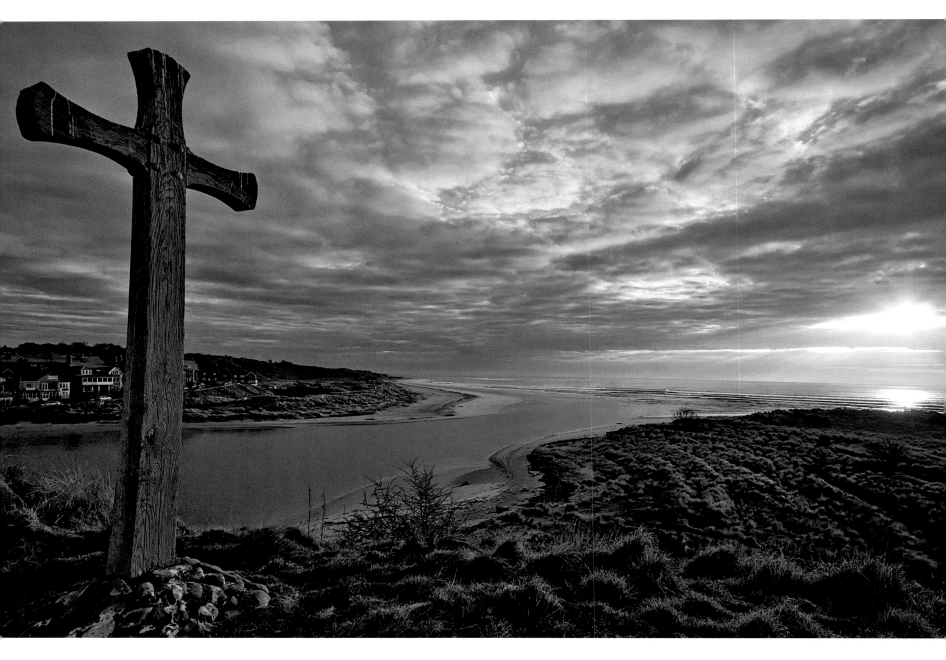

CAROLYN DAVISON

The dawn of Good Friday 2007, Alnmouth, Northumberland, England

Alnmouth is a lovely part of Northumberland that, in my view, embodies Britain's coastline at its best. I was keen to try to capture a view that would encompass all the classical features of this coastal landscape and the quintessential charm of the village, whilst hoping for something a little different. As Good Friday dawned, I was struck by the poignancy of the warm glow of morning light on the Cross on this new Easter day.

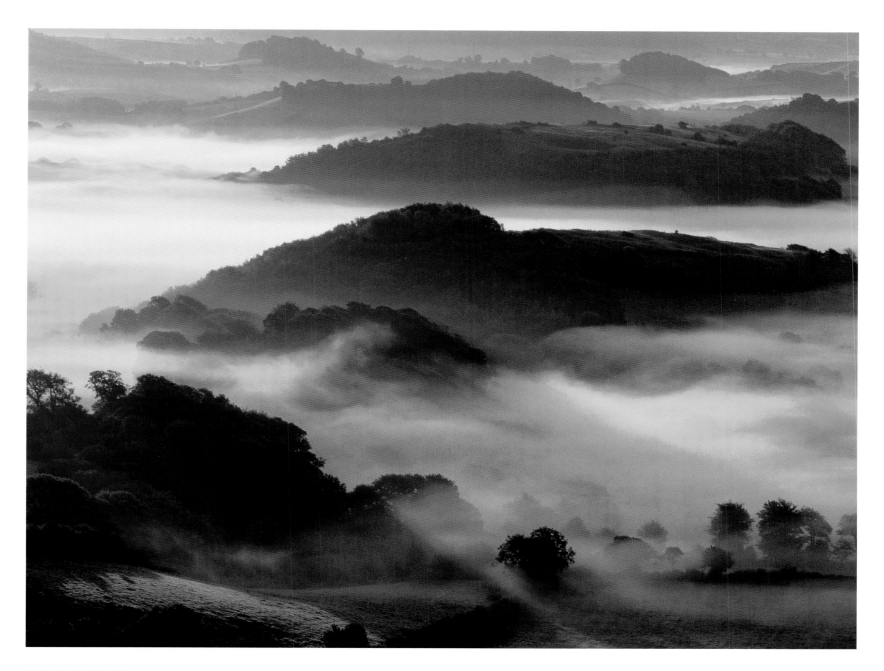

GUY EDWARDES

Dawn near Bridport, West Dorset, England

This view, of the mist in the hills around Bridport in Dorset, was taken from Quarry Hill.

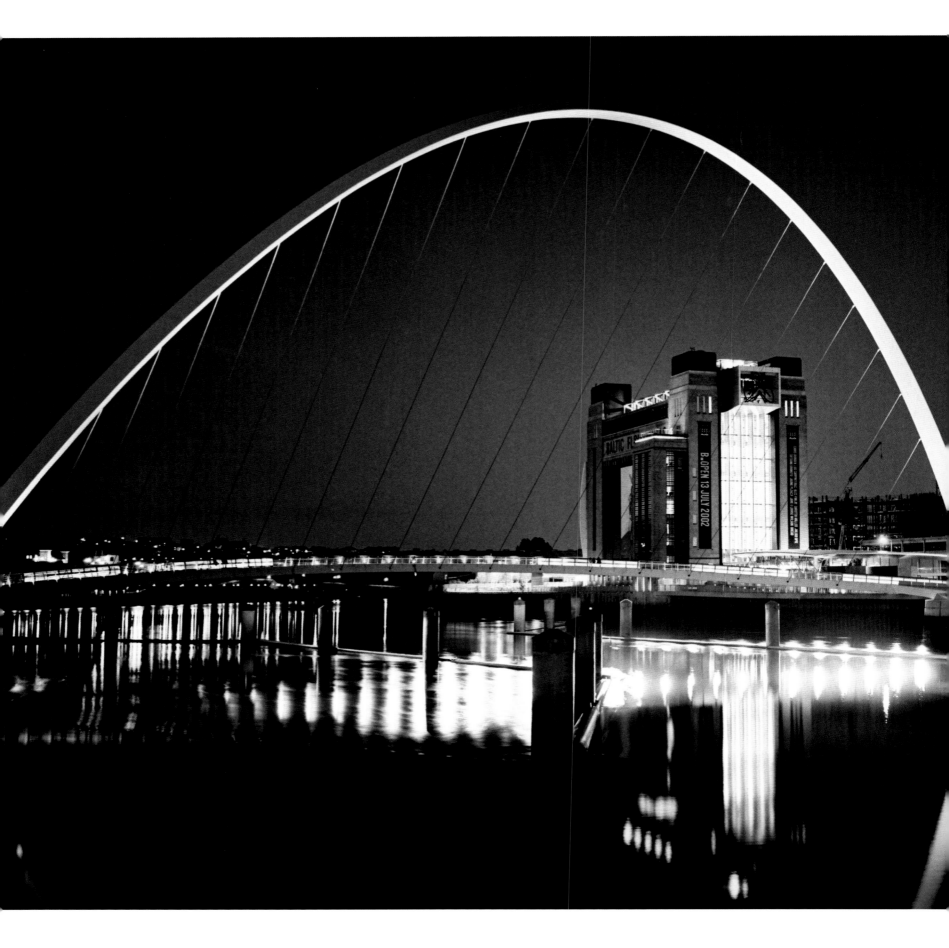

PAUL RICKELTON

Gateshead Millennium Bridge, Newcastle, England

Newcastle has a reputation for its party atmosphere and nightlife. I wanted to capture the peaceful side of Newcastle's quayside at night and the transformation of the city into one of northeast England's most important arts centres.

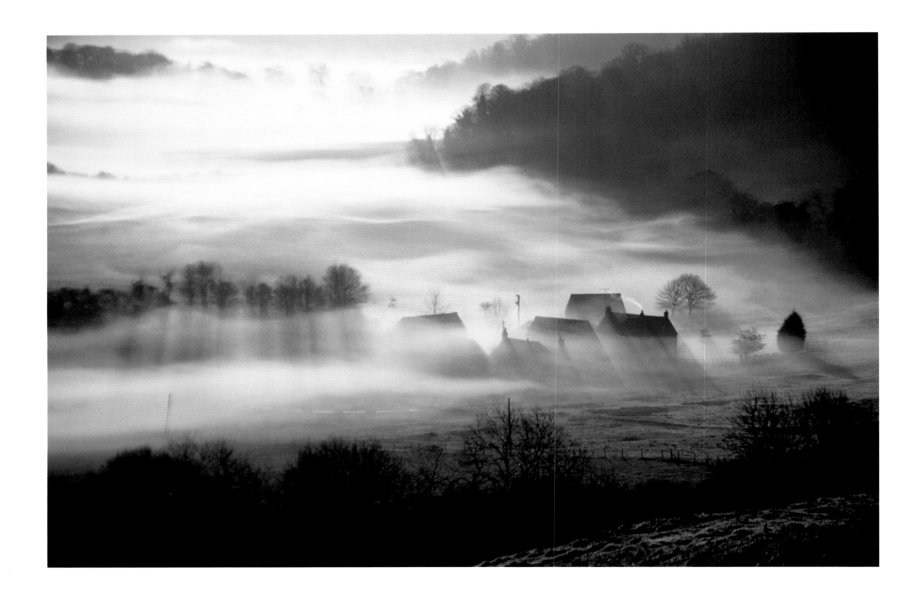

STEVE BARKER

Lower Barpham in the mist, Angmering Park, West Sussex, England

I had left my camera at home on this particular morning, which was unheard of for me. I was extremely busy in my work as a gamekeeper, but the light was so fantastic that I had to drive back for my camera to get the shot.

ANDREW FYFE

Right: Sea groyne at dawn, Shanklin, Isle of Wight, England

This image was captured at dawn just prior to sunrise when the colour of the sky turned a magical pink. The remainder of the day was wet and grey, but everything came together for just a few seconds that morning.

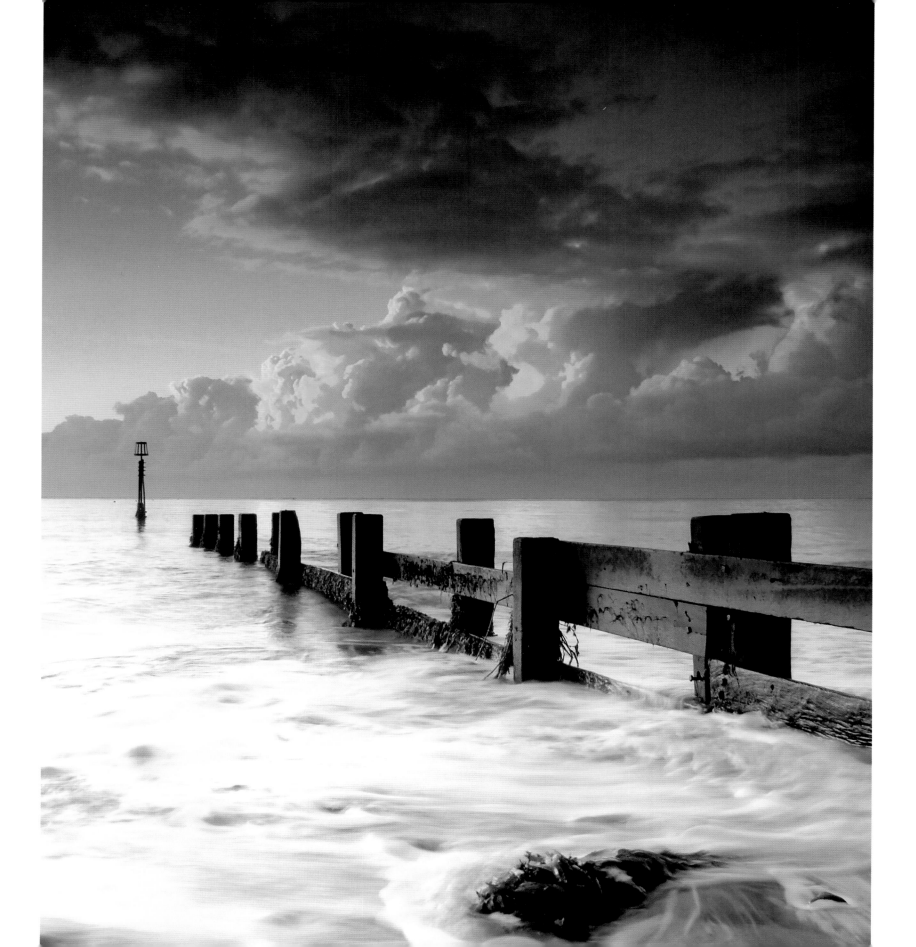

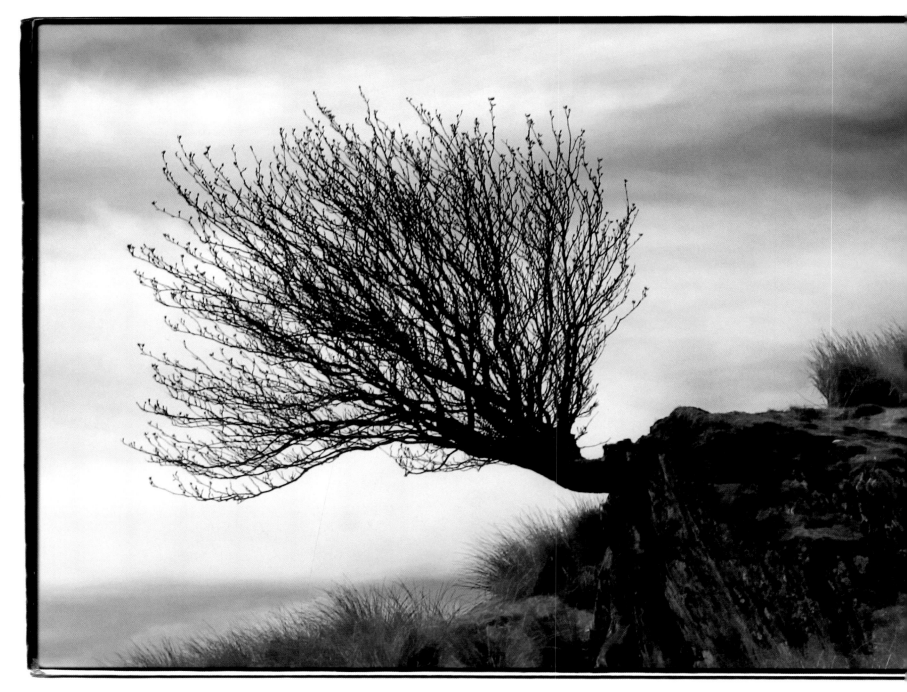

STEVE DEER

Moel Siabod, Capel Curig, North Wales

I had taken a fairly decent shot of this tree on a previous walk and hoped to catch it again in a different light. I had to stand in a marsh to capture it and I was sinking all the time. I didn't have a tripod with me and it was very windy, hence the soft foreground grass, but I feel that the softness here adds to the image.

56

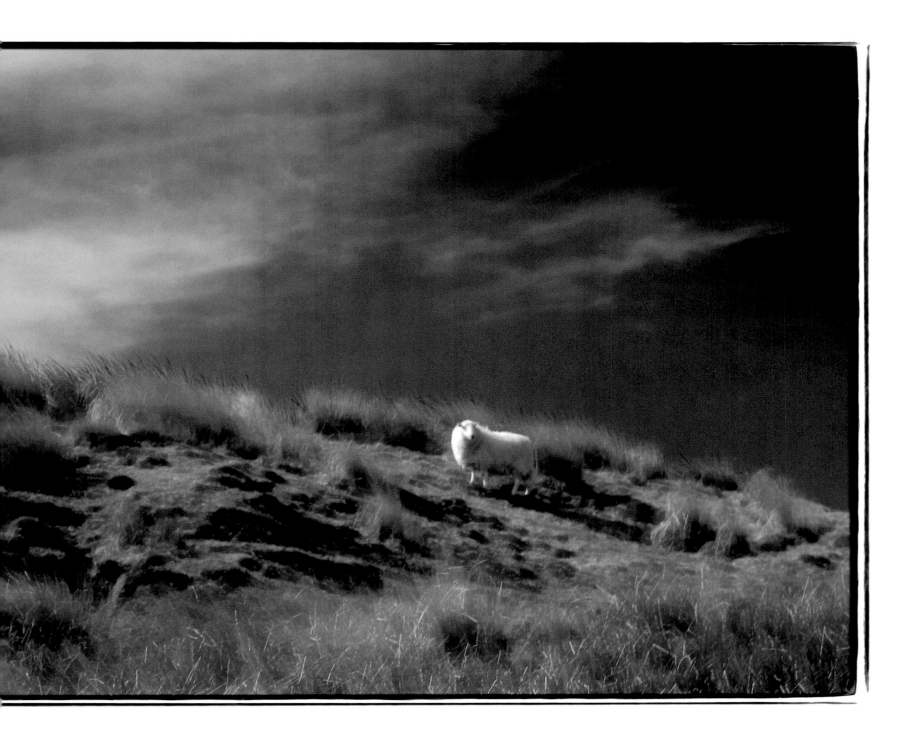

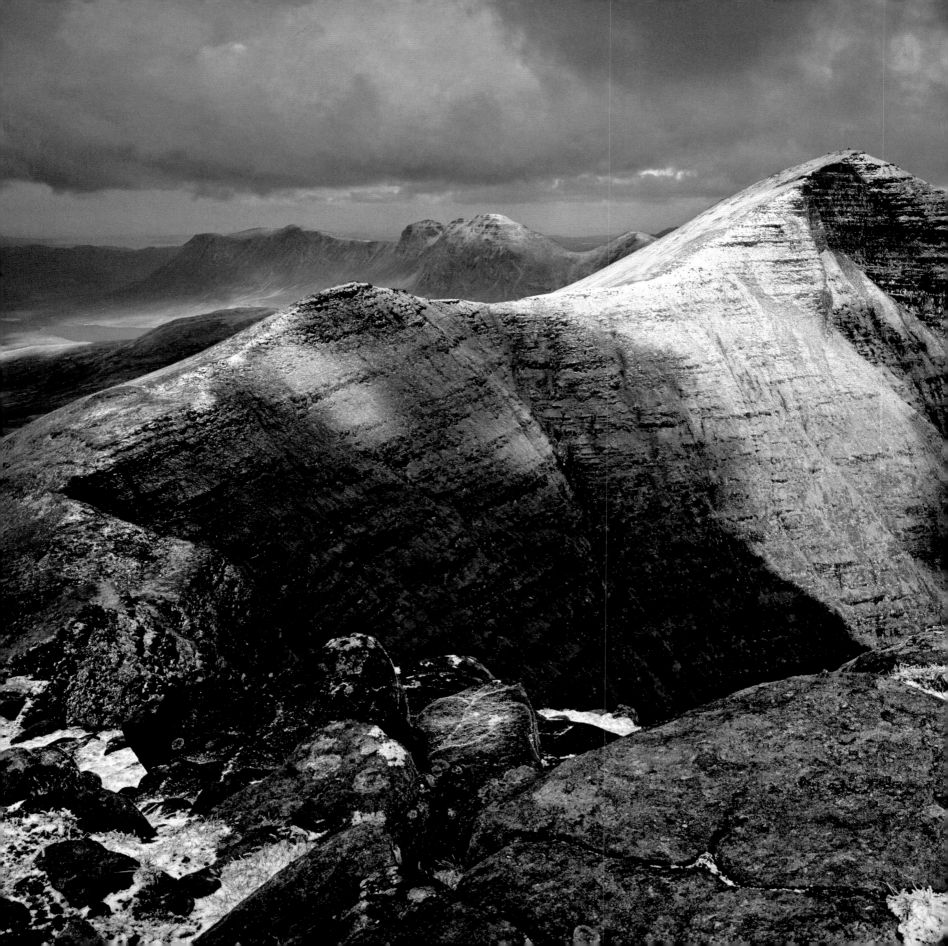

IAN CAMERON

The summit of Beinn Alligin overlooking the roof of Torridon, Scotland

On this particular day, I was buffeted by savage squalls that just as suddenly passed, leaving bright sunshine and blue skies – my favourite conditions for landscape photography. The view that greeted me after the steep and arduous hike to the top was astonishing. It was bitterly cold, but I duly set up my tripod and watched as occasional shafts of light peppered Beinn Alligin. I watched as one of these light ladders traversed the mountain tops and realised that it would strike the summit. I got just three frames as the moment came and went, and this was the only one to reveal the sapphire blue of a distant loch in the upper left corner in a similar moment of transient light.

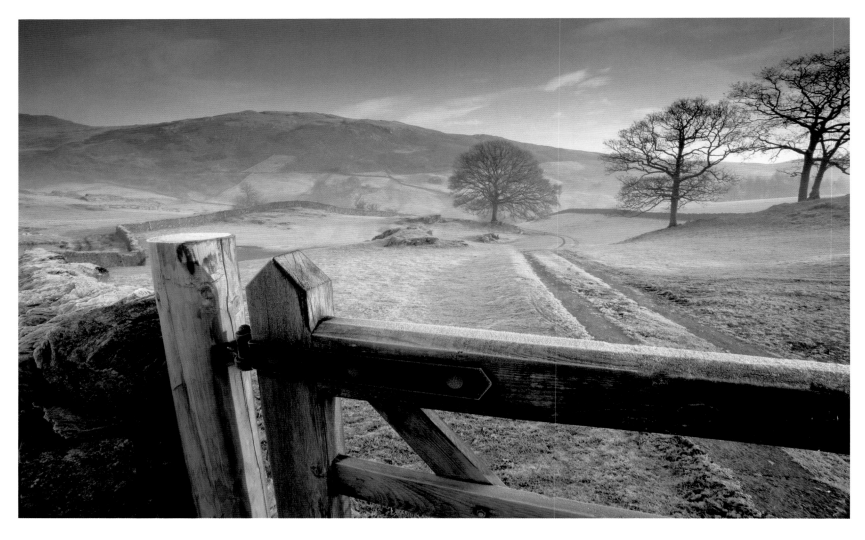

DARREN CIOLLI-LEACH

Dawn frost in the Lake District, Cumbria, England

I'd spotted this location the night before in the dark and just had to return. It meant a very early start, but the frost and the warm sunrise were beautiful.

MIKE McFARLANE

Right: Loch Mallachie, Cairngorm National Park, Scotland

This rocky microcosm is one of the most amazing natural sights I have ever seen, showing just how hard nature perseveres to exist. Growing on this lump of granite in the edges of Loch Mallachie, in a wafer thin scattering of compost, were a fir and a rowan/birch tree. Given the lack of nutrients, the competition with each other and the harsh climate, these trees are likely to be at least three to five years old.

How can nature exist on so little? How can we need one or more houses, one or more cars, one or more TVs, a myriad gadgets, wardrobes full of clothes, and a huge pile of food each day? This rock really is a miracle of life.

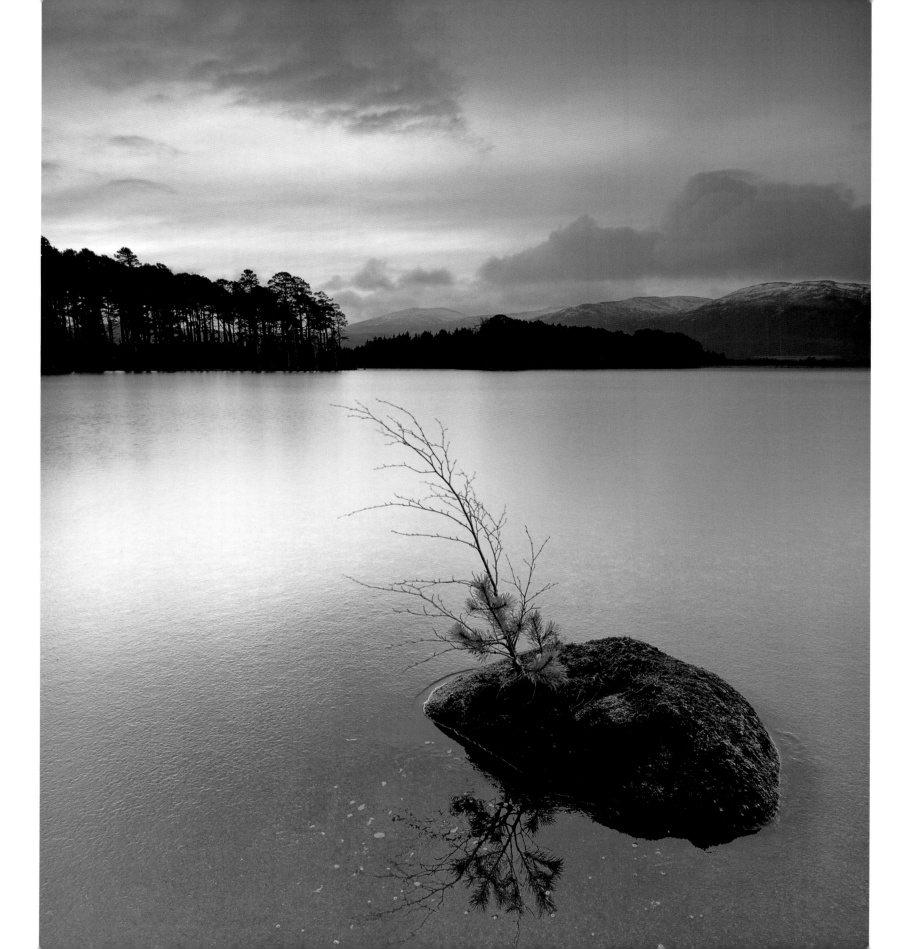

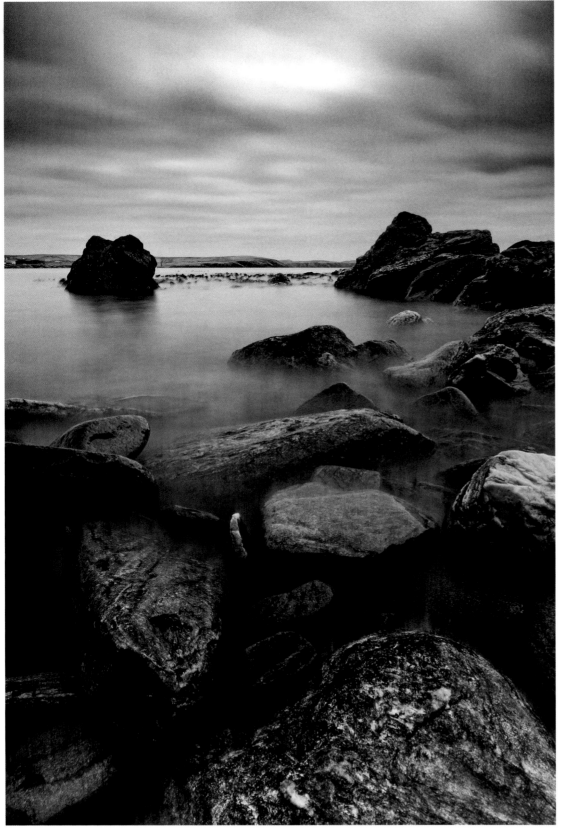

MARK SINCLAIR

Levenwick, Shetland Isles, Scotland

This image was taken after scaling down a small cliff in Levenwick in the Shetland Isles. The extended exposure gives the dreamy atmosphere to the sea and the clouds.

DAVID LOTHIAN

Right: The Watkin Path, Snowdonia, Wales

This spectacular view over Llyn Llydaw was taken from the Watkin Path shortly before it begins the final steep ascent to Snowdon's summit. Some local legends have it that Llyn Llydaw is the lake into which Sir Bedevere threw *Excalibur*. Stories aside, there is still certainly something dark and mysterious about it.

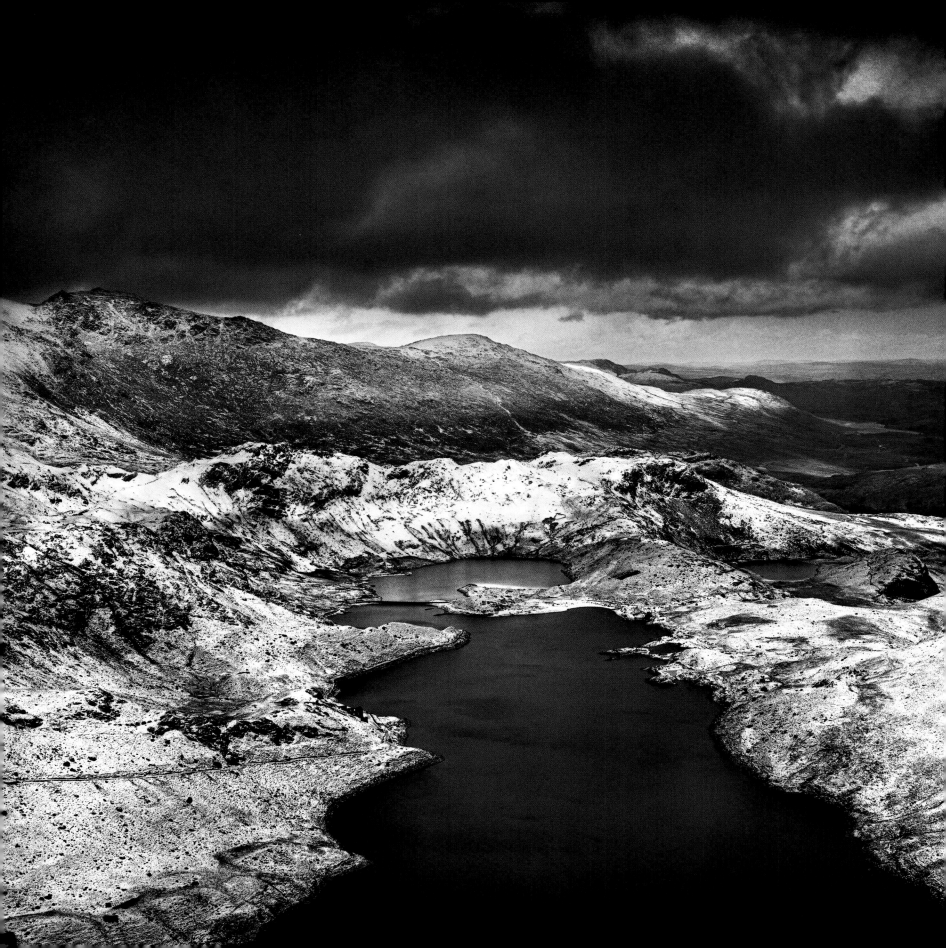

JAMES OSMOND

Chalk cliffs from Durdle Door on the Jurassic Coast, Dorset, England

As the tide was going out, shingle gradually gave way to orange sand that seemed to glow in the afternoon light and, together with bright blue sky and white cliffs, revealed a colourful scene. I set up at the water line where the sand was perfectly smooth and took a couple of frames with the waves lapping at my feet. This frame seemed to work best as the sinuous curve of the water's edge is mirrored in the curved shape of the two headlands in the distance.

Judge's Choice Charlie Waite

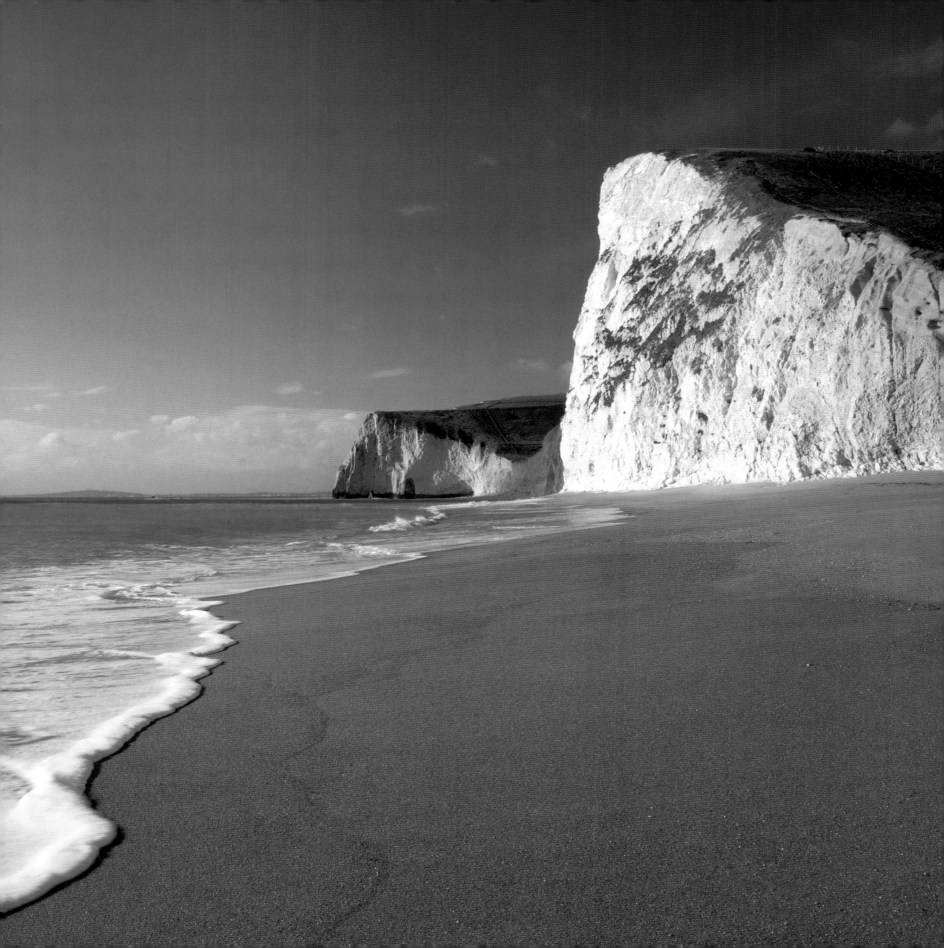

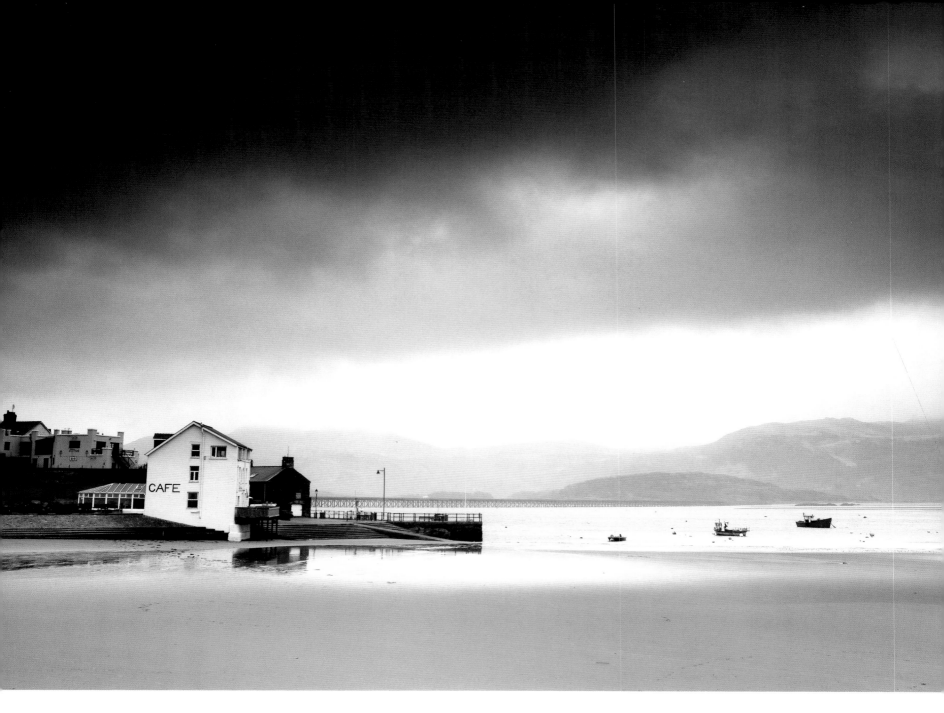

DAVID J WHITE

Barmouth, North Wales

I went to Bala in North Wales in January with the intention of getting some dramatic shots of the area. It rained constantly for several days so I drove to Barmouth, on the coast. The bleak weather and the empty café, closed for the winter, pretty much summed up my feelings at the time. However, the moment I saw the picture appear on the screen of my camera, I knew I had something special.

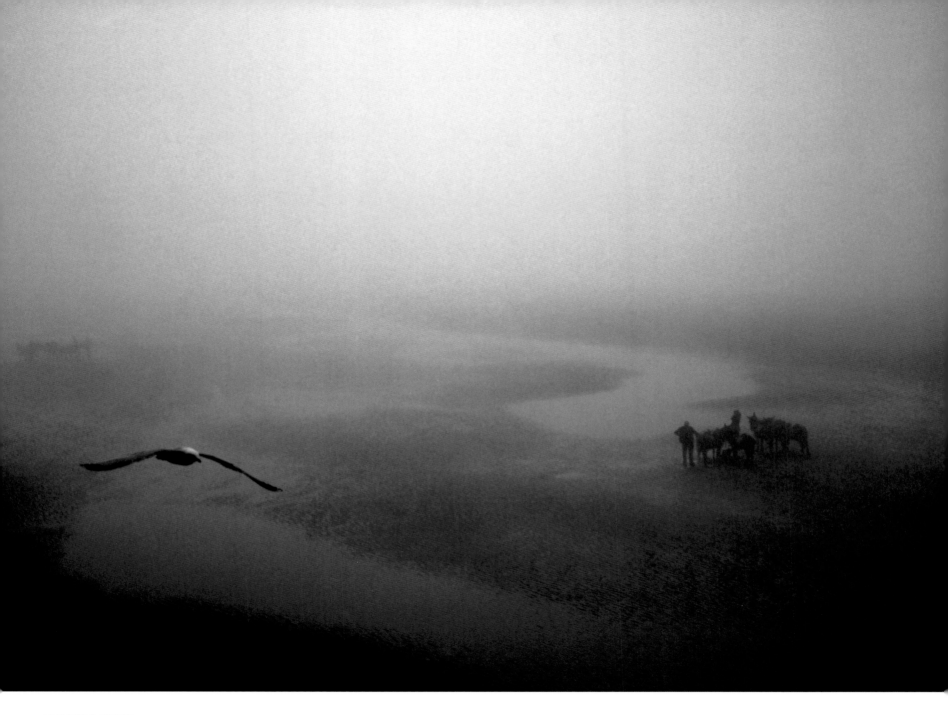

JOE FAULKNER

Blackpool, Lancashire, England

I wanted this image to show the decline in the British summer holiday, and how a family trip to the beach for a weekend break is now much more of a rare occurence.

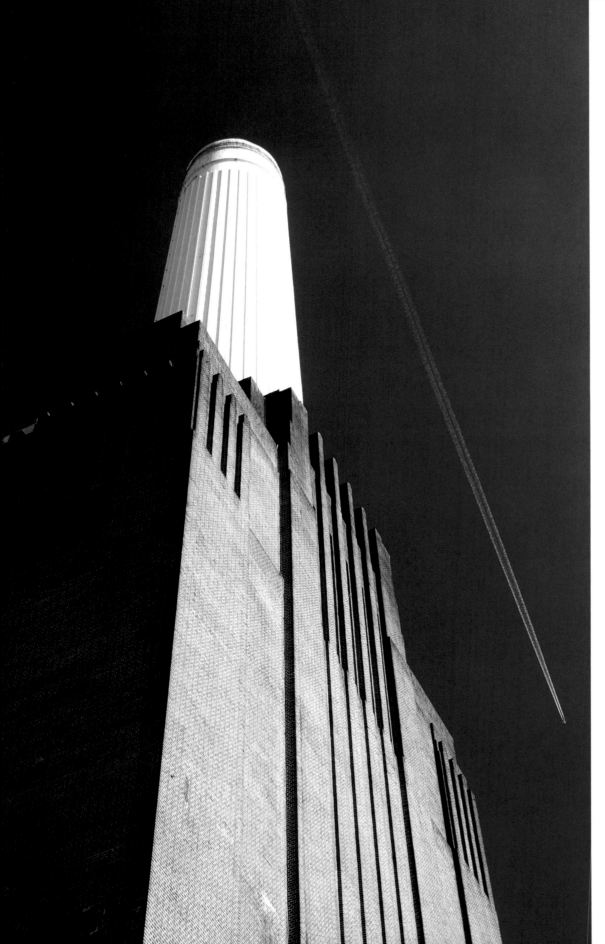

ADAM CAVALIER

Battersea Power Station, London, England

One of those fortunate moments….

DAVID CANTRILLE

Right: Burton Bradstock coastline, Dorset, England

The light attracted me to this location late one afternoon, there being no activity in the sea. I had not noticed this particular rock formation previously, so it proves that it pays to visit and revisit your local area.

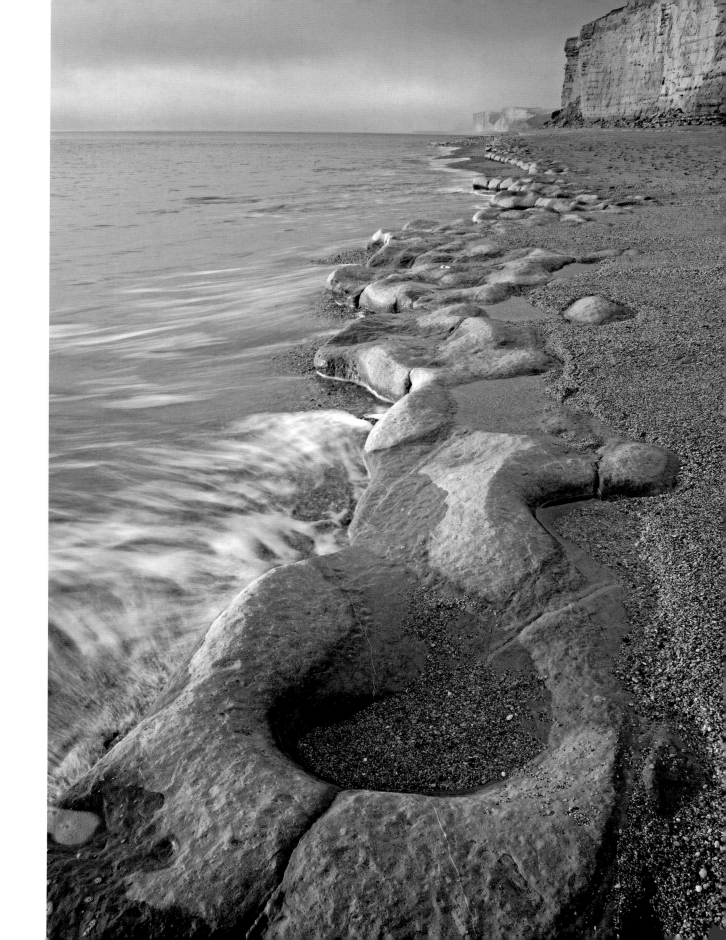

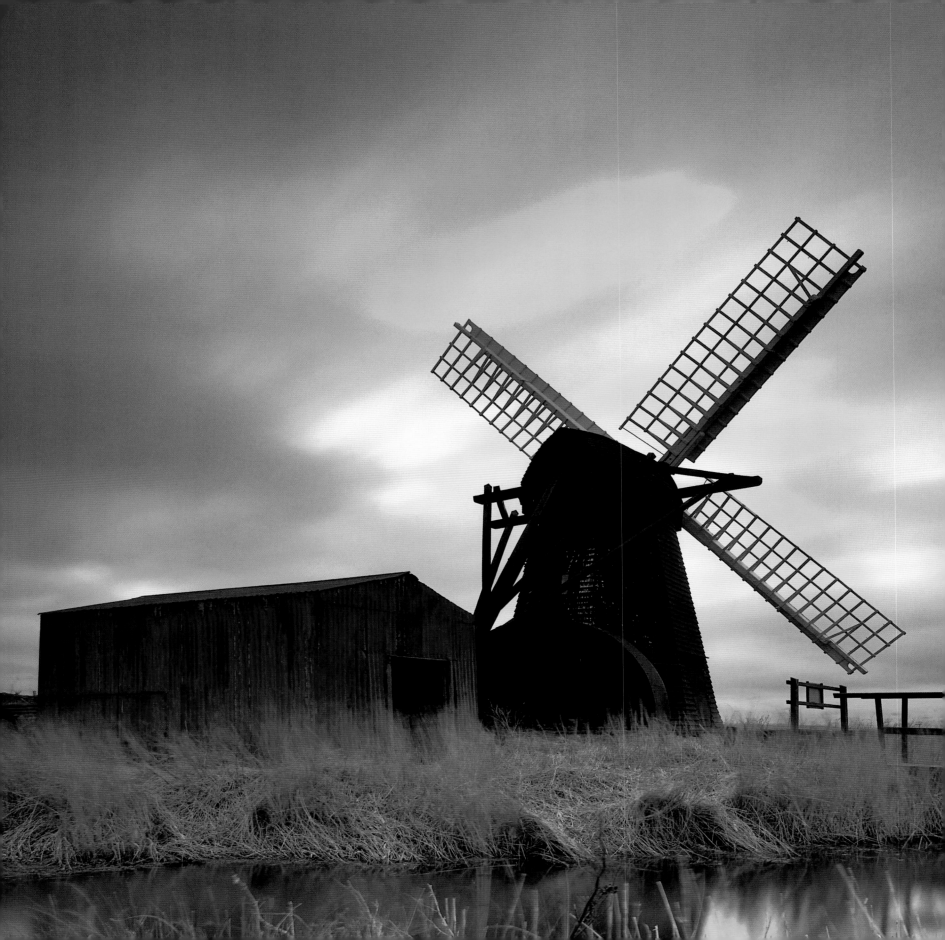

IAN FLINDT

Smock Drainage Mill, Herringfleet, Suffolk, England

Located on the Suffolk side of the Norfolk/Suffolk border, the Grade II listed mill is accompanied by the less aesthetically pleasing feature of a corrugated iron shed, built to house the steam-driven pump that was eventually to take over from its picturesque companion the responsibility for draining the surrounding marshlands. This image was captured as the light faded on a brutally cold and windy February day.

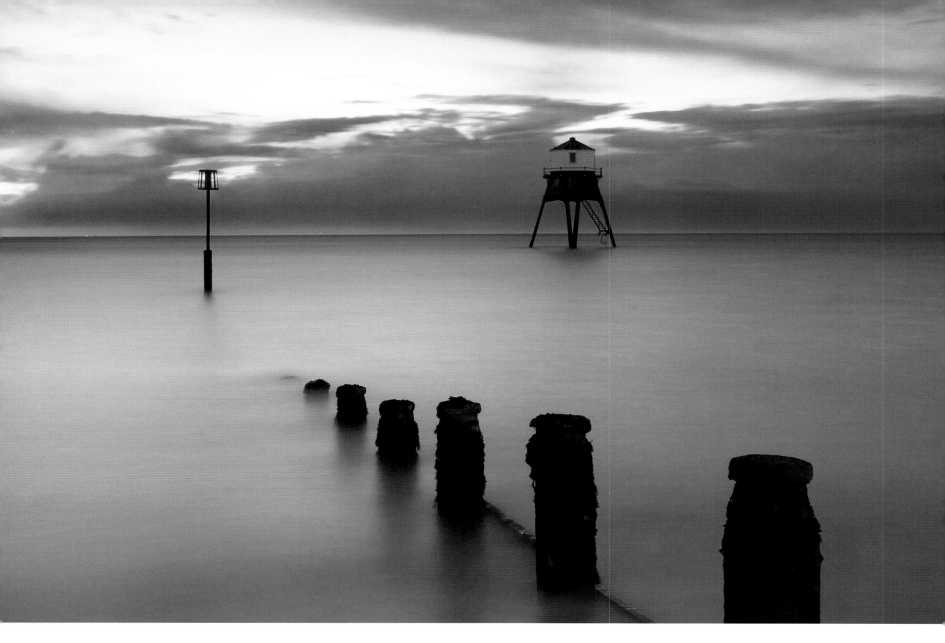

ANDREW DUNN

Dovercourt Lower Lighthouse, Essex, England

This photograph of Dovercourt was taken three quarters of an hour before sunrise on New Year's Day. A two-minute exposure softened the shape of the sea as the incoming tide lapped around the groynes. At its nearest point, the foam from the waves has picked up a little red colour from the streetlights running along the sea front. Similarly the white parts of the lower lighthouse are also tinged with pink.

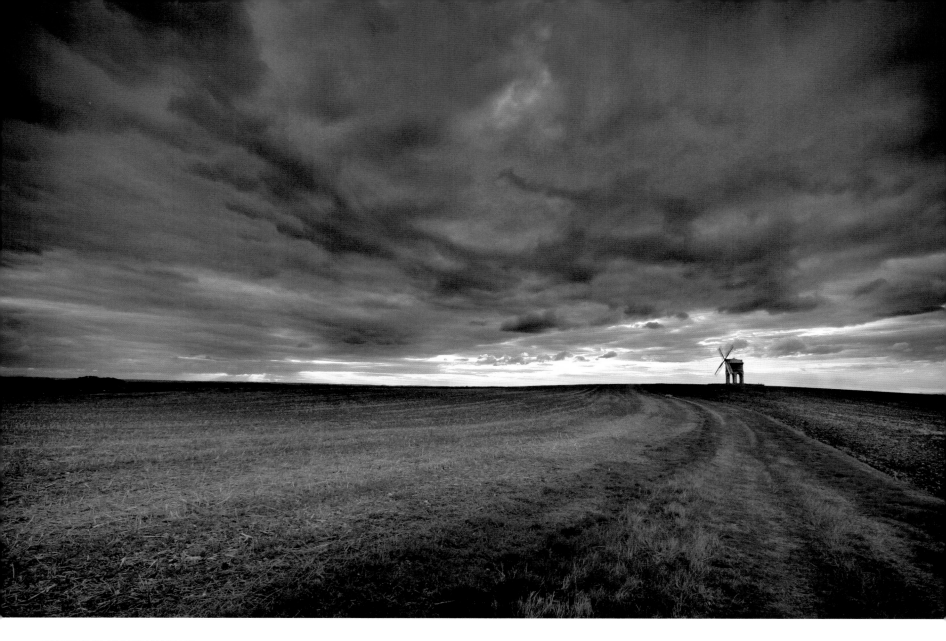

CHRISTINE LYNNE BURKE

Chesterton Windmill, Warwickshire, England

At the time this image was taken I was recovering from the birth of my son. Chesterton Windmill is the place I escape to when I need to feel free, and this particular evening was my first escape in months... I knew I had captured something special to take home with me and it is a night I will never forget.

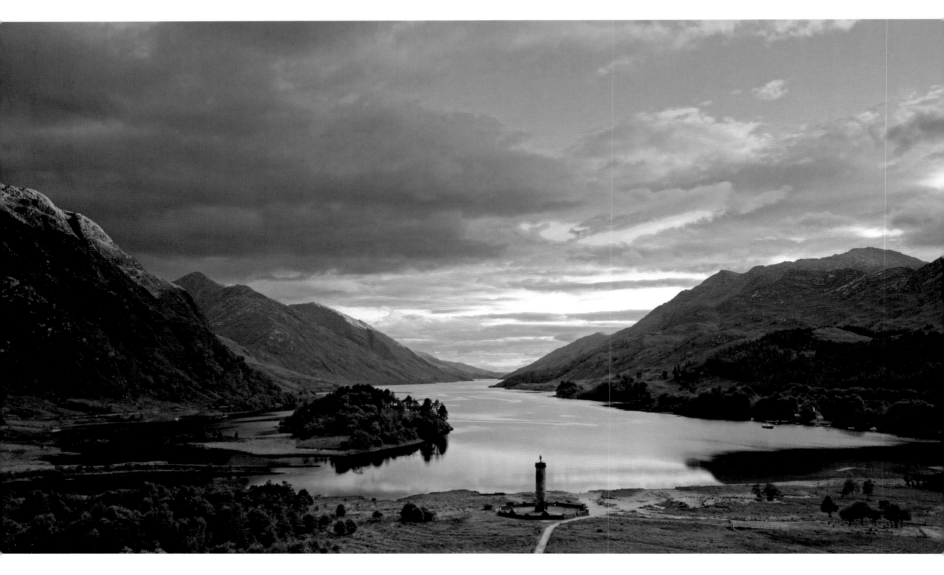

PIOTR CZECHOWSKI

Summer sunset at Glenfinnan, Scotland

This shot captures the imposing majesty of the Scottish Highlands at sunset. The monument to Bonnie Prince Charlie can be seen on the shores of a tranquil Loch Shiel.

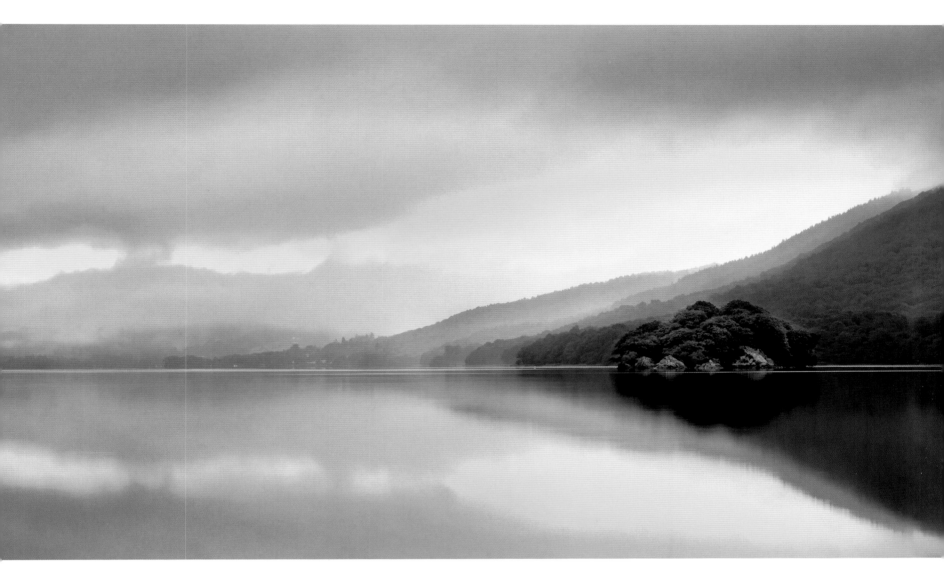

OLIVER HAWKER

Dawn over Coniston Water, Lake District, Cumbria, England

The shot was taken at around 6am on a morning in late August. The island on the right is known as Peel Island, and it is near this point that Donald Campbell lost his life while attempting the water speed record in 1967. When I arrived at the place, the utter silence combined with the ethereal light created by the receding dawn mist both exhilarated me and filled my heart with a strange sense of foreboding. Campbell's ghost could have shimmered across the frame and I would not have been surprised.

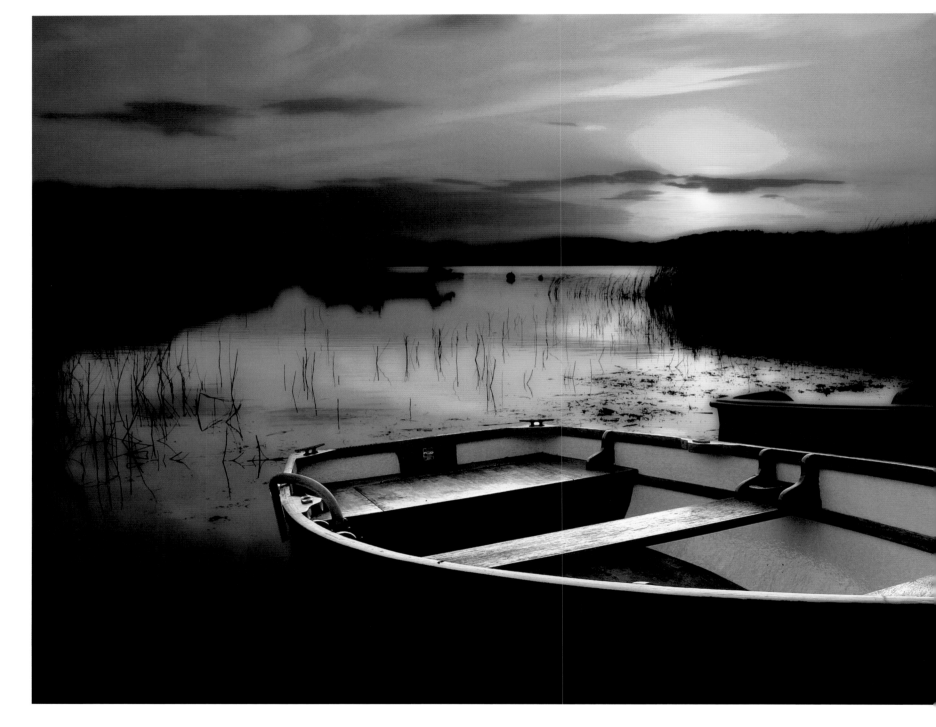

ANDREW BARTON

Llyn Alaw at sunset in summer, Anglesey, Wales

There are often boats moored up at this point on Llyn Alaw, and on this particular evening the lighting seemed perfect for this shot, with just enough hitting the inside of the boat. The result is a wonderfully tranquil image.

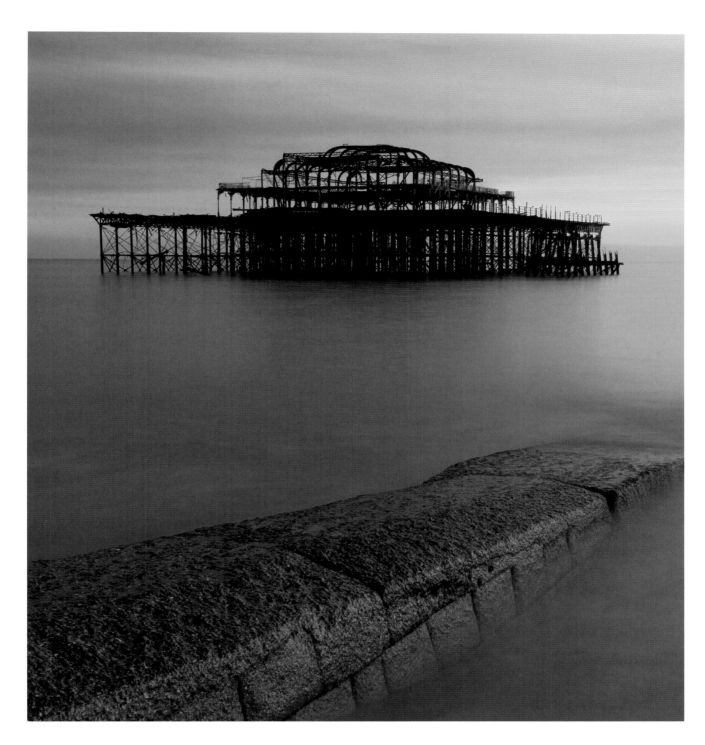

BEN PLEWES

Brighton West Pier after sunset, East Sussex, England

I was so engrossed in the composition of this shot that I failed to notice a big wave set that was coming my way. I lost some equipment to the elements on that day but came away with a big smile having got the shots I was after.

GERRY GAVIGAN

Chanctonbury Ring, West Sussex, England

I usually try to 'recce' my shoot locations beforehand. I had spotted the potential for this image one year previously, but had to wait until I liked the light and it all came together.

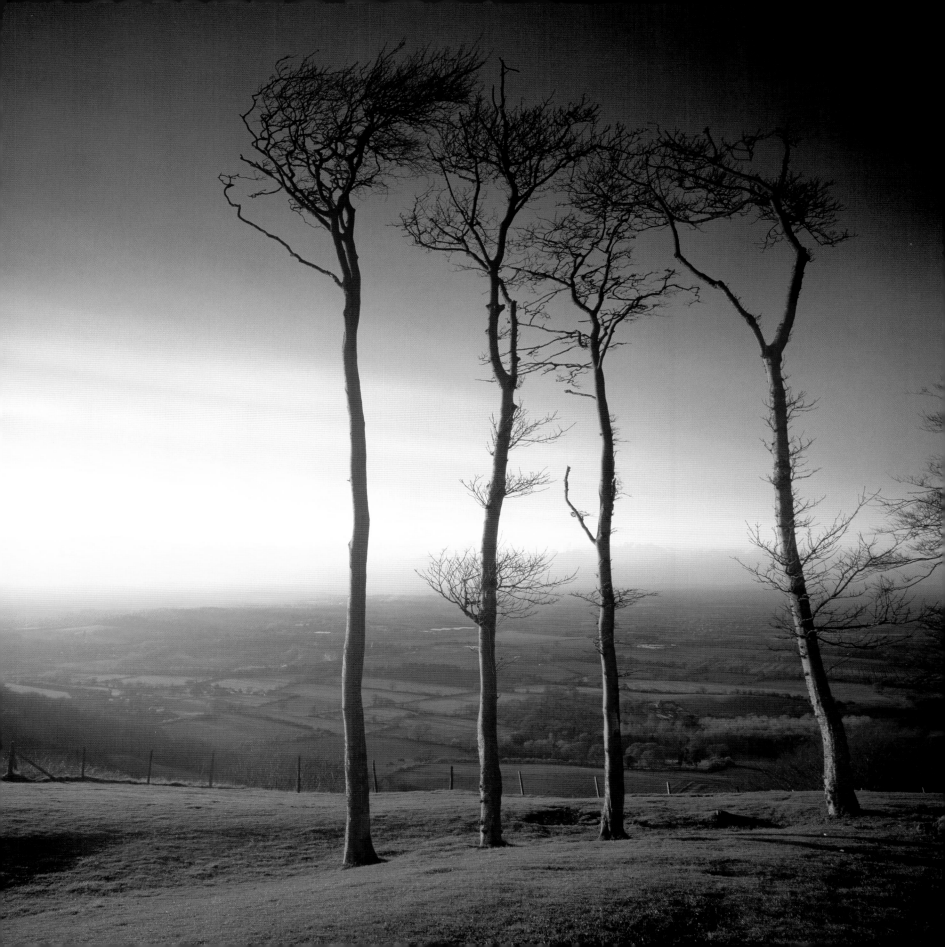

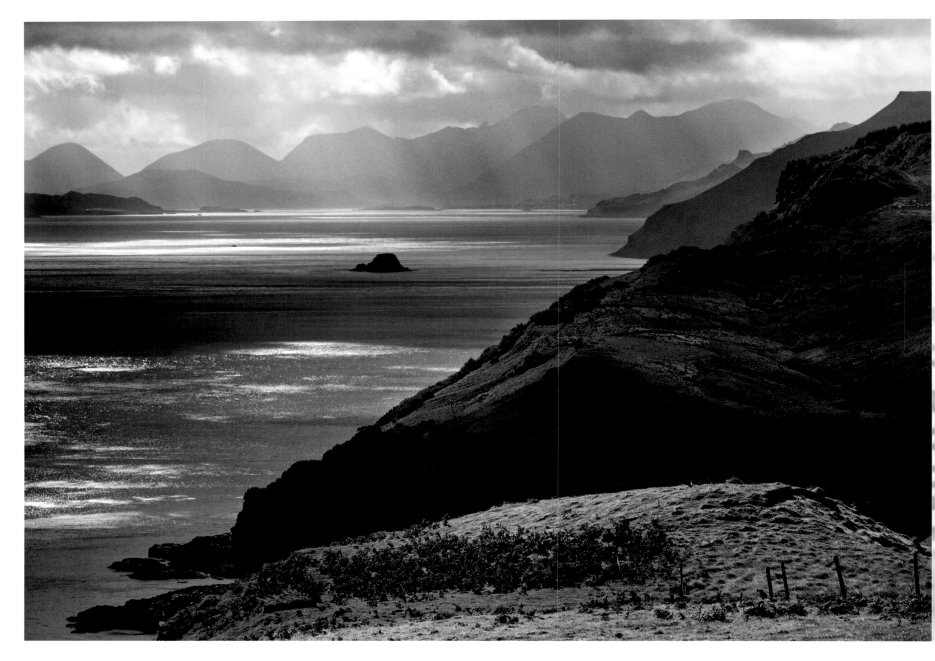

**PÁRAMO AWARD WINNER
BEST MOUNTAIN IMAGE**

PAUL MARSCH

Along the Sound of Raasay, Isle of Skye, Scotland

Although there are several iconic features on the Isle of Skye, for me this less well-known view, looking south along the Sound of Raasay, sums up the island. It captures the atmosphere, the changeability of the weather, and the magic created by the play of light across the landscape.

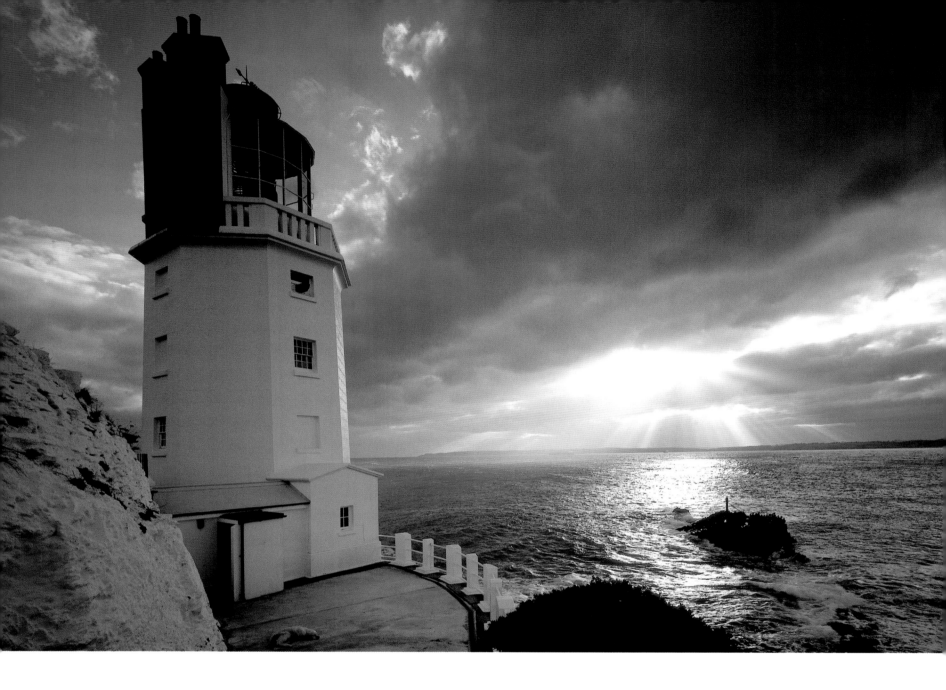

RICHARD WAITE

St Anthony Head Lighthouse, St Mawes, Cornwall, England

Lighthouses are generally in dramatic locations and provide a strong initial draw for the photographer. In this image, the fortuitous reverse action of the sunlight across the water towards the lighthouse, together with the thunderous clouds, provided the main inspiration for the picture. It was an exciting moment that quickly passed.

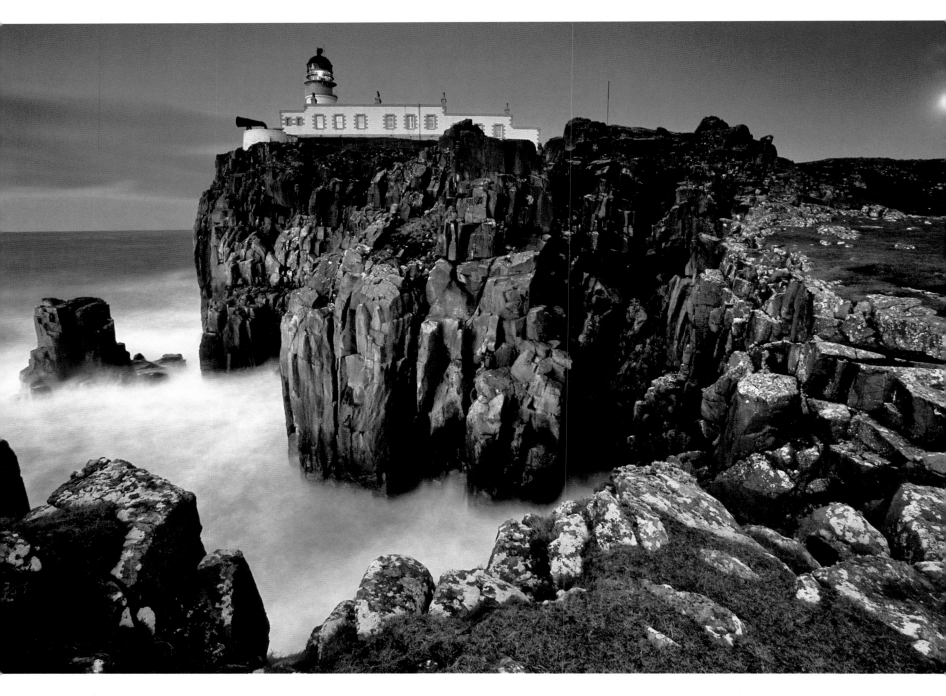

FRÉDÉRIC LEFEBVRE

Neist Point, Isle of Skye, Scotland

This shot of the rising moon at Neist Point Lighthouse on the Isle of Skye was taken in early December. The swirling mist around the rocks creates an almost mystical scene.

CHRIS TANCOCK

Right: Strumble Head in winter, Pembrokeshire, South Wales

This was an all-day shoot waiting for the storm lighting and, as it came in, the sea turned this amazing blue, only to disappear as the storm rains fell a short while later.

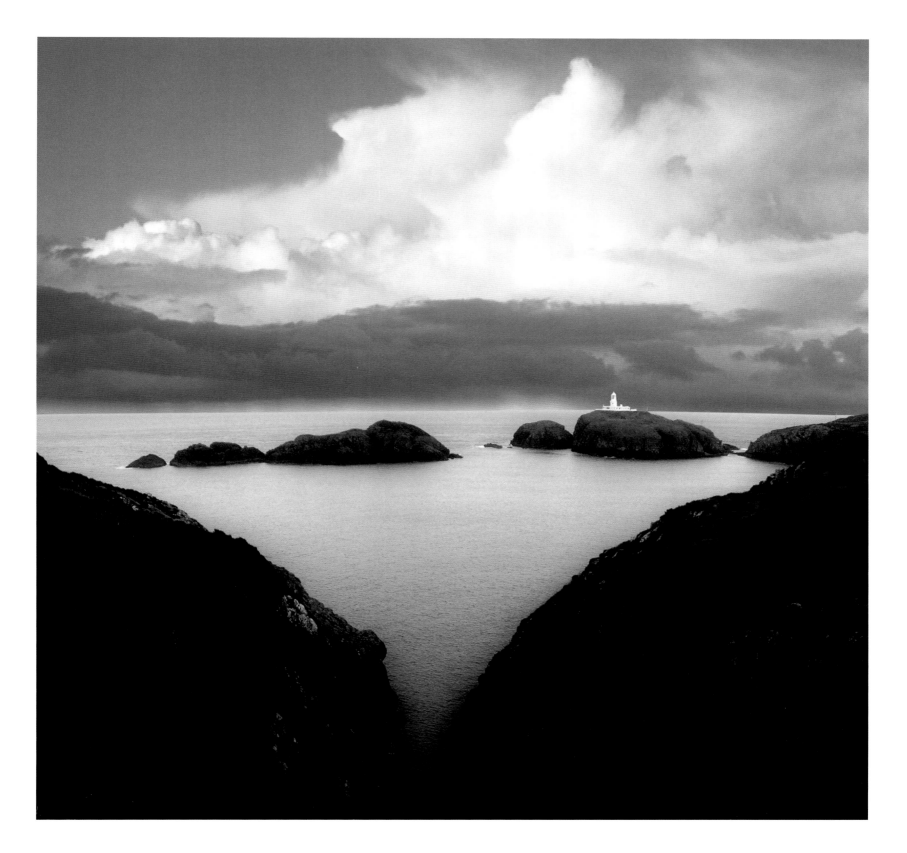

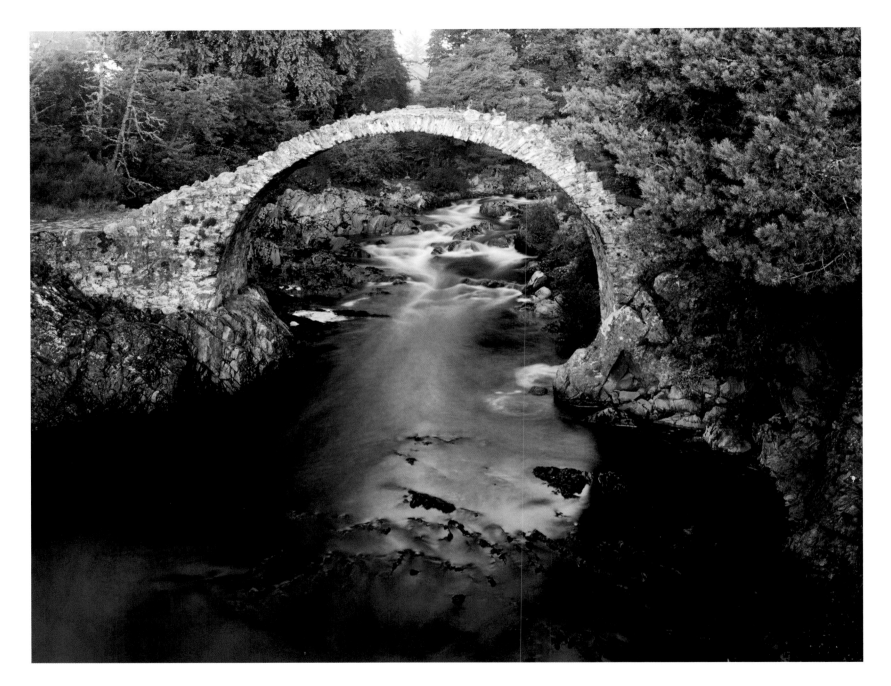

CRAIG ALAN HUBER

Old Packhorse Bridge, Carrbridge, Scotland

As the sun came nearer to the horizon on this calm September morning I saw the image I wanted to take. I made two exposures, one only a few minutes before the sun broke over the horizon, the other just after. The image while the sun was not directly on the bridge offered the most serene and calming effect.

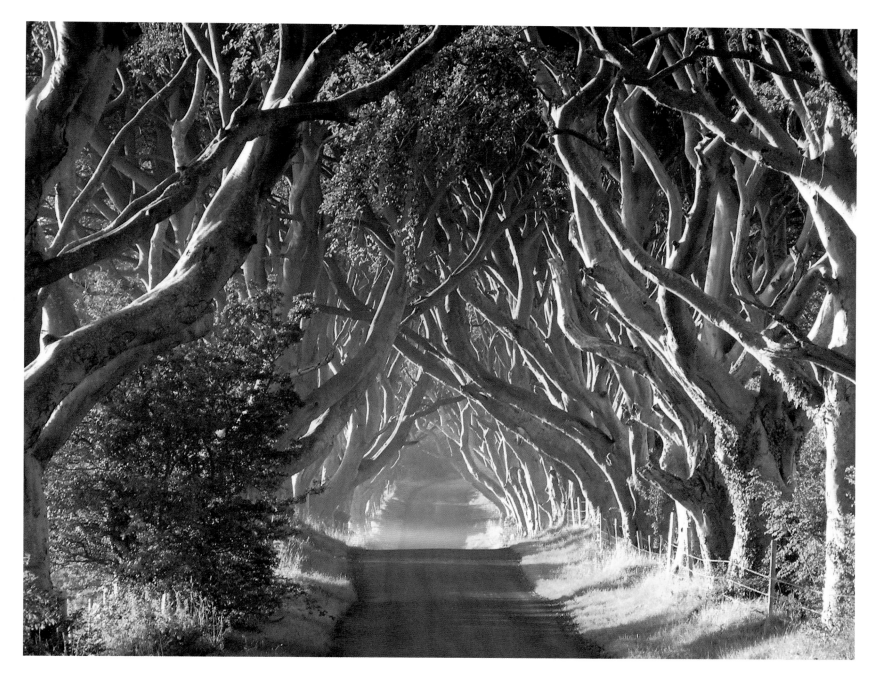

GARY JACKSON

The Dark Hedges, Northern Ireland

At around 7am one morning, I grabbed my camera and rushed to the trees. The mist
and sunlight made an awesome sight – and I was lucky to capture this handheld shot.
The trees are to be felled by the end of 2007 – at least now there is a record of them in
their prime, so future generations can see them in their former glory.

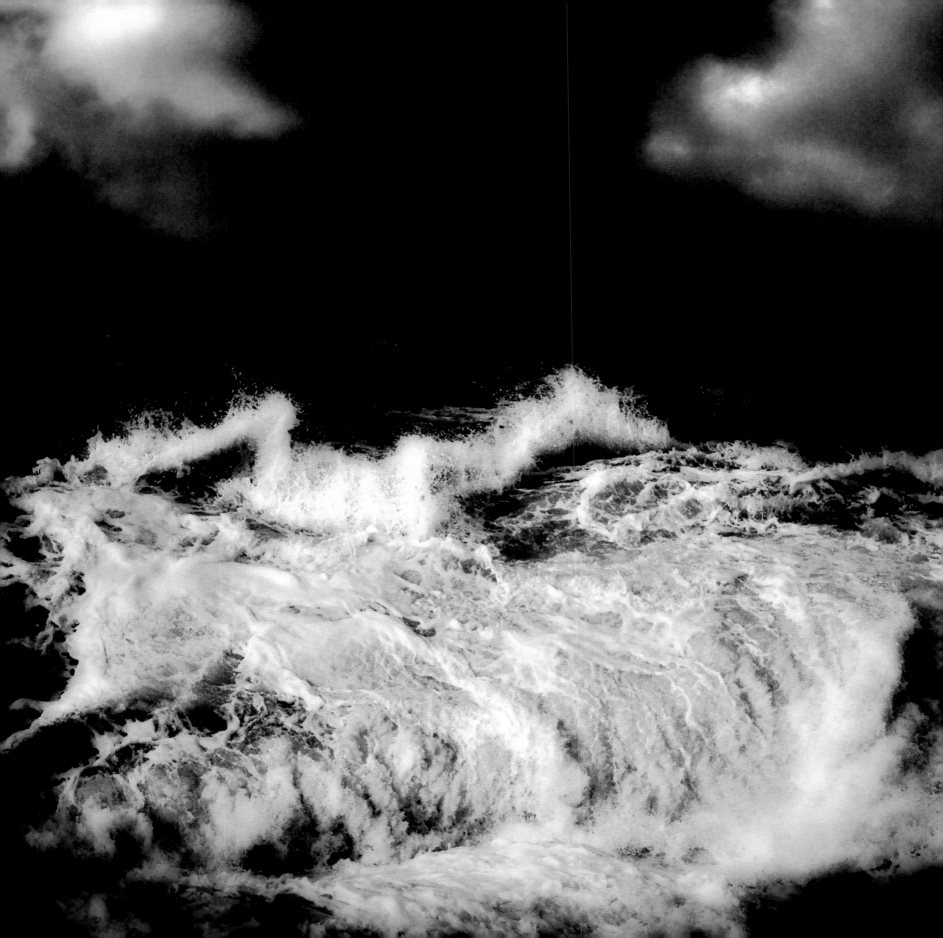

CHRIS TANCOCK

Left: St Brides Bay, Pembrokeshire, South Wales

I have a soft spot for this photograph because I lost my first digital camera getting it! We had phenomenally choppy waves after gale-force winds and I had to strap myself to the cliff with a climbing harness to get the right angle. It was immediately after this shot that I got drenched by a really big wave and the camera ended up full of salt, sand and water.

Judge's Choice Monica Allende

DAVID CLAPP

Land's End, Cornwall, England

A late summer sunset at Land's End. The cliff-side was being battered by a south-westerly gale that pounded fast-moving waves into Longships Lighthouse and the Armed Knight. I was lucky enough to capture the spray of a breaking wave and only when I got home did I see the great black-backed gulls roosting on the northwest face of the arched island of Enys Dodman.

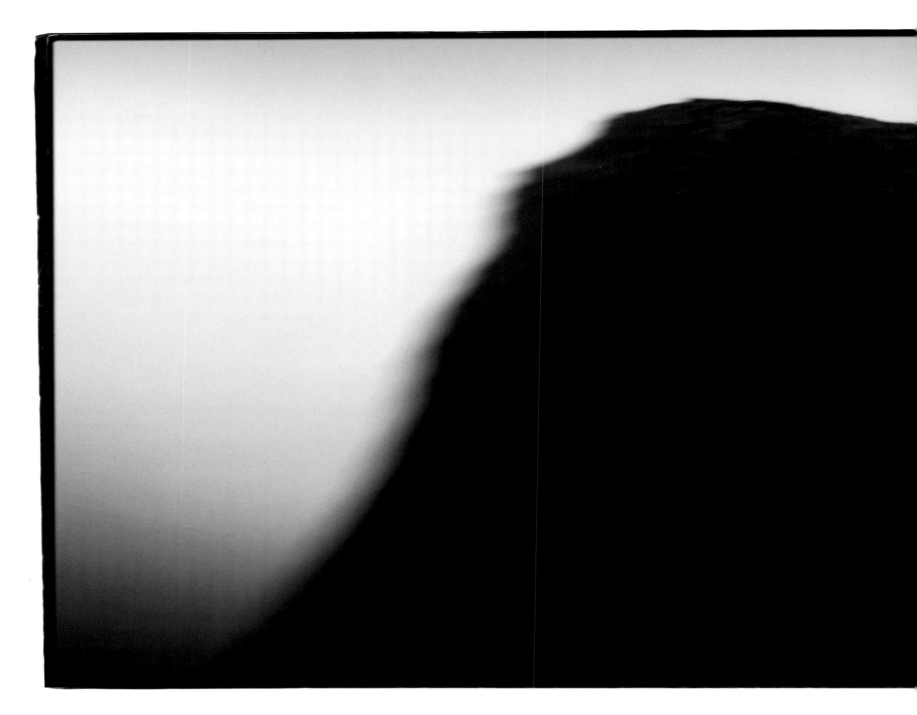

STEVE DEER

Back Tor, Peak District, Derbyshire, England

I was art directing an outdoor fashion shoot and saw this little mountain (Back Tor) in the distance. I decided to visit it over the weekend with my camera. It was a wet and miserable day, but the conditions suited the graphic simplicity of the image I was after.

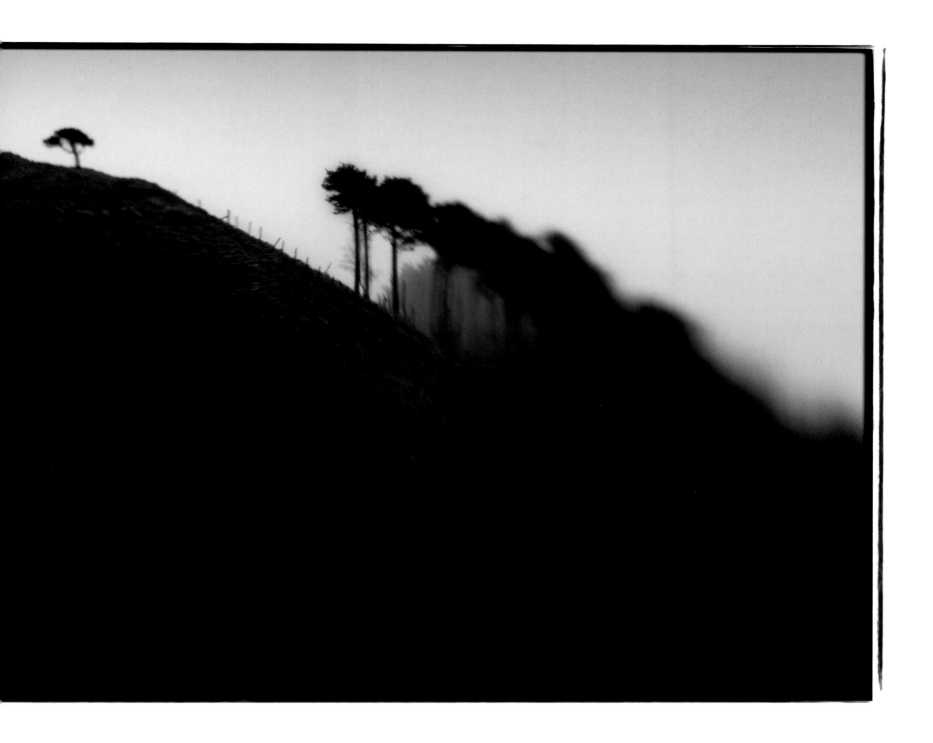

CLASSIC VIEW
youth class

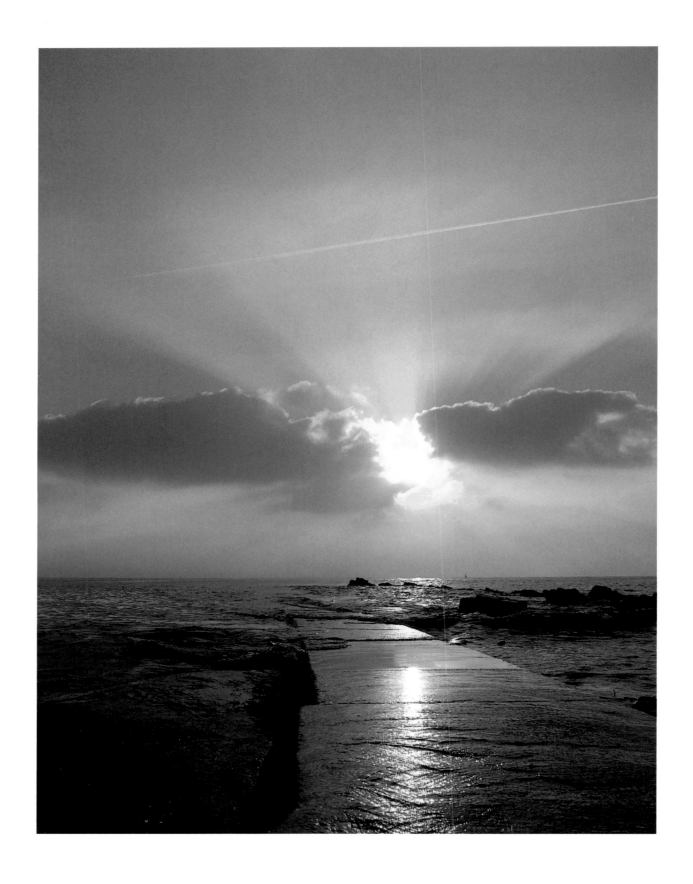

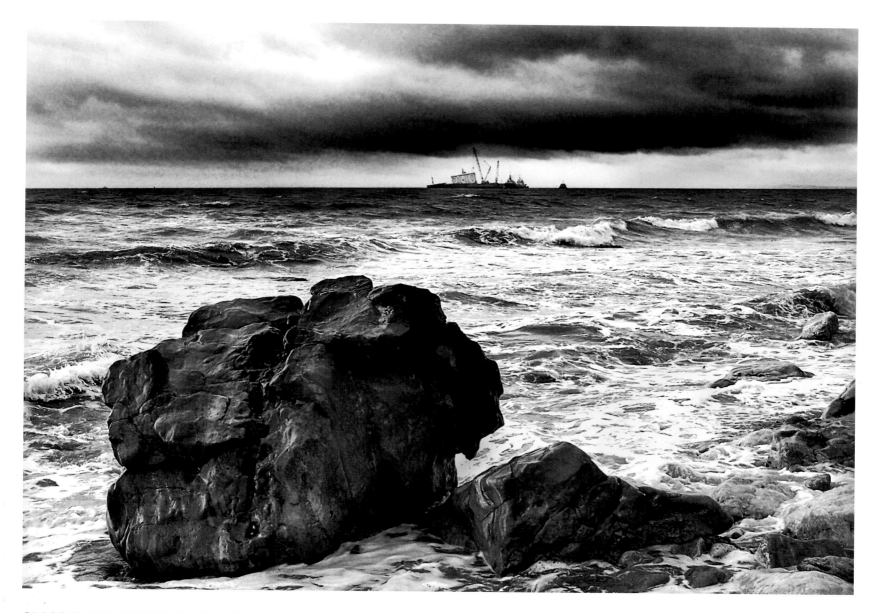

CLASSIC VIEW YOUTH CLASS WINNER

HARRY TILSLEY

Left: Dawn at Peveril Point, Swanage, Dorset, England

This was taken during a dawn shoot organised as part of a photography workshop.

HIGHLY COMMENDED

JOE STEPHENS

Ship aground, Branscombe, Devon, England

This shot shows the SS Napoli which had run aground just off the coast at Branscombe in early 2007. It was a rough day and I managed to get some photos in between heavy windy showers. I was very pleased with the image I managed to capture, which I converted to black and white to give it a more dramatic look.

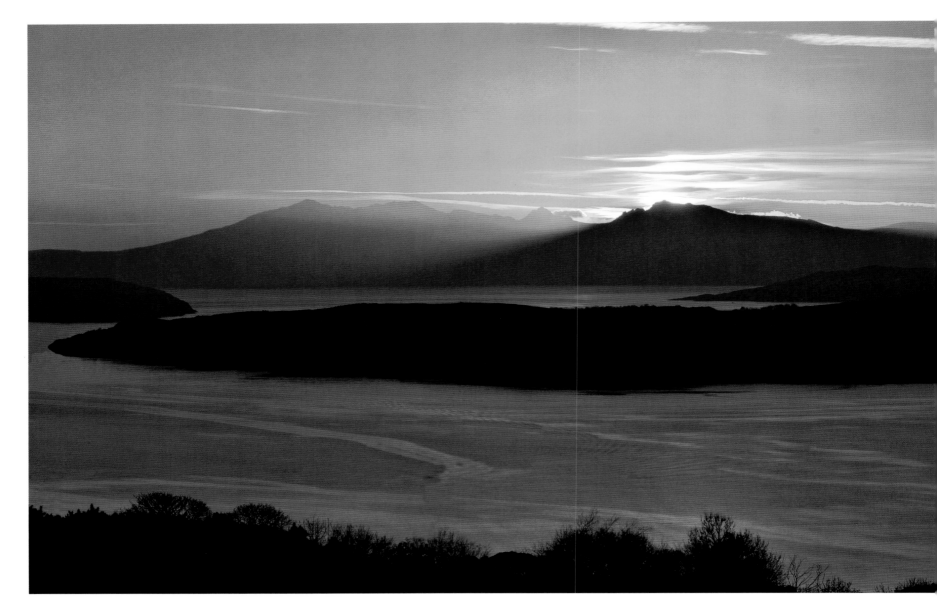

LIAM LESLIE

Last light over Arran, Haley Bray, Largs, Scotland

After waiting for the perfect shaft of light to strike the mountains, I was finally rewarded with the very last vestiges of sunlight backlighting the mountains with a single beam of light shining through one of the mountain valleys.

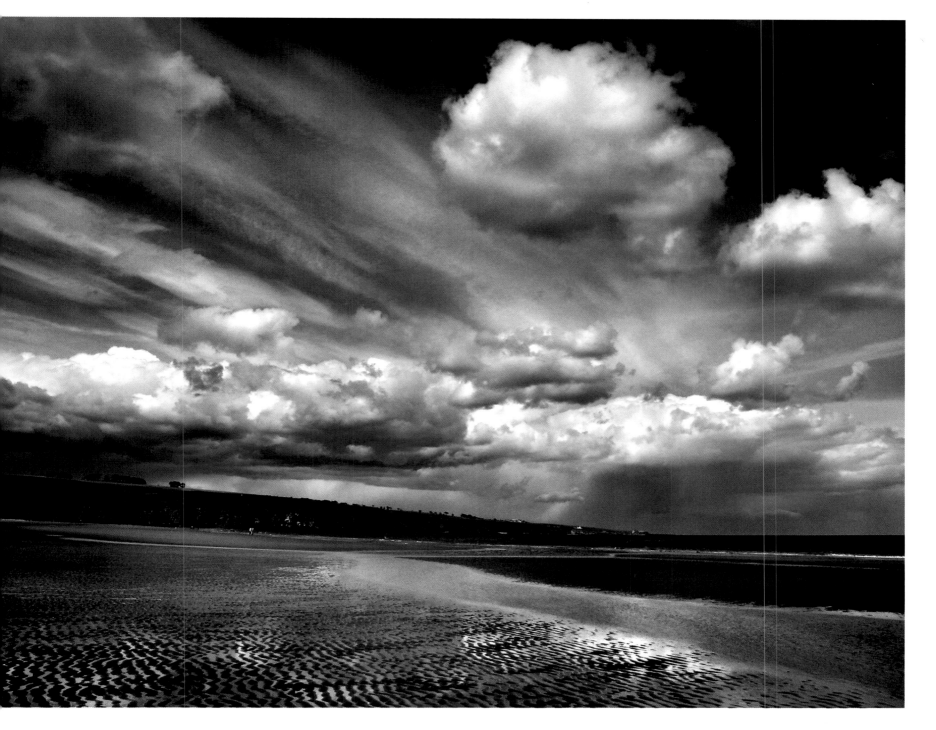

FINLAY ROBBINS

Lunan Bay skyline, Lunan Bay, Angus, Scotland

I took this shot with an old camera that belonged to my dad – we were on a day trip to Lunan Bay in Angus and the sky was amazing!

LIVING THE VIEW
adult class

LIVING THE VIEW ADULT CLASS WINNER

JOHN DAVIDSON

A stroll along the seawall, West Kirby, England

A man in a wheelchair is pushed along the seawall between the West Kirby marina and the River Dee on the Wirral in Merseyside.

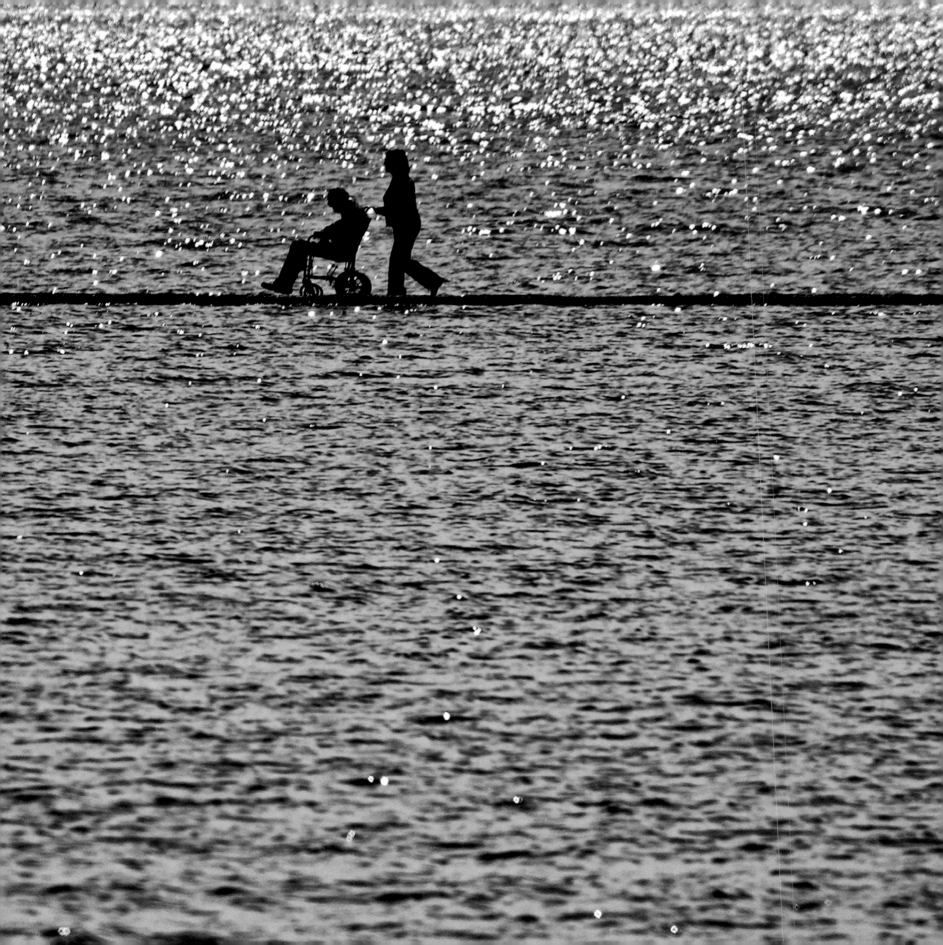

LIVING THE VIEW ADULT CLASS RUNNER-UP

PAUL SANSOME

Windsurfer in force nine, Hayling Island, England

I have never seen the Solent, normally sheltered by the Isle of Wight, anything like as rough before. To have a windsurfer go right out to the highest waves was a total bonus! It was too windy for my tripod to hold the camera steady, so I rested the camera on a groyne. After two hours of battling the elements I left the windsurfer to it!

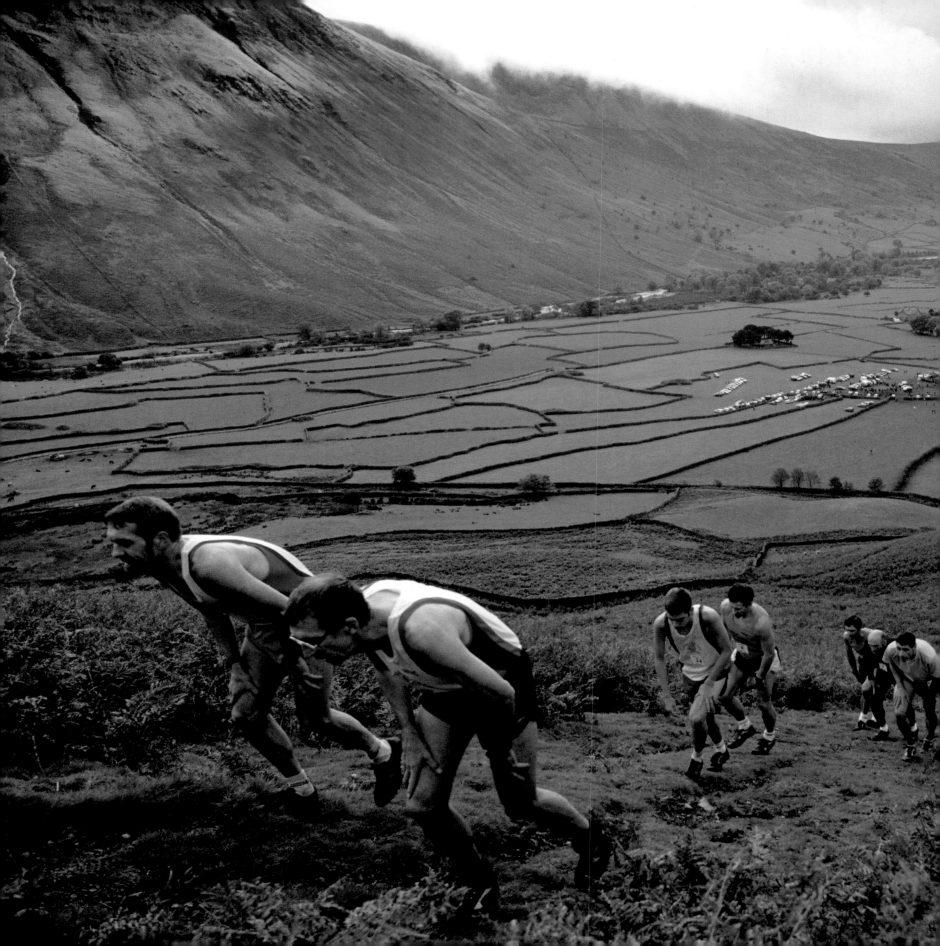

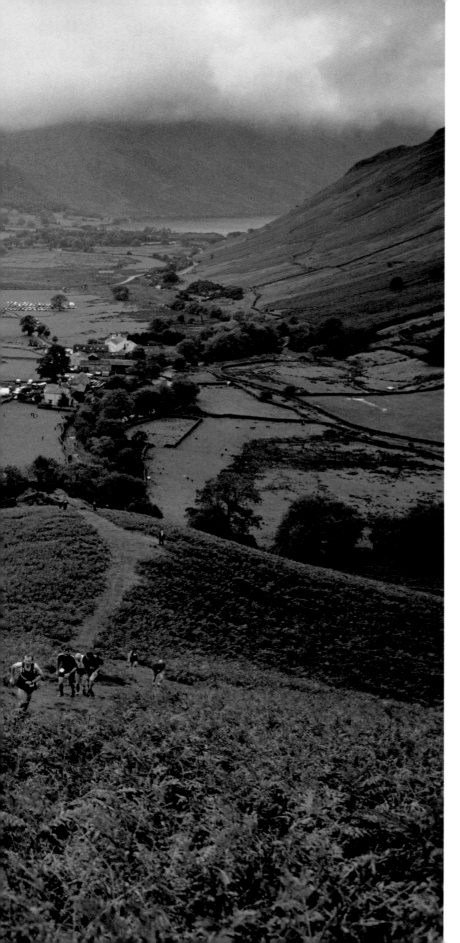

HIGHLY COMMENDED

PATRICK WARD

Fell race at Wasdale Shepherds' Meet and Show, Cumbria, England

These exhausted fell runners were heading up the mountainous peaks overlooking the annual Wasdale Show, in a little-visited corner of the Lake District.

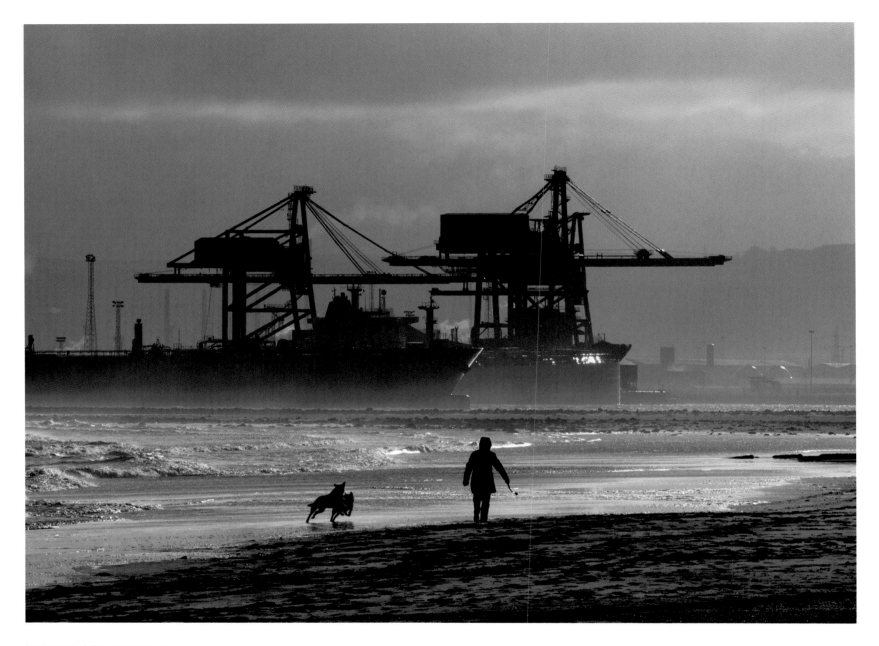

HIGHLY COMMENDED

JOHNNY JETSTREAM

North Gare Beach, Middlesbrough, England

This image was taken on North Gare Beach in Middlesbrough on a cloudy, hazy day. The sun peeped out for a few moments. It just seemed to sum up everyday life in the area.

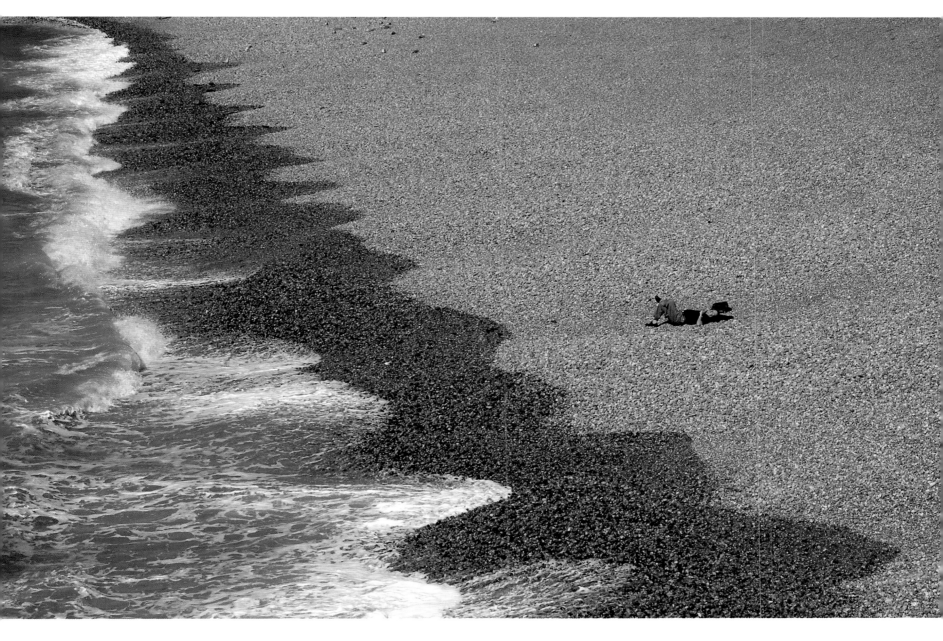

HIGHLY COMMENDED

PAUL PUNTER

Resting on a summer beach, Brighton, East Sussex, England

This particular August morning at about 11am, I had finished taking shots and was walking back down the pier when I saw this man relaxing on his own. It just struck me that the beach is usually crowded in the summer and he had managed to find a quiet spot before the crowds descended to enjoy the sunshine.

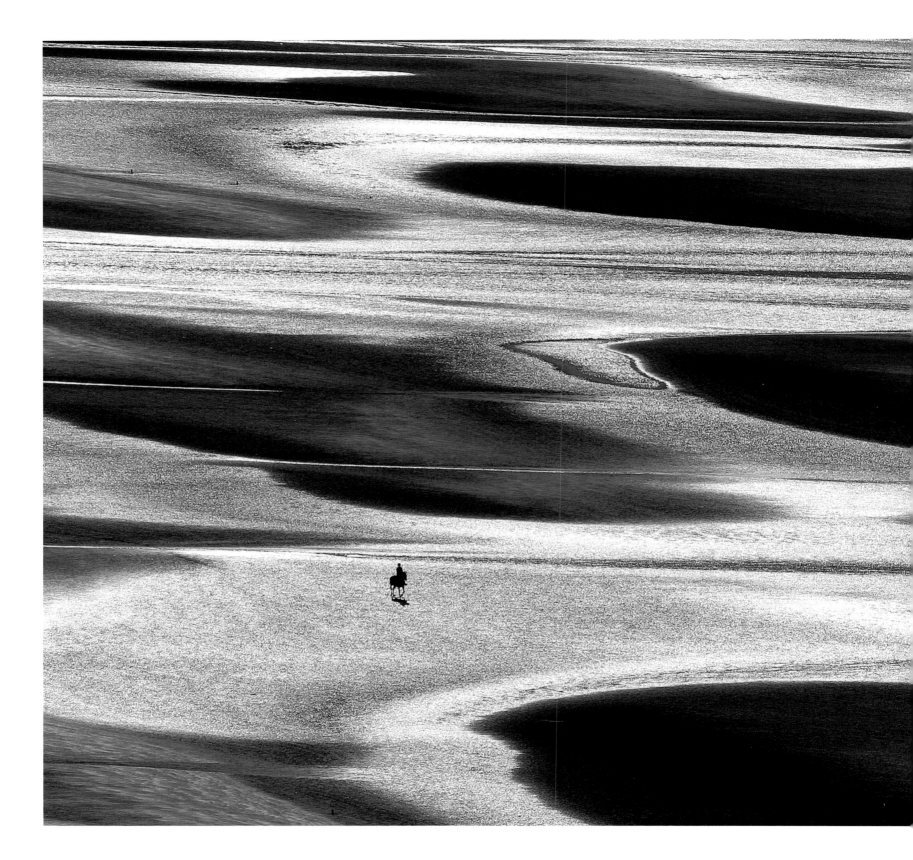

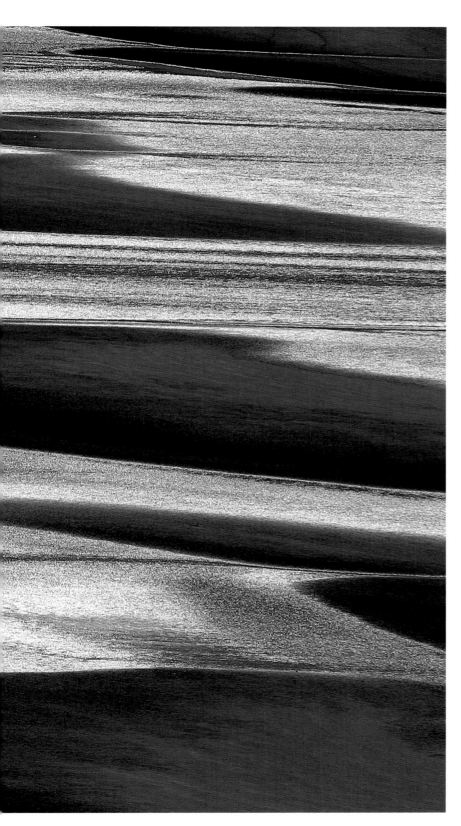

HIGHLY COMMENDED

ANDREW BARTON

Llanddona Beach just before sundown in summer, Anglesey, Wales

There are a few riding schools in this area, but every time I went to this location nobody was ever riding on the beach. After many visits, on this evening all the elements were right. The tide had just gone out leaving the sand wet and the horse rider came into shot.

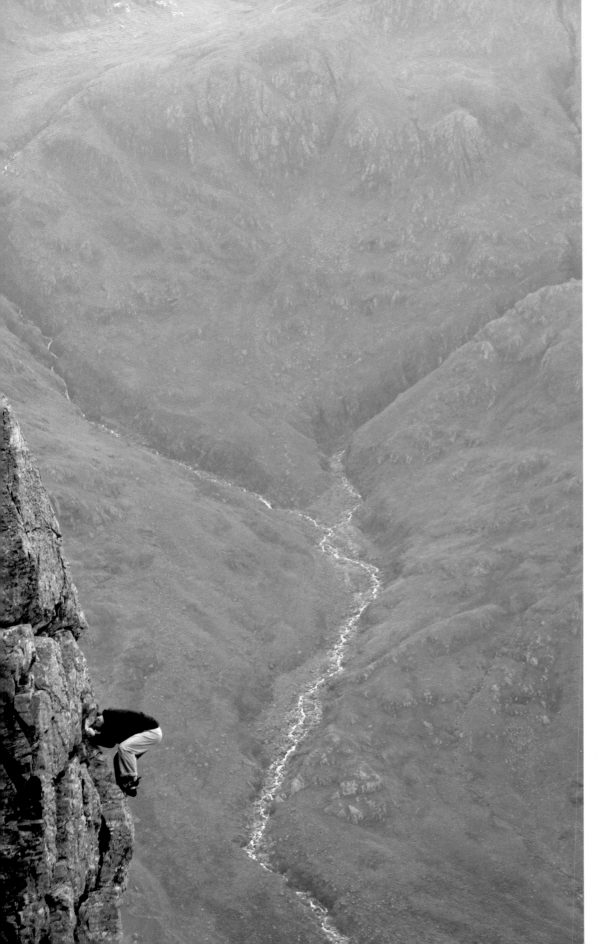

TOM SINGLETON

Nape's Needle, Great Gable, Cumbria, England

I've visited Nape's Needle many times – on this particular occasion, there was a young man practising his climbing skills by climbing right round the Needle – and without using ropes. He made it look so easy that I thought I would take a photograph to make it clear how high he was, with the valley of Wasdale down below.

MATTHEW BULLEN

Right: Curbar Edge, Derbyshire, England

This image was taken on one of the most amazing mornings I have ever seen – the mist stayed around all day. I only managed to take one picture of the climber – and decided to compensate for the brightness by overexposing one stop.

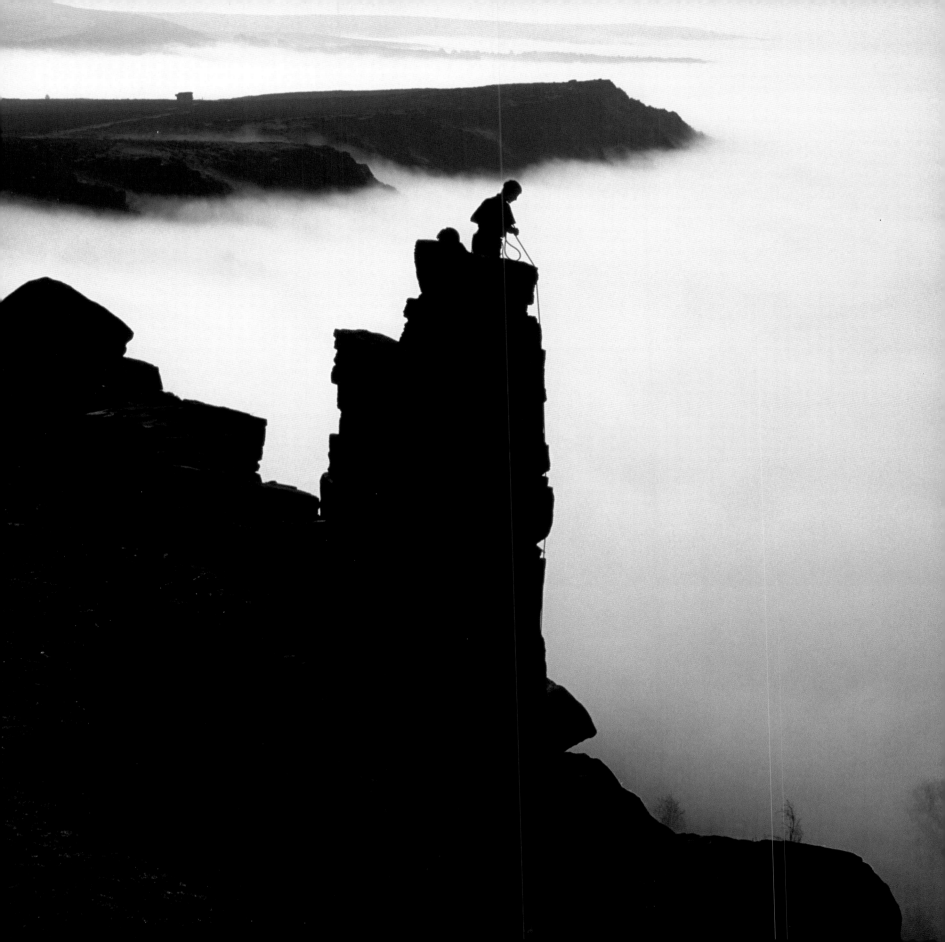

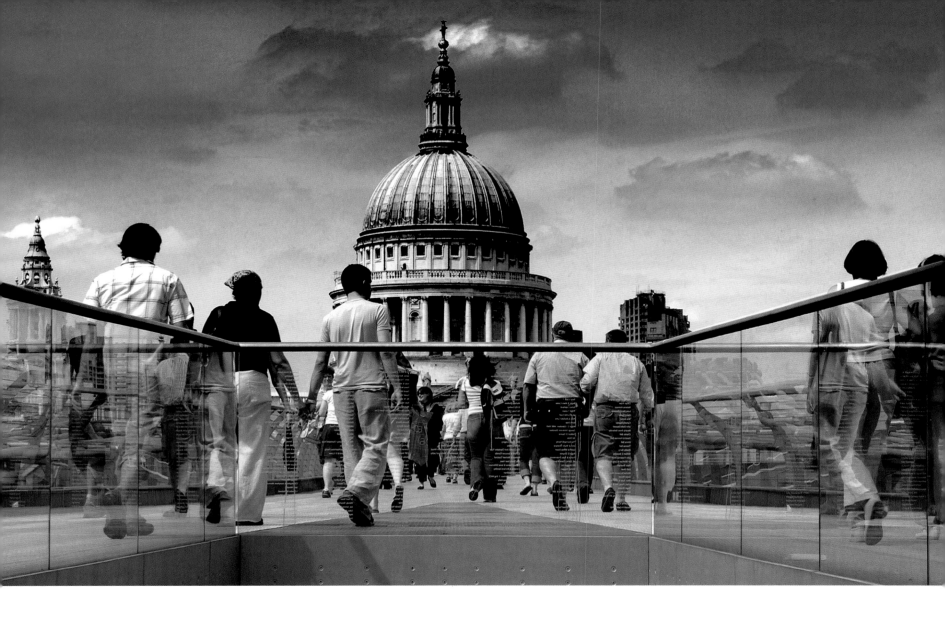

COLIN STREATER

Millennium Bridge, London, England

I love the way the Millennium Bridge is designed so that you don't just walk off the other end and never look back. It turns you back round and presents St Paul's Cathedral beautifully framed in the distance. I wanted to illustrate the impression I get of people marching across the bridge, seemingly drawn towards some kind of higher being on the other side. The image reminds me of a scene from the film *Close Encounters of the Third Kind*.

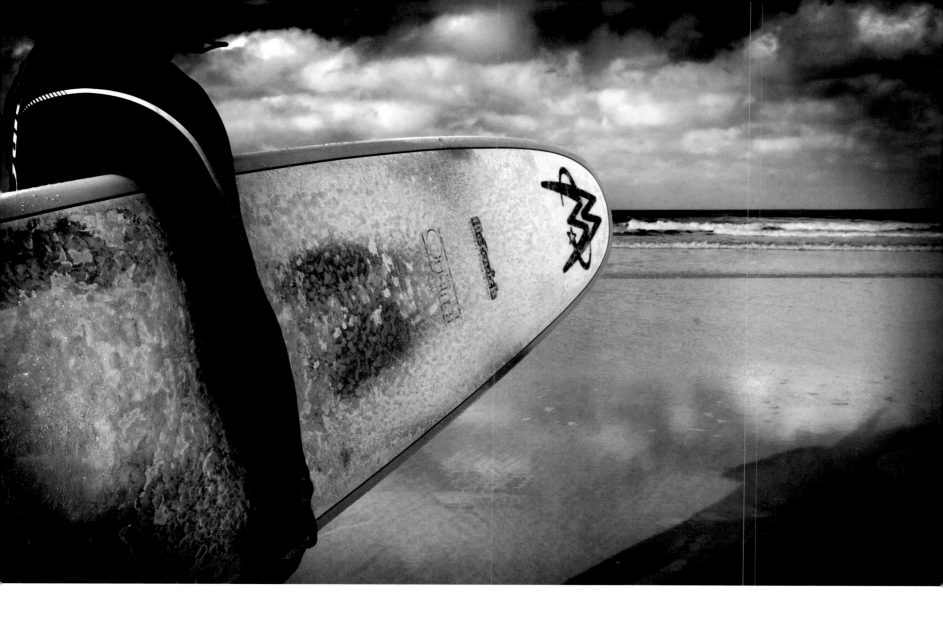

DAVID STERRATT

Gwithian Beach, Cornwall, England

Surf's up! I wanted to create a different view to that of the typical surf photo. In this shot
I have created an image where the board has become an extension of the surfer, as he
focuses on his impending entry into the sea.

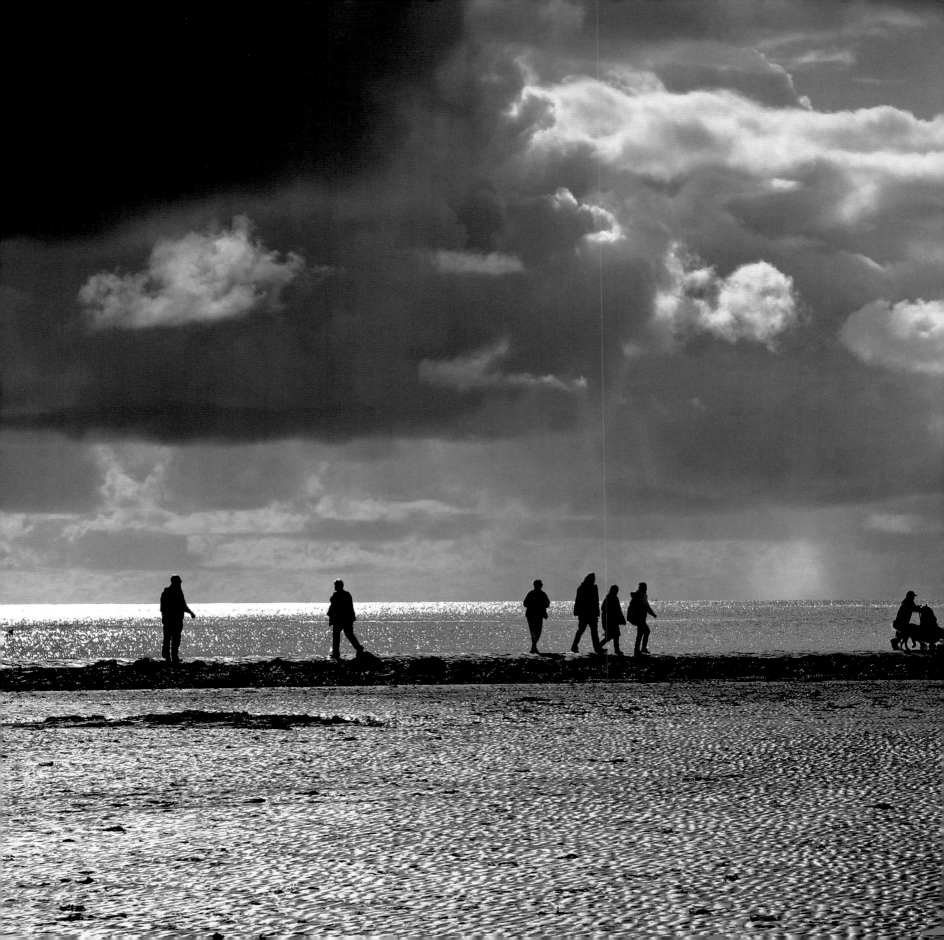

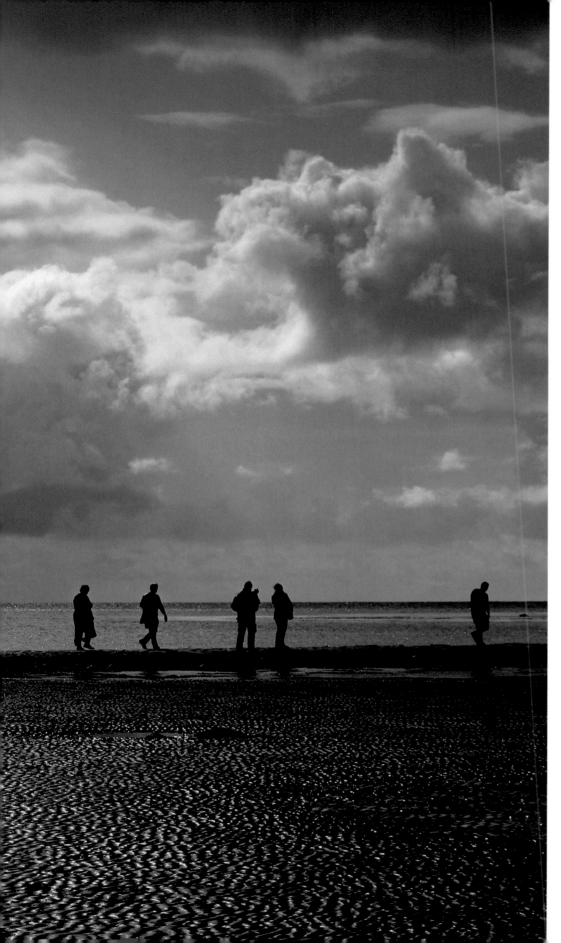

ANDY SPAIN

St Michael's Mount, Cornwall, England

This picture was taken in the last few warm days of summer in 2006. Half an hour later, the causeway was under the sea.

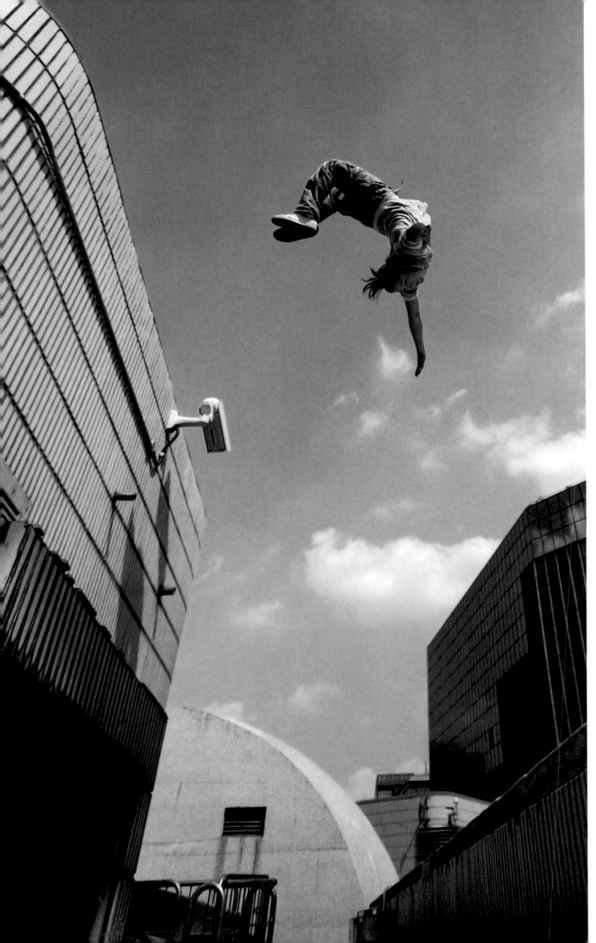

JONATHAN LUCAS

'Antigravity', Old Street roundabout, London, England

The isolated architecture of Old Street roundabout presented the ideal context for Daniel Ilabaca's expertise in parkour. His seemingly effortless grace contrasts with the distinctive geometry of the tiling, while the CCTV camera looks on blindly.

Right: 'The Shadow', Barbican, London, England

The powerful concrete forms of the buildings offered an imposing, theatrical backdrop to the ebb and flow of Daniel's artful movement – presenting an unexpected harmony of man and structure unforeseen by the architects. The summer's evening was beautiful, creating many shadows and this particular view struck me, as if a solar projector had been laid on for just this moment.

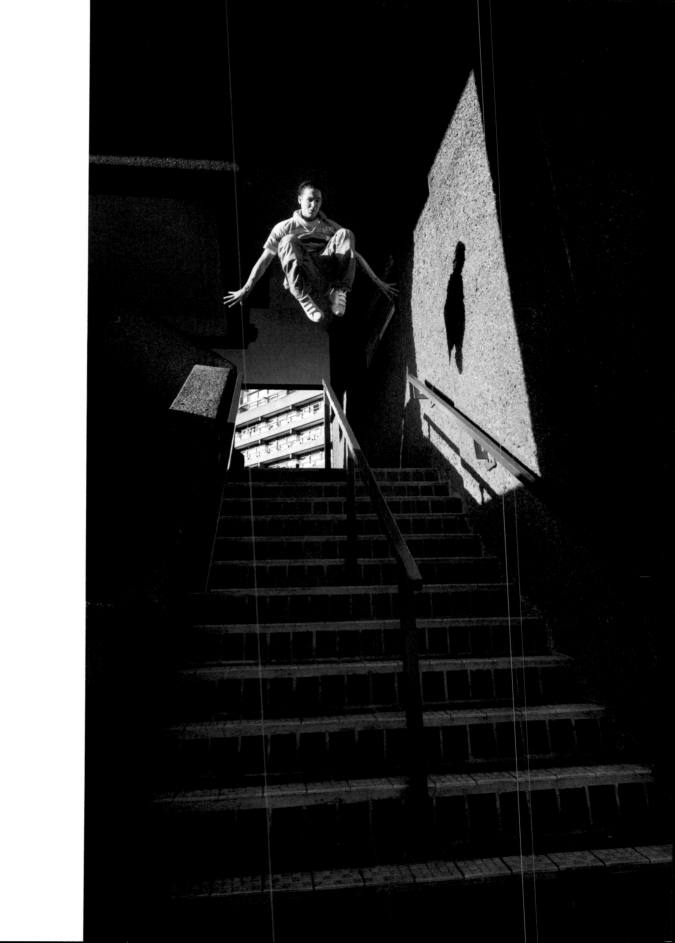

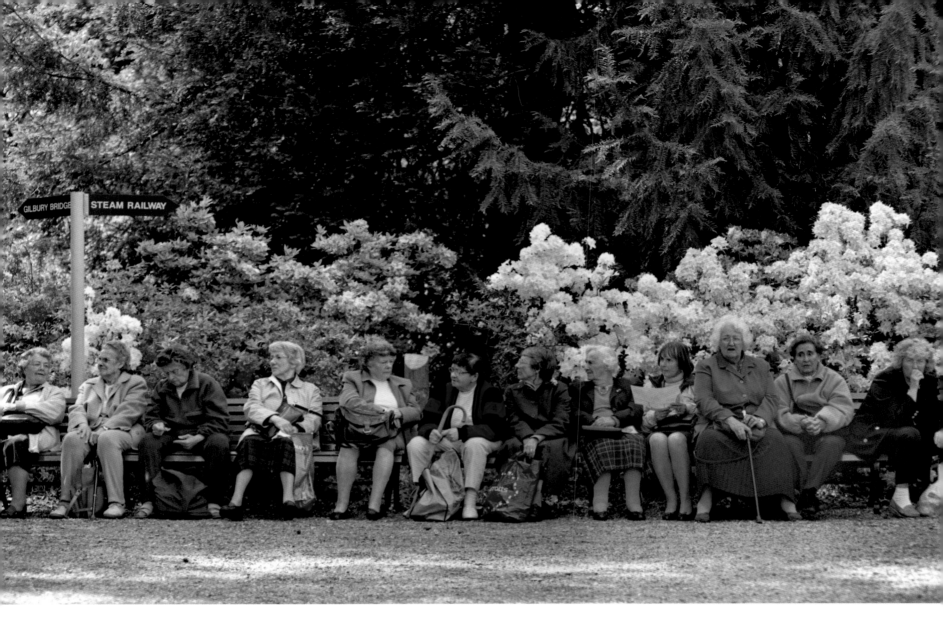

BOB AYLOTT

Waiting for the bus, Exbury Gardens, Hampshire, England

I was leaving Exbury after a full day of photographing flowers, when I noticed this group of exhausted ladies. It is often the case with photography that you spend hours waiting and looking for that special picture, and it turns out to be the last frame on the film.

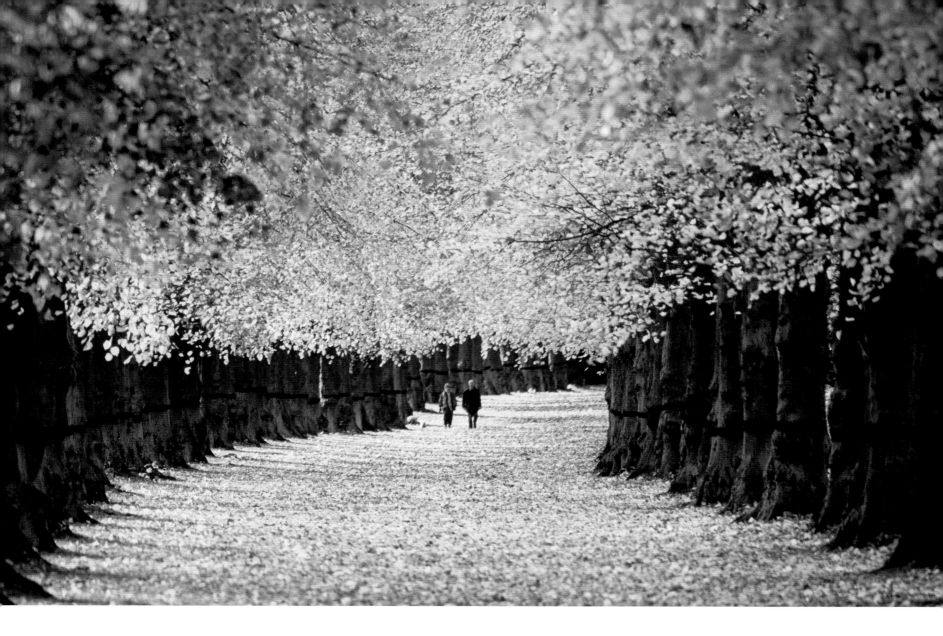

ALEX ROSEN

Clumber Park, Nottinghamshire, England

Although small in the frame, I feel that the people make a big contribution to this photo. The compressed perspective of the telephoto lens seems to have the effect of intensifying the autumn colour and giving the impression that the walkers are enveloped by the trees.

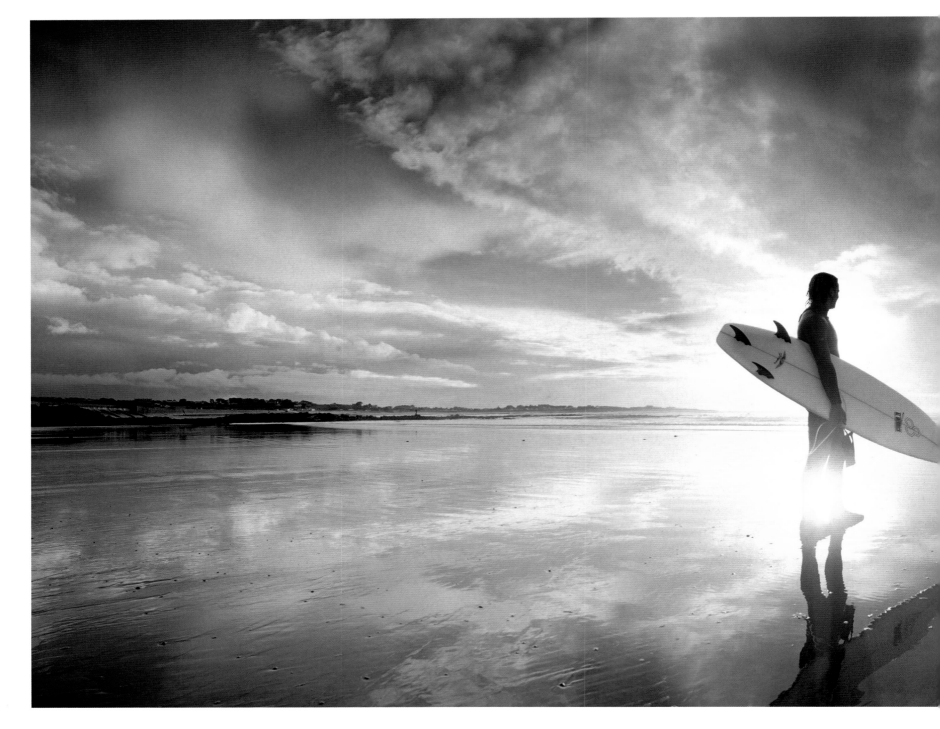

ALEX WALLACE

Surfer, Peter Frankland, at Vazon Bay, Guernsey, Channel Islands

The layered cloud formations looked stunning in the wet sand, but I was struggling to find a focal point for the photo. Then I decided to pose the surfer to cover the glare of the sun and form the centre-piece that glued the whole composition together.

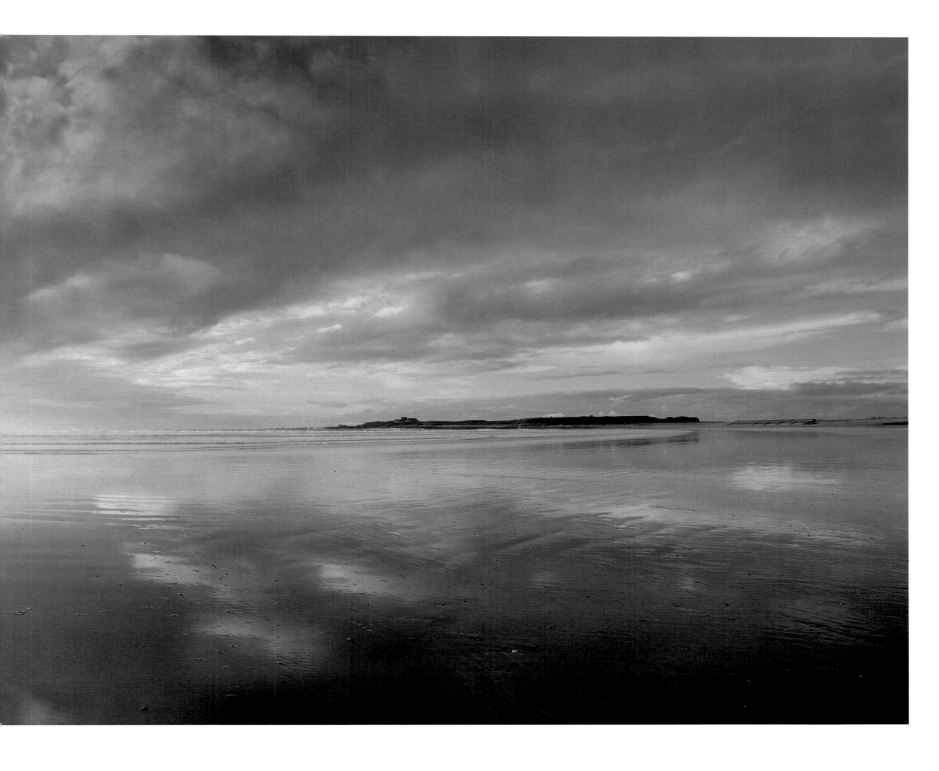

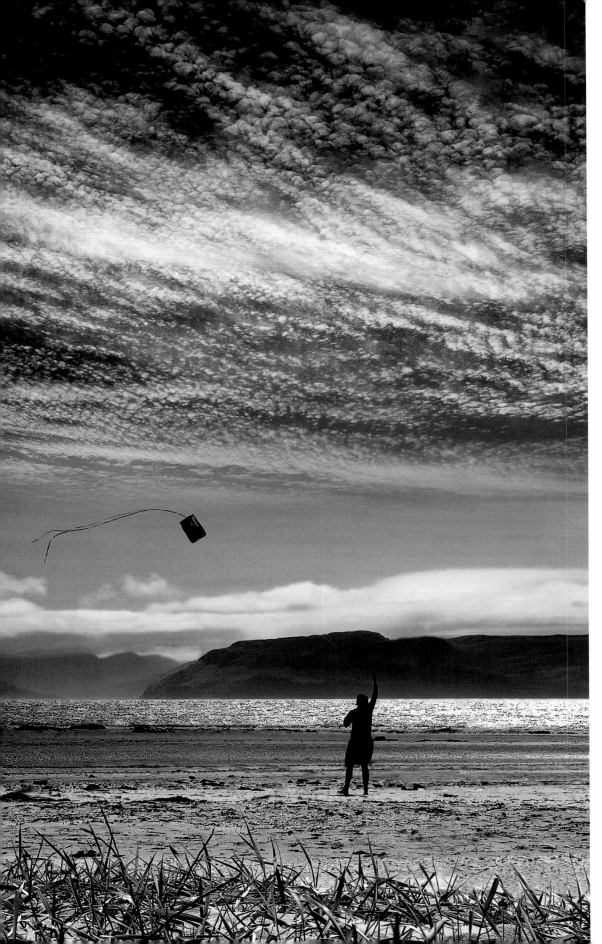

SEYMOUR ROGANSKY

On Applecross Beach, Northwest Scotland

This was taken on the beach at Sand Bay on the Applecross peninsula in Northwest Scotland – with Skye and Raasay in the background. The end of a glorious summer's day, with one visitor taking advantage of the ever-present breeze.

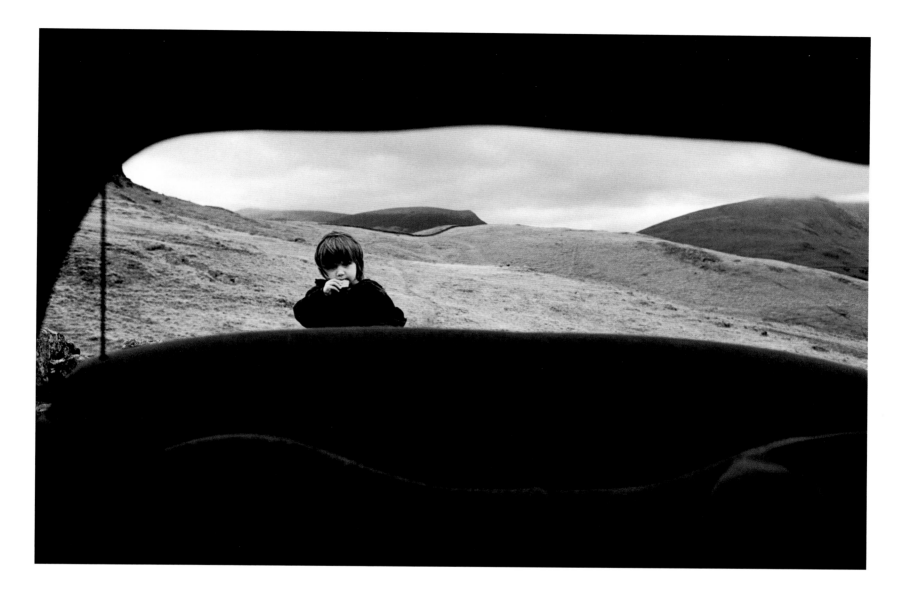

JO CROWTHER

St John's in the Vale, Cumbria, England

For years, this lovely landscape has just been a blur to me, seen in passing from the car. Setting out with the family and intent on walking within it, I reached into the back of the car for the map and spied Luke through the boot.

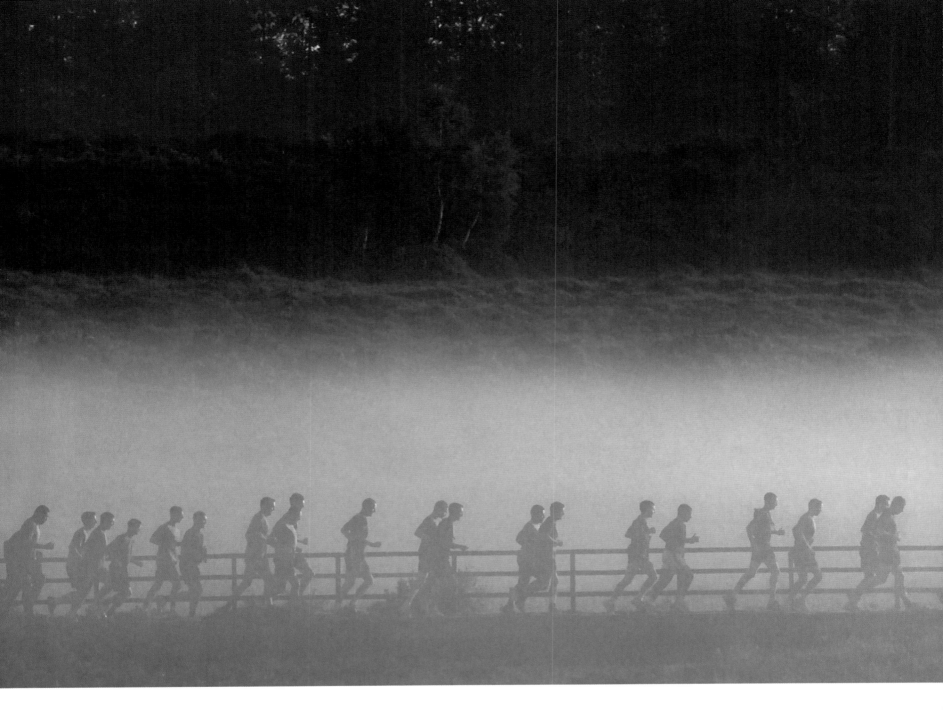

COLIN ROBERTS

Runners, New Forest, Hampshire, England

I visited Beaulieu Heath in late summer, arriving before sunrise. The ground was wet with dew and there was a thick layer of mist. All was silent – until I heard the thumping of feet. Over the brow of a hill, a few runners appeared, then more. They began descending into the valley and headed for the bridge and I saw the potential for a dramatic shot.

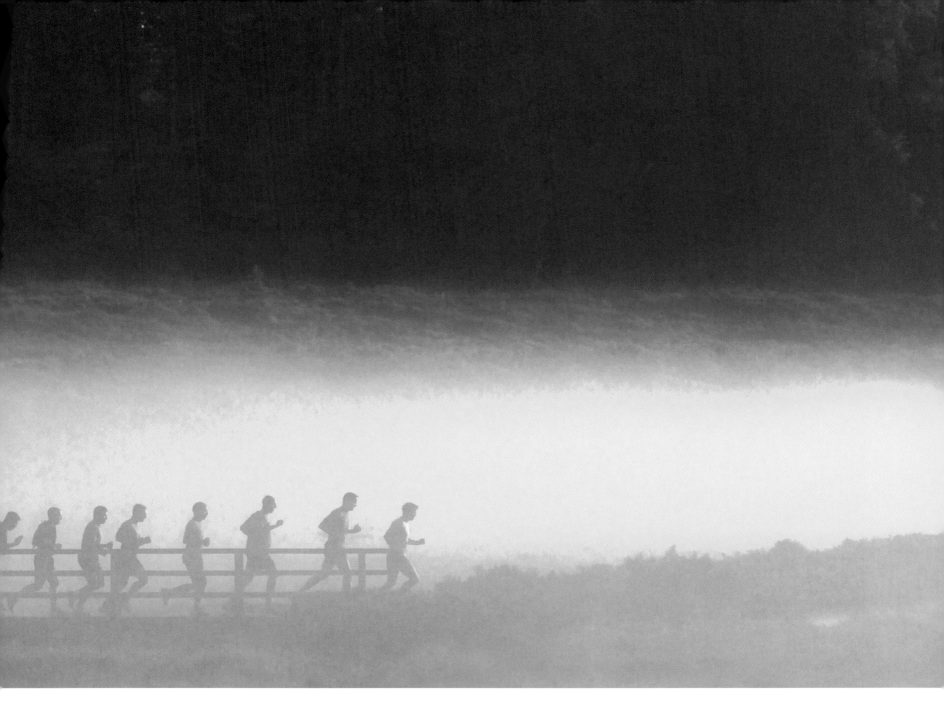

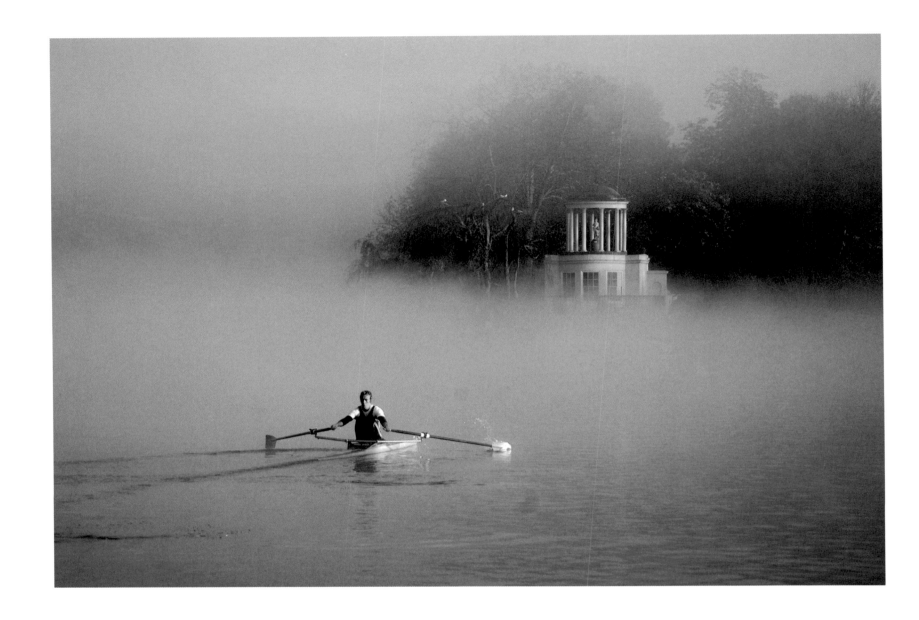

RAD HART-GEORGE

A single sculler in training, Henley-on-Thames, Oxfordshire, England

A single sculler out training on a cold winter's morning. There was not a sound except for the noise of his oars entering and leaving the water. In the background is Temple Island, which marks the start of the Henley Royal Regatta racecourse.

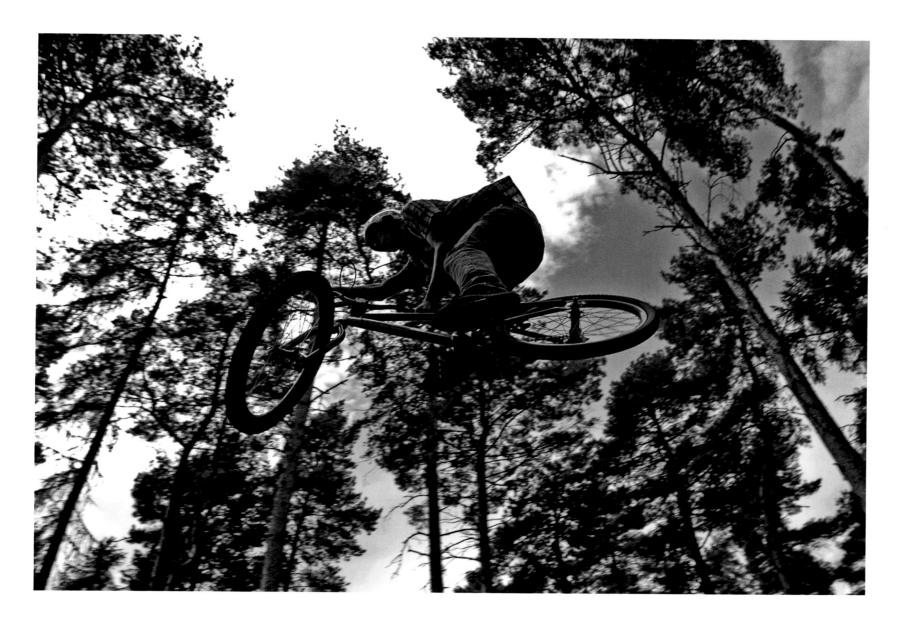

GARY COLET

Chicksands, Bedfordshire, England

This image was taken when I was flat on my back underneath a take-off ramp at Chicksands mountain bike area in Bedfordshire. As a mountain biker myself, I am in awe of these guys who achieve incredible heights in their aerial ballet.

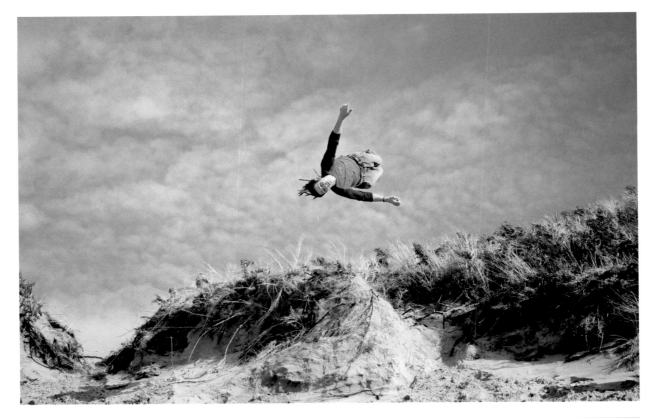

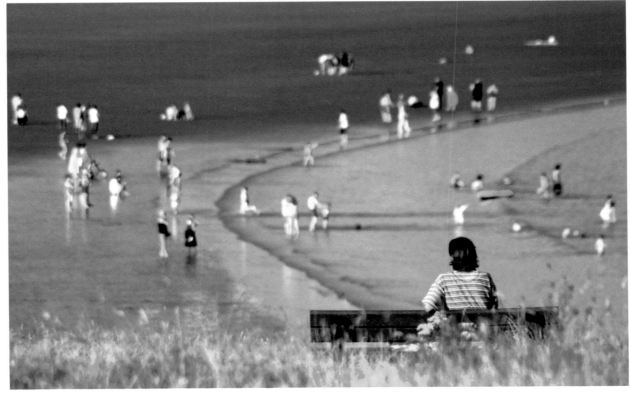

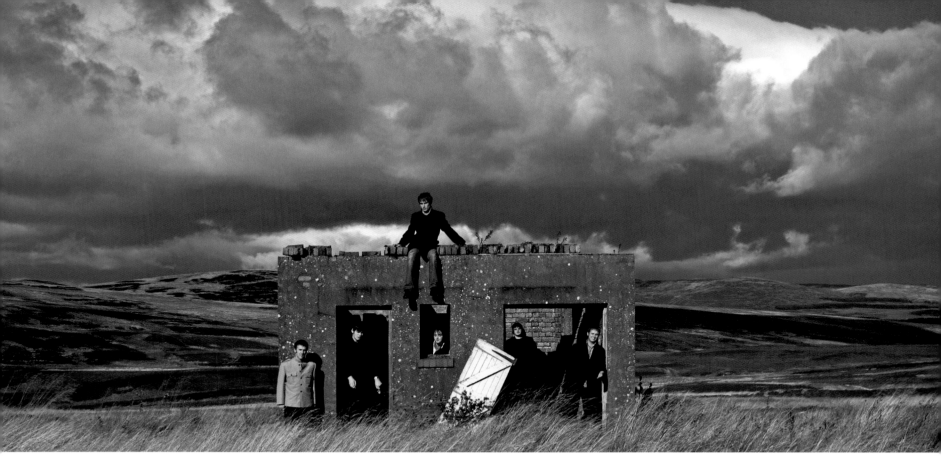

SCOTT MCBRIDE

Scarlet Blue at Wester Fowlis, Perthshire, Scotland

This image was taken for an album cover for the band Scarlet Blue and was used as the centre spread in the CD booklet. The album went into limited print and sold out.

JAMES BAILEY

Top left: 360-degree back flip off a sand dune, South Wales

I was taking pictures of my friend running and jumping off the sand dunes. For this picture, he attempted the 360-degree back flip – landing it first time.

CLARE HOMER

Bottom left: Barry Island, South Wales

This image was taken when my fiancé and I picnicked in the area one summer's evening.

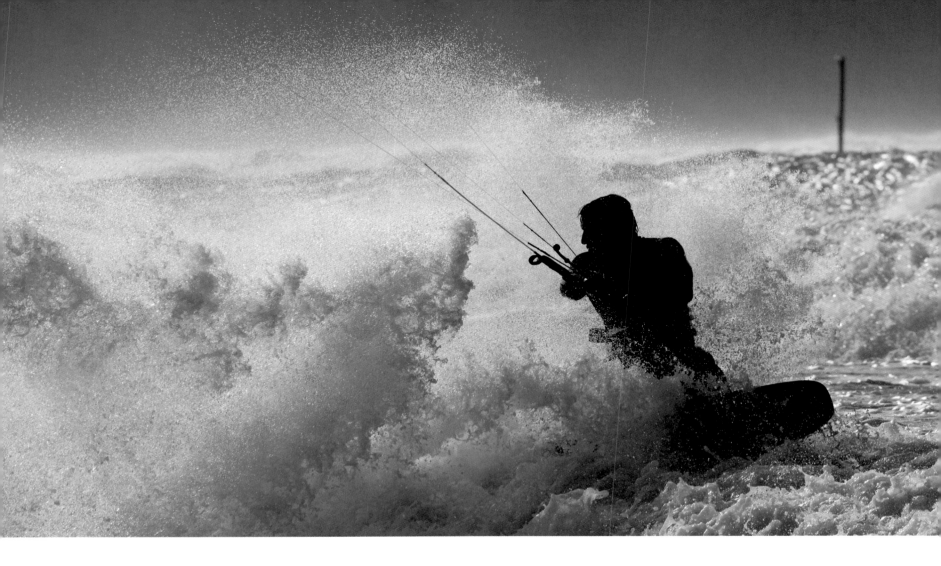

BOB BERRY

Above and right: Mike Smith, the Bluff, Hayle, Cornwall, England

After spending several hours with Mike – a champion kite surfer – doing technical sequence shots of board jumps and turns, we headed off down the beach towards the Bluff and some pretty rough water. What a memorable day – just two blokes out doing what they love. I think I came off best on the 'numb fingers' front though; Mike emerged after an hour – a cold shade of blue. These shots are thanks to Mike and his creativity on a board, some beautiful light and a camera that can take a beating from the elements.

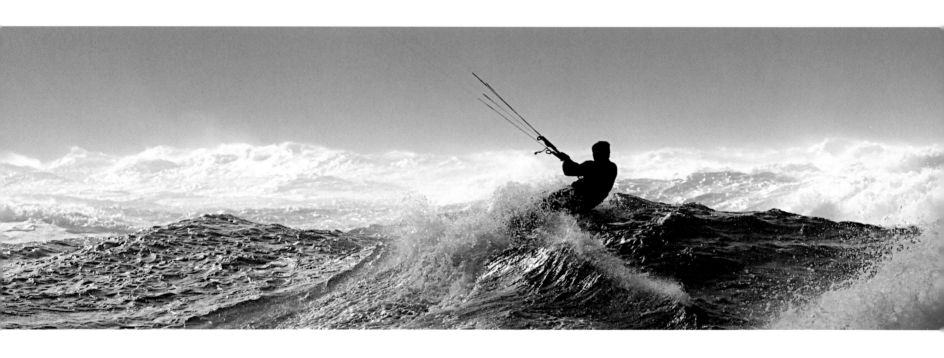

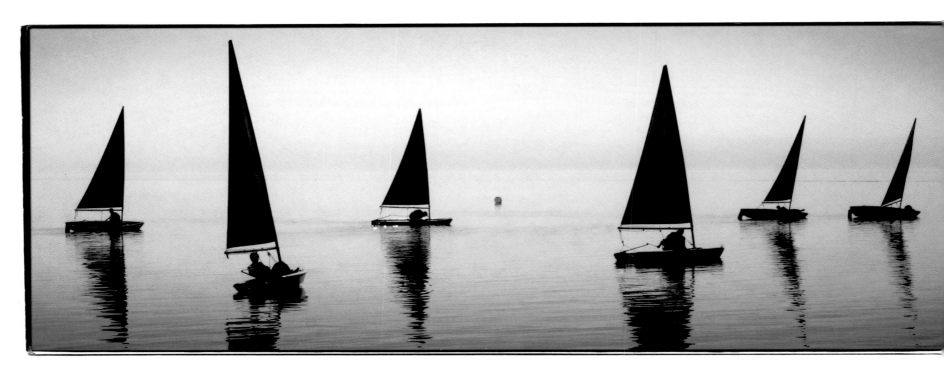

STEVE DEER

West Kirby, Wirral, England

This image was taken at West Kirby Marine Lake on the Wirral. The day was fairly calm and the graphic shapes drew me to the scene, particularly those of the hunched sailors.

130

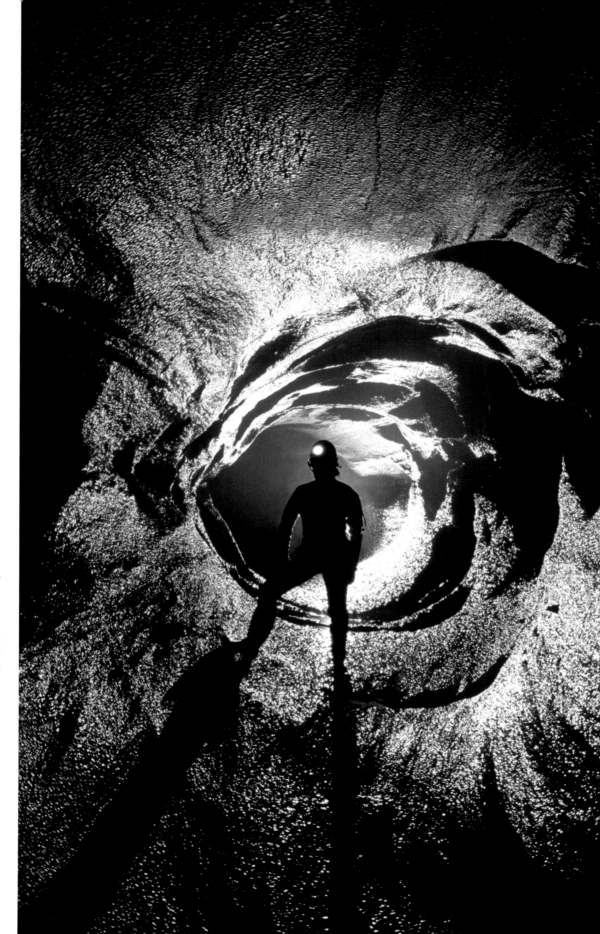

TONY BAKER

Bakerloo Straight in Dan-yr-Ogof Caves, South Wales

Reaching this passage involves around an hour of swimming, climbing and crawling. It is lit with a single flashbulb, held behind the caver. Before we started taking pictures, we spent five minutes throwing water around the walls and roof to improve reflections!

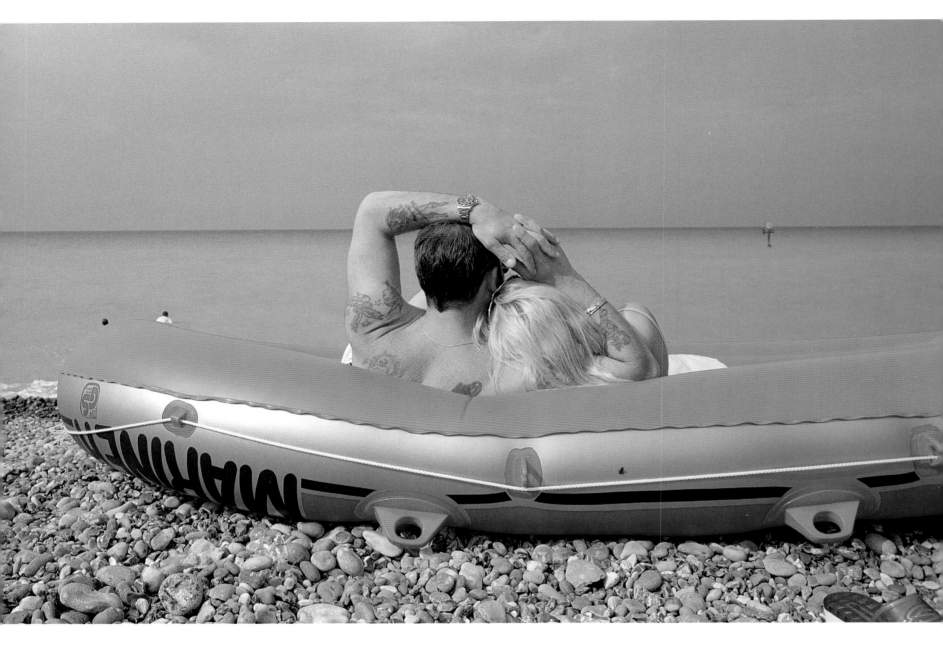

JOHN TAYLOR

Sheringham, Norfolk, England

The rich blue sky and the beautiful luminosity of the grey-green sea instantly attracted my attention. The beach was in cloud shadow but, as I watched, the light broke and illuminated everything on shore and, in particular, the couple in the dinghy. As the woman snuggled in to the man, her blonde hair shone and picked up red tones from the dinghy; his watch caught the light brilliantly and his tan contrasted with her hair and the sea.

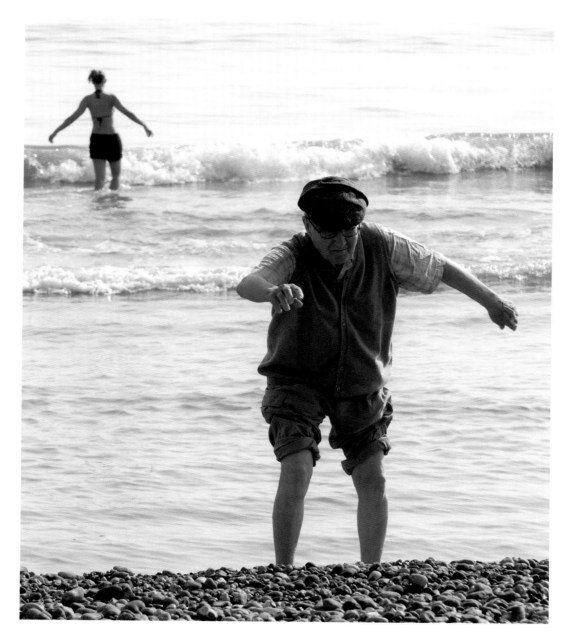

PETER STEVENS

Brighton Beach on a Sunday in spring, East Sussex, England

This was taken on a very busy Sunday on Brighton Beach. This image contrasts old and young enjoying the sea; the old man just struggling back over stones, and the young girl entering the sea with youthful enthusiasm.

RICH HENDRY

August Bank Holiday, Croyde, Devon, England

This shot was taken at Croyde in Devon on a very busy August Bank Holiday weekend.
I arrived at the beach, in glorious sunshine, about an hour before I took this picture, but
as I unpacked my kit the horizon started to darken, and slowly a mist started to roll in.

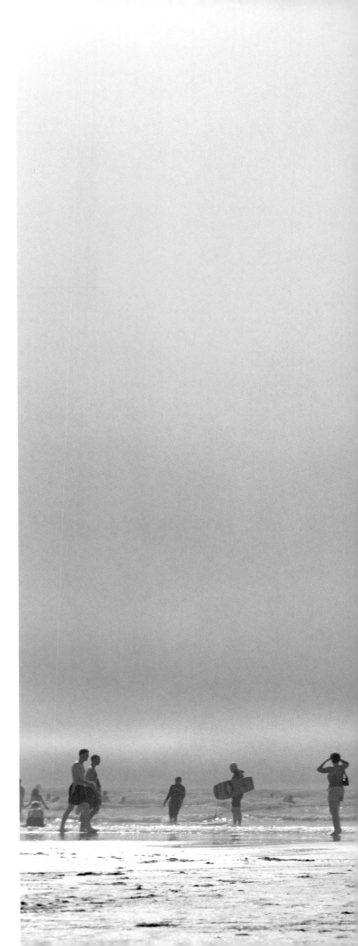

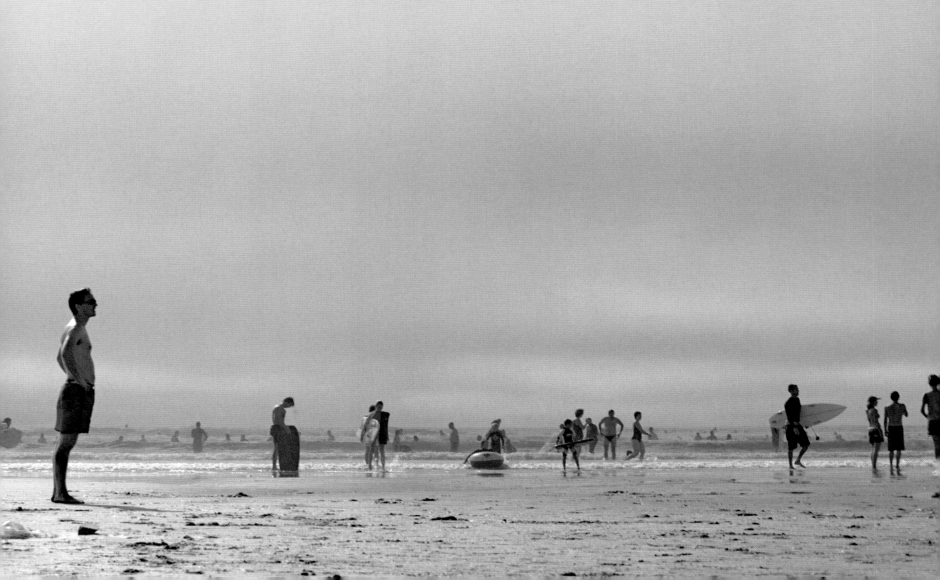

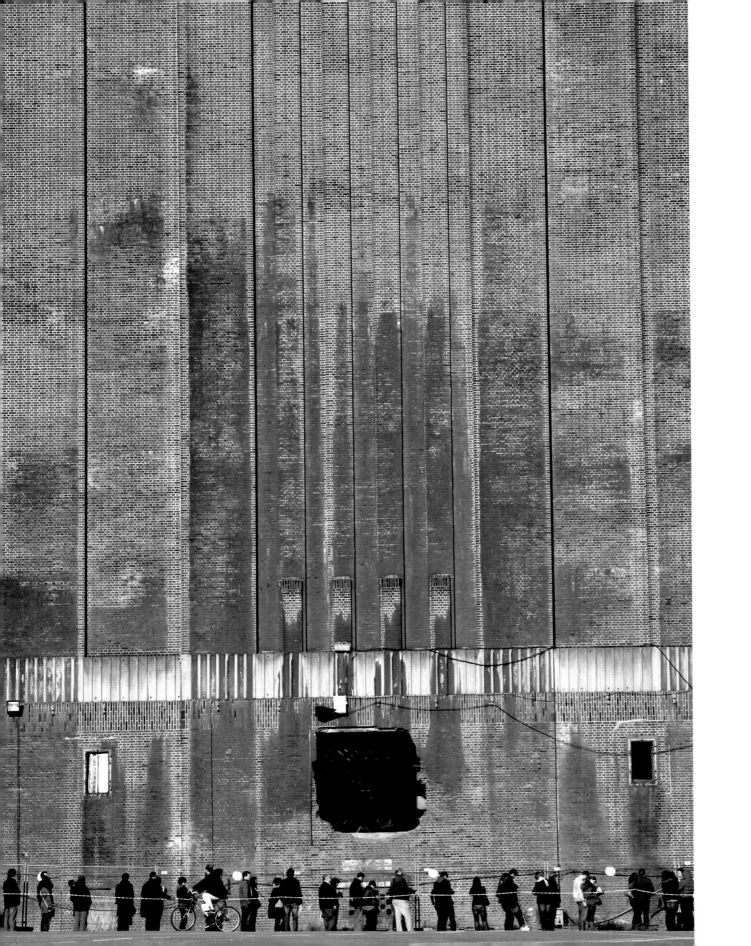

ADAM CAVALIER

Left: Queue, Battersea Power Station, London, England

The owners of the power station had opened it to the public for three days. It was incredibly moving to be close to such an iconic building, and one that was built entirely with bricks..

CHAO-YAN CHAN

Night view from London Eye with Houses of Parliament, London, England

I lived in the UK for two-and-a-half years whilst studying for my MA degree. I took this picture on my last night before returning to my country – it has a special meaning for me.

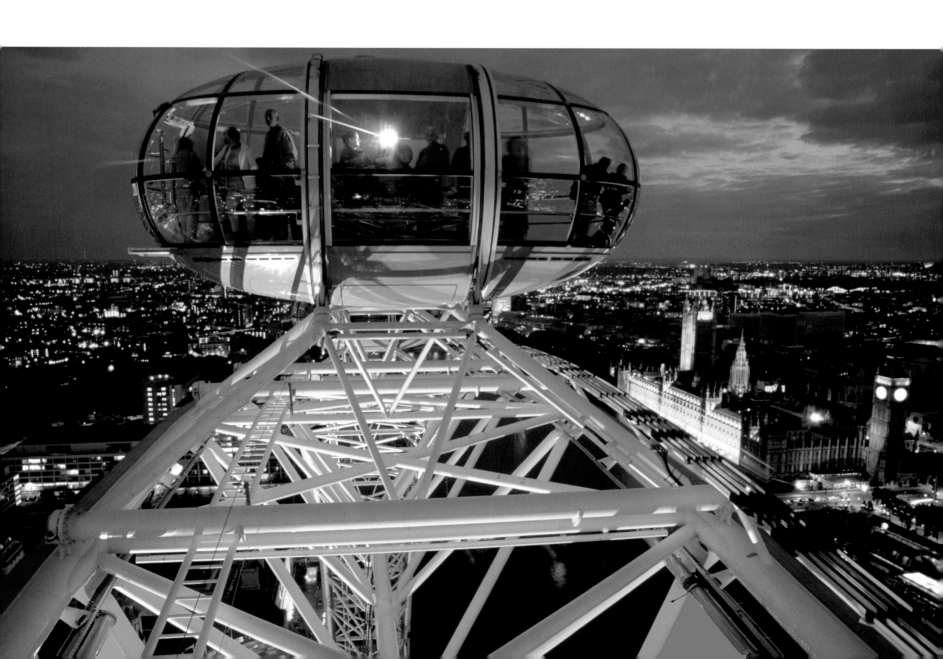

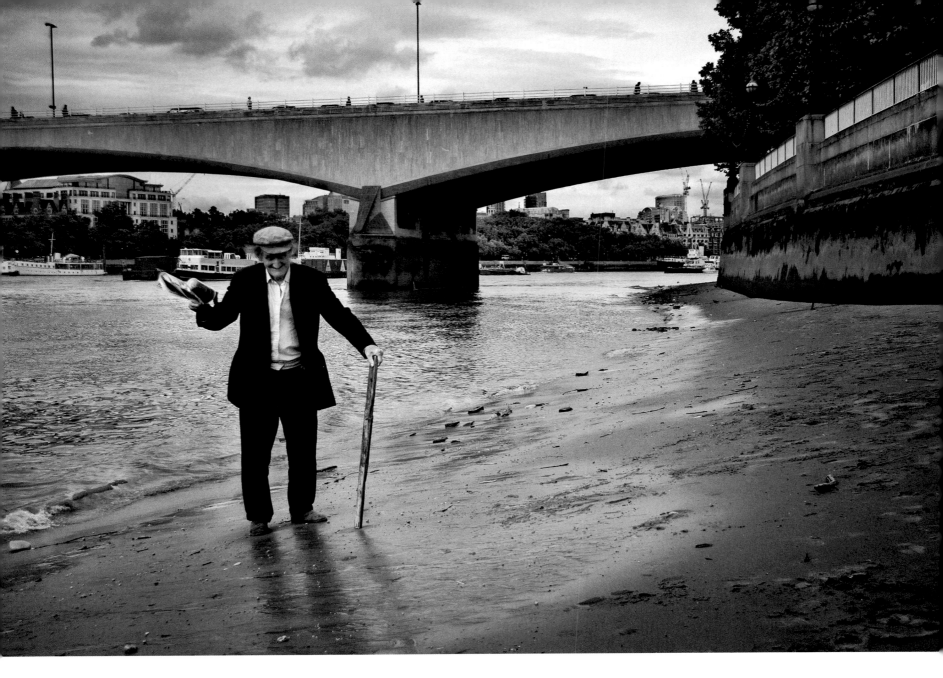

JONATHAN LUCAS

'Maybe it's because...', South Bank, London, England

I often make my way down to the beach on the Thames and, on this occasion, I met this gentleman wandering with his paper and enjoying the ambience. I pointed my camera towards him and he seemed to enjoy the attention, striking this characterful pose.

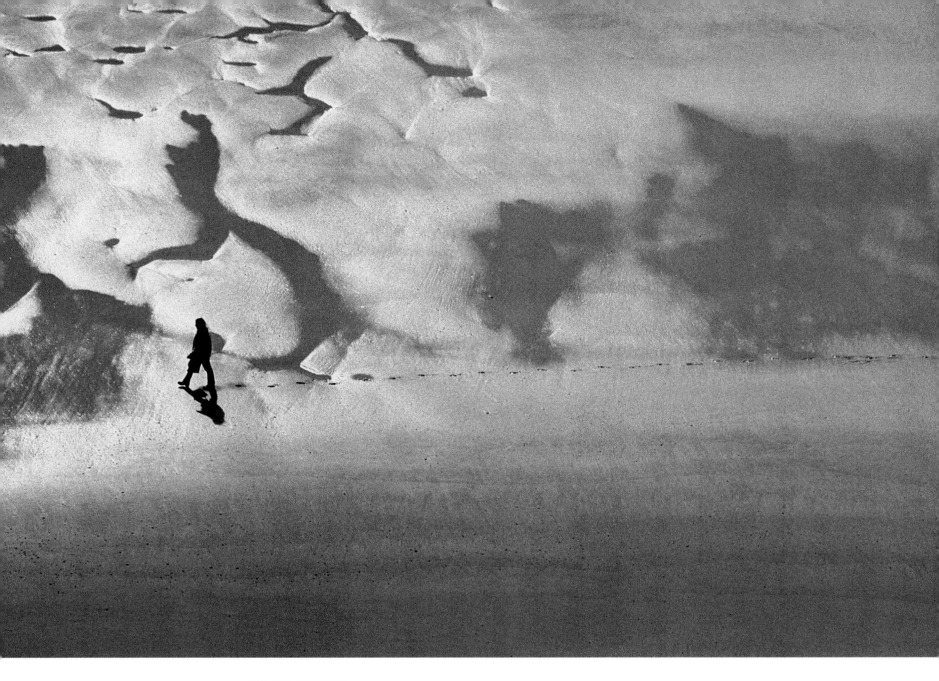

MATT WREFORD

Walker on beach, Wales

I was in Wales having just finished my university finals. Walking along the cliffs, I looked down to the beach and saw someone leaving fading tracks behind them in the sand. It wasn't until I printed the photograph that I saw the running figures in the sand above the person. It reminds me of the end of that period in my life and moving on to new things.

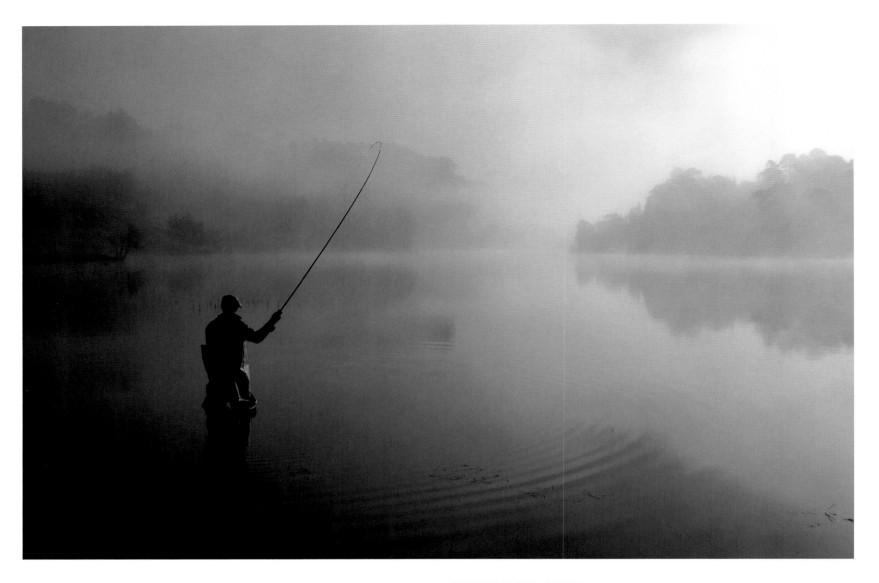

EMMA HODSON

Early morning fishing, Loch Affric, Scotland

This photo was taken at about six in the morning on the penultimate day of a week's holiday in Scotland. I'd been getting up early every day to take pictures and I thought I'd get up and just go for a walk to enjoy my last proper morning in that way. My friend had the same idea and had chosen to go fishing. I was so happy that I had a camera with me and could capture the landscape and the moment.

CHRISTOPHER KEENE

Right: Early morning at Woolacombe Bay, North Devon, England

This image is a 300mm telephoto shot of about a third-of-a-mile portion of the beach at Woolacombe. It shows the weaving design pattern made by the tractor that cleans the beach along the high tide line every week. The scene only remains intact for about an hour in early morning and can only be seen in its entirety from a very high position. The shot was taken from the top balcony of a four-storey apartment block.

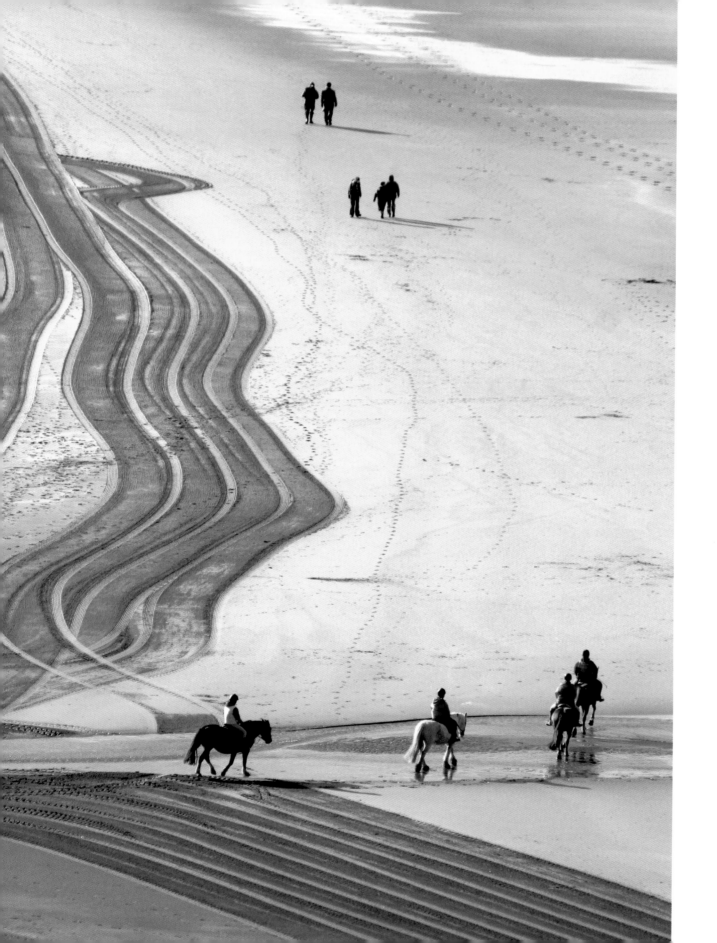

LIVING THE VIEW
youth class

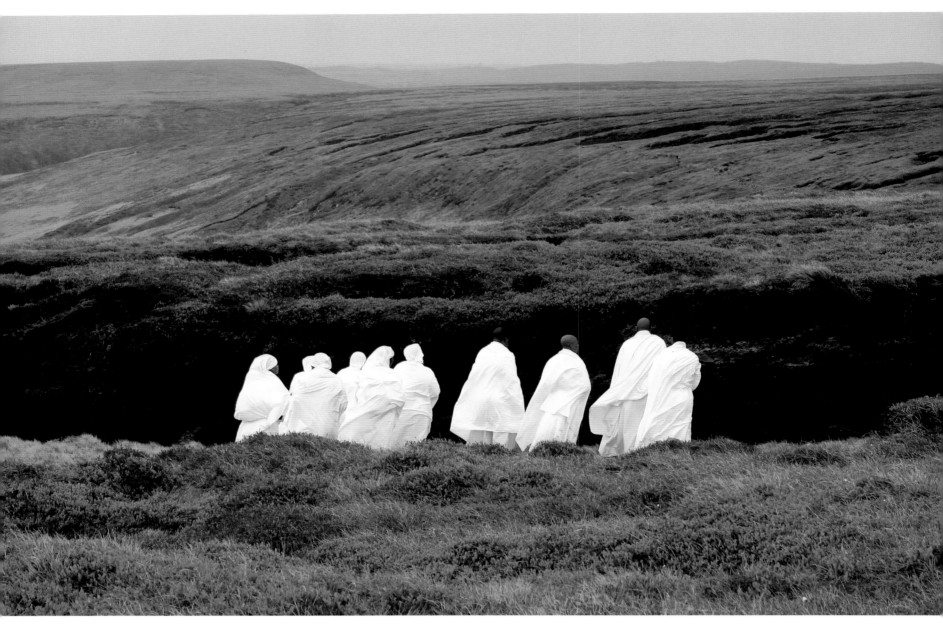

LIVING THE VIEW YOUTH CLASS WINNER

CONNOR MATHESON

Preparing to pray, Holme Moss, Holmfirth, Yorkshire, England

This shot was taken on top of Holme Moss in the Pennines, as a religious group prepare
for a prayer ritual on the Yorkshire moors.

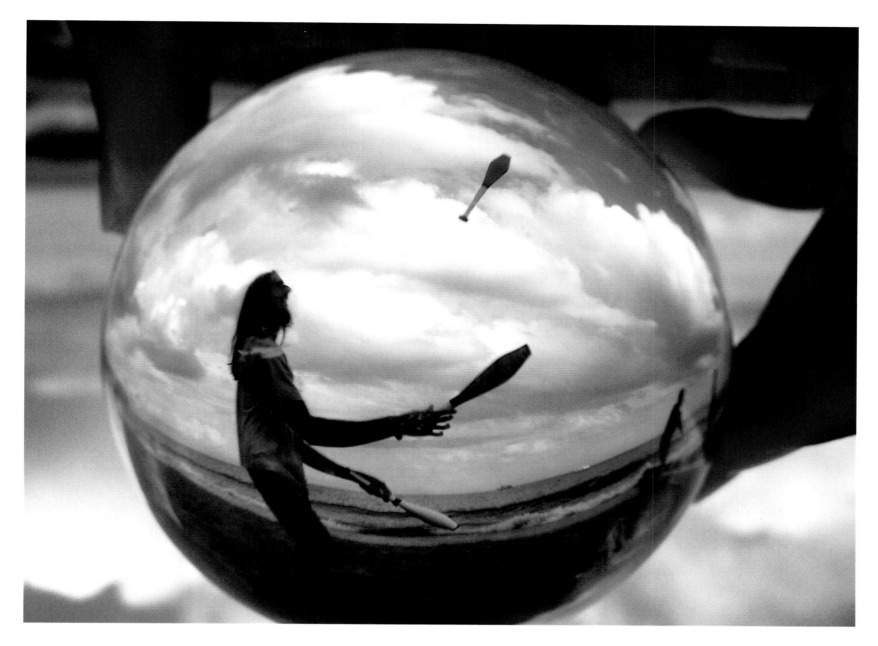

HIGHLY COMMENDED

HARRY TILSLEY

Juggling on the beach, Swanage, Dorset, England

This is a photo of my brother juggling on the beach at Swanage – it was taken through a perspex contact juggling ball. I like the distortion, but you can still see the beach too!

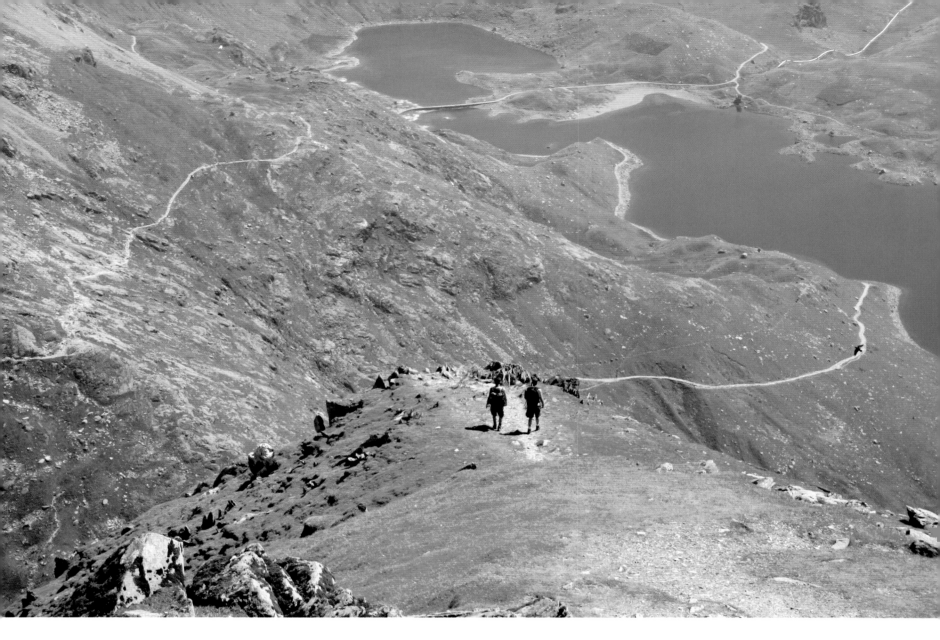

EMMA CLARE

From the summit of Snowdon, Wales

I was looking towards the lake (Llyn Llydaw), as somebody had just told me about the legend of the sword of Excalibur, when I noticed the walkers. The path they are taking turns to the left, but it almost looks as if they are going to walk off the edge.

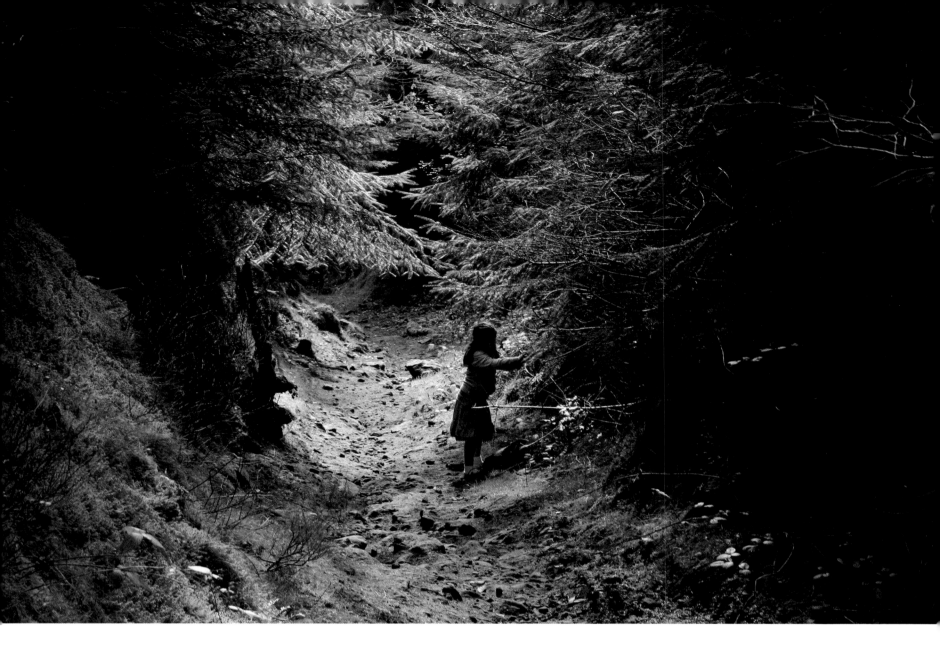

CONNOR MATHESON

Dalby Forest near Pickering, North Yorkshire, England

This was captured during a family trip to Dalby Forest in the North Yorkshire Moors. The girl is picking flowers from the trees as we are taking a walk through the valley.

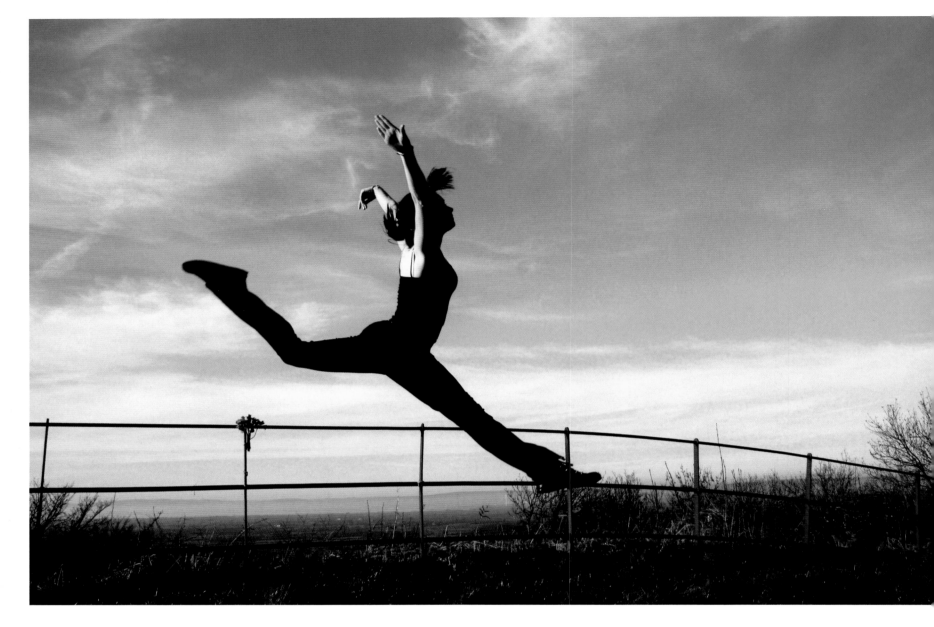

EMILY GROSS

Leaping over the Severn Estuary in Almondsbury, Bristol, England

This image was taken on top of a hill overlooking the village of Almondsbury, with the Severn Estuary barely visible some four miles away in the background. The picture was taken from ground level to create an impression of a high leap. The contrast of the black clothes of the model against the blue sky is quite striking.

Right: Tytherington Quarry Track near Bristol, England

This picture was taken on a dull day in spring as part of a GCSE Photography project. The model was wearing bright colourful clothes to create a strong contrast with the rest of the scene. I placed her to the right of the frame to allow the disappearing parallel lines of the railway track to give the image a sense of depth.

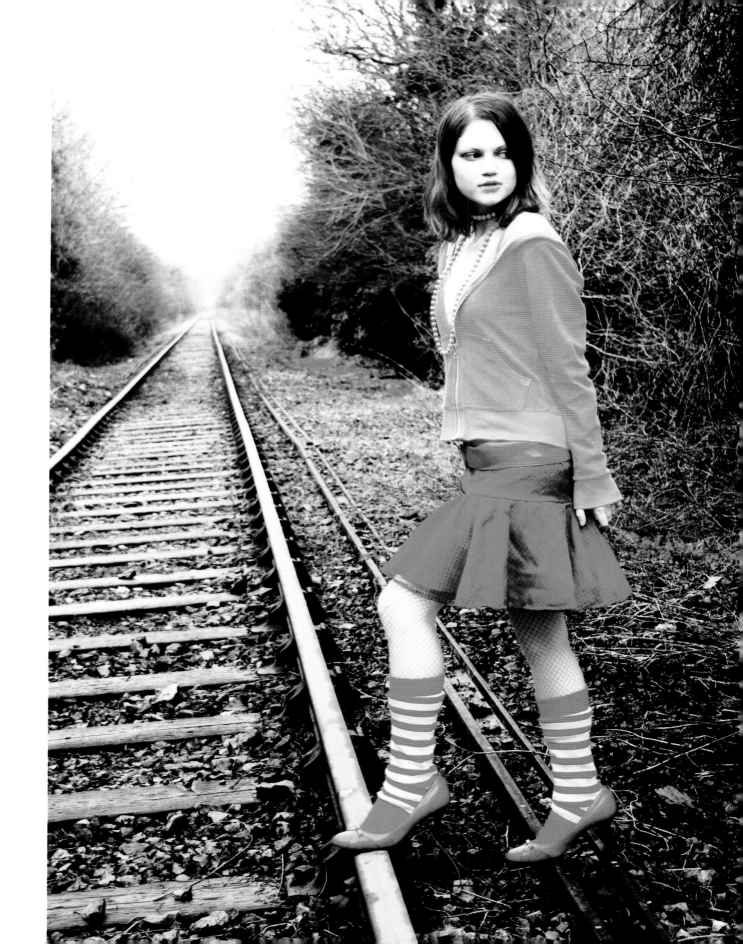

YOUR VIEW
adult class

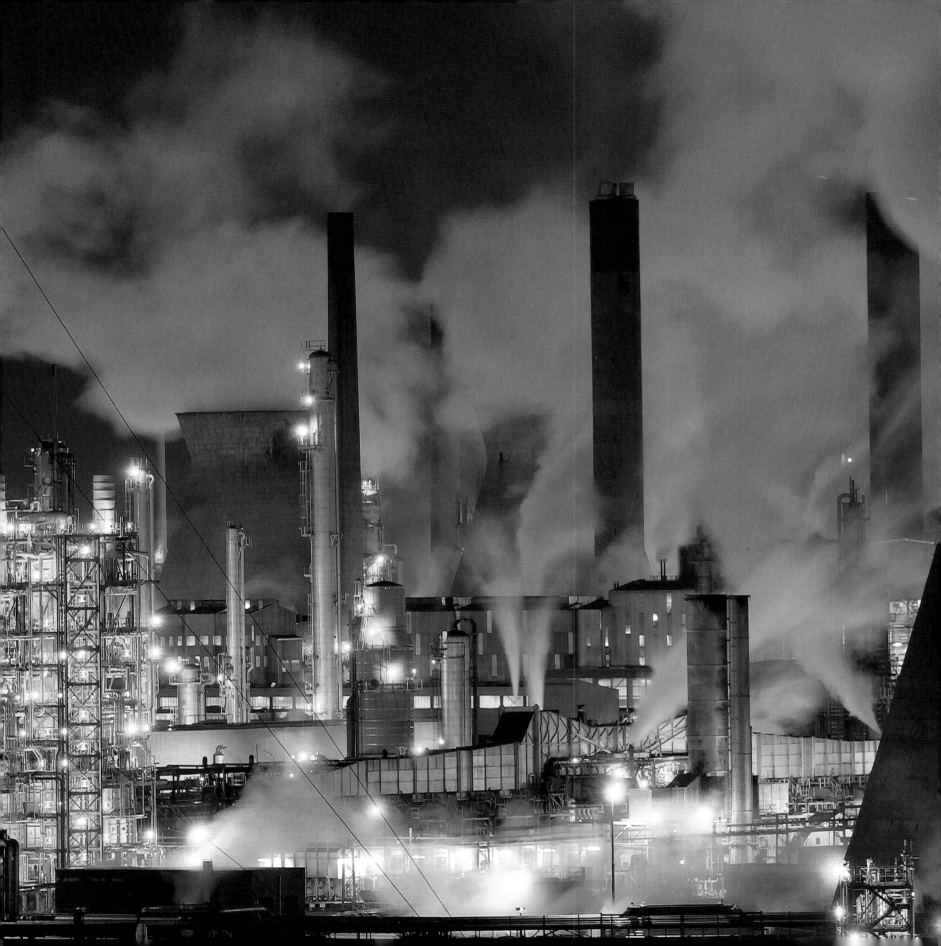

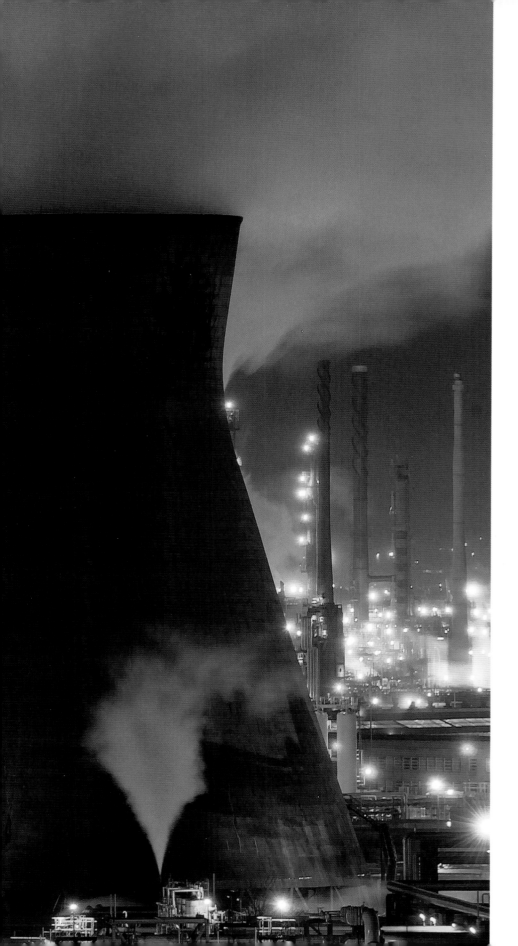

YOUR VIEW ADULT CLASS WINNER

GRAEME POLLOCK

Grangemouth Oil Refinery at night, Scotland

I liked this picture because all the elements worked well – the steam, the lights and the composition. Scotland is home to heavy industry as well as incredible scenery, and Grangemouth Oil Refinery exemplifies Scotland's industrial landscape. However, there is a sense of beauty in amongst these towering chimneys and machinery. This is one of my favourite views of Scotland.

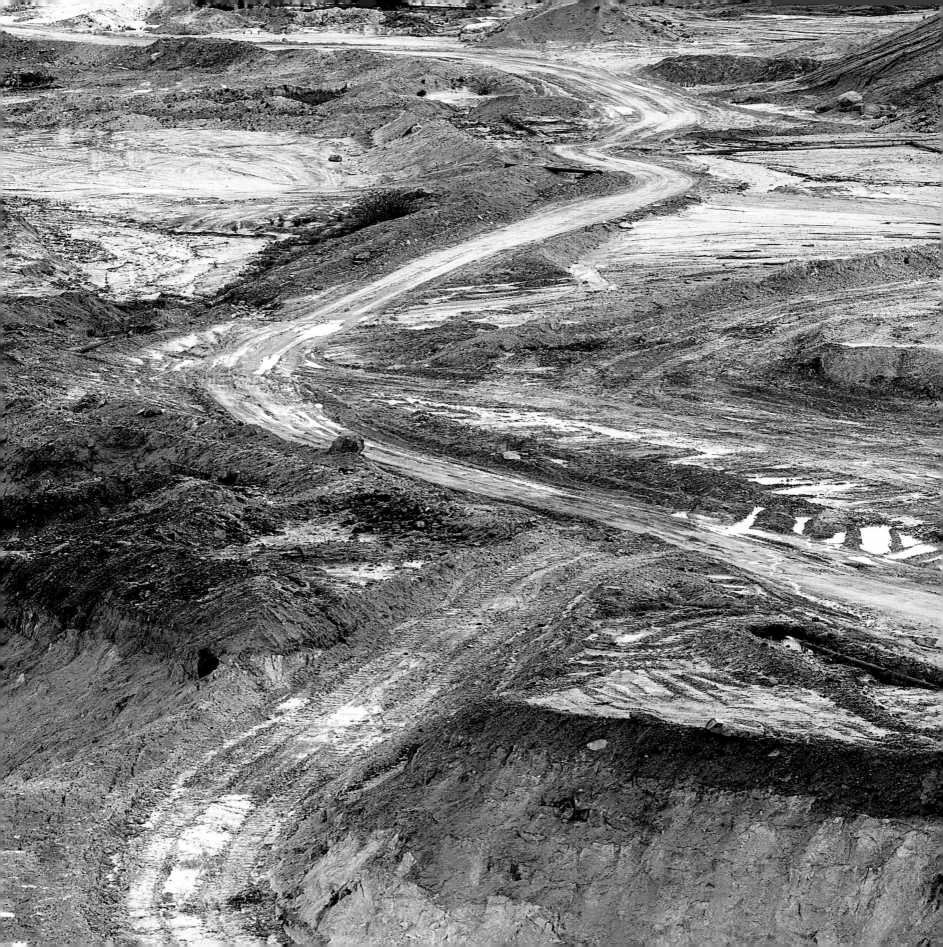

YOUR VIEW ADULT CLASS RUNNER-UP

ROBERT BUCHANAN TAYLOR

Clay trails, St Dennis, Cornwall, England

This image captures the landscape symmetry in a china clay waste valley in Cornwall.

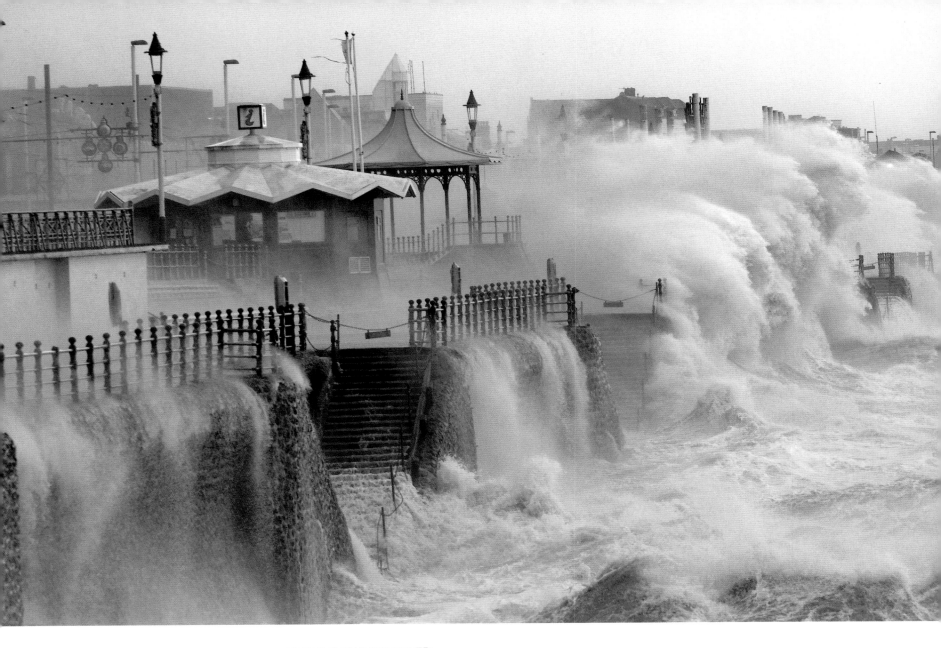

HIGHLY COMMENDED

ED ROPER

Force nine gale at Blackpool, Lancashire, England

The image was taken on a very stormy day in Blackpool when any sensible person would have stayed in bed. Sheltering at the end of the North Pier, I took this to show the sheer power of the storm crashing against the coastline.

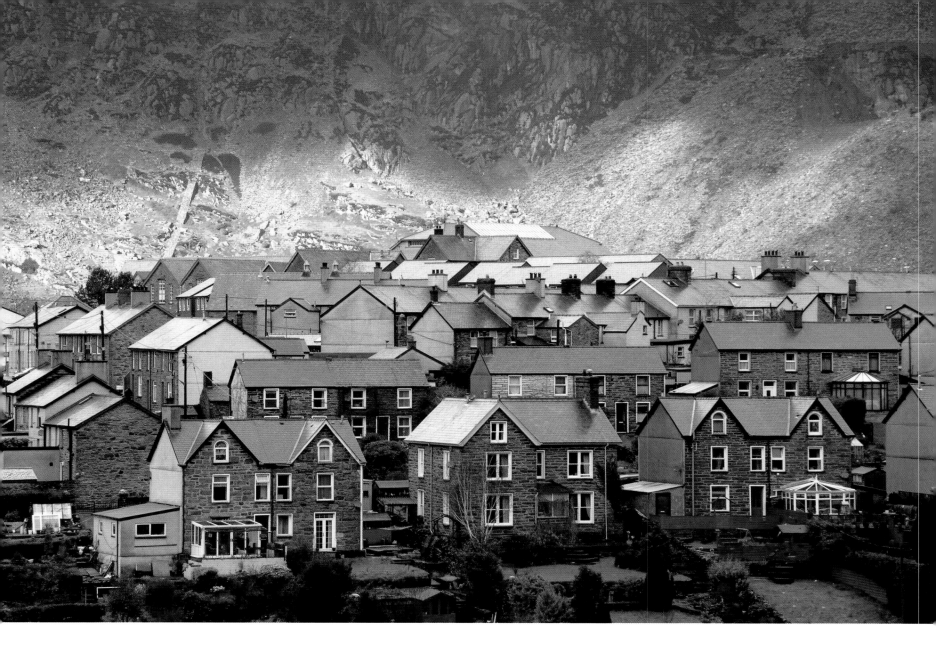

HIGHLY COMMENDED

RICHARD SMITHIES

Blaenau Ffestiniog, Snowdonia, Wales

I had just come out of the local shop when I saw this view. The contrast between the burst of sunlight and the cold blue slate here in the birthplace of slate struck me forcefully. I ran to the car and managed to grab my camera just in time.

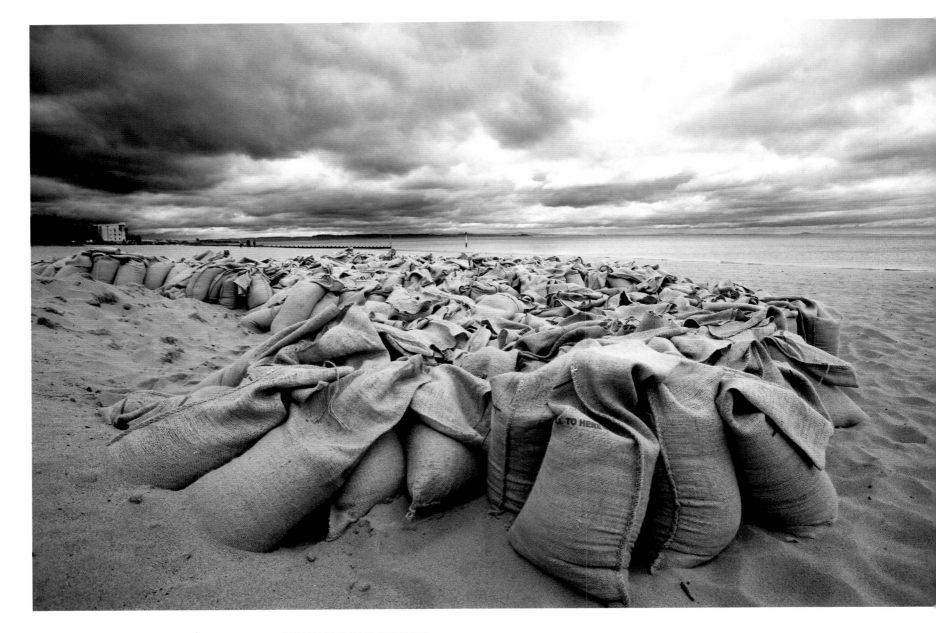

HIGHLY COMMENDED

DOUGLAS KURN

Sand bags on Portobello beach, Edinburgh, Scotland

The cloud cover in Edinburgh when I took this image was amazing. I headed down to a lonely, near-empty Portobello Beach where I found these sandbags, and was left wondering as to their purpose and significance. The clouds seemed particularly moody and foreboding, and the coldness of the image reflected a sense of isolation.

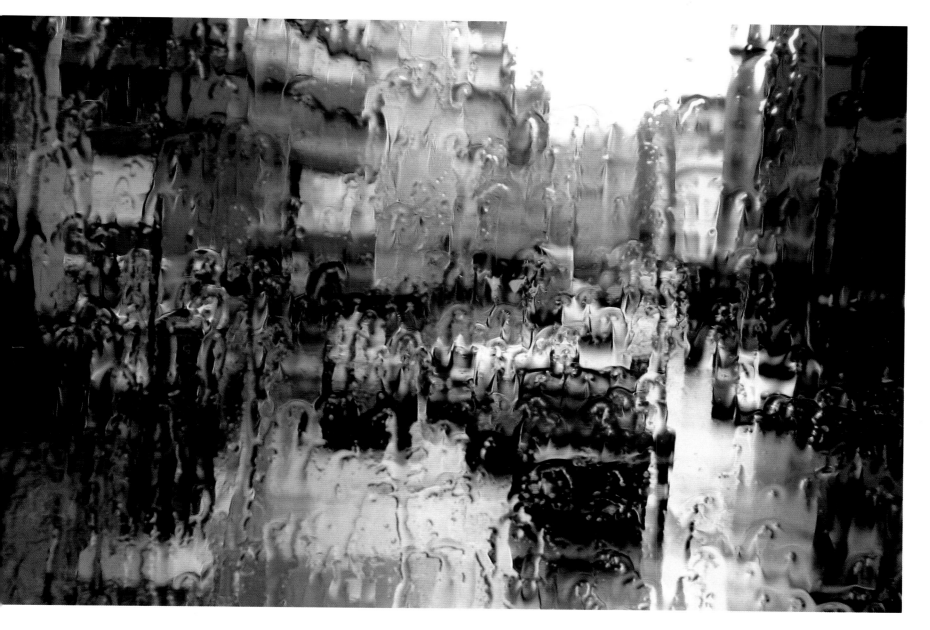

HIGHLY COMMENDED

SARAH LITVINOFF

Through the bus window, London, England

I was sitting at the front on the top of a 43 bus going towards London Bridge when it started to pour heavily. I was extremely fed up as I had no umbrella; my mother had recently died and I was already feeling fragile. I started to take photographs, as I always do, and then realised that the bus window had become the frame for a series of Impressionist oil paintings. Throughout my mother's decline, death, and during the grey aftermath, my camera kept me connected to life and its possibilities.

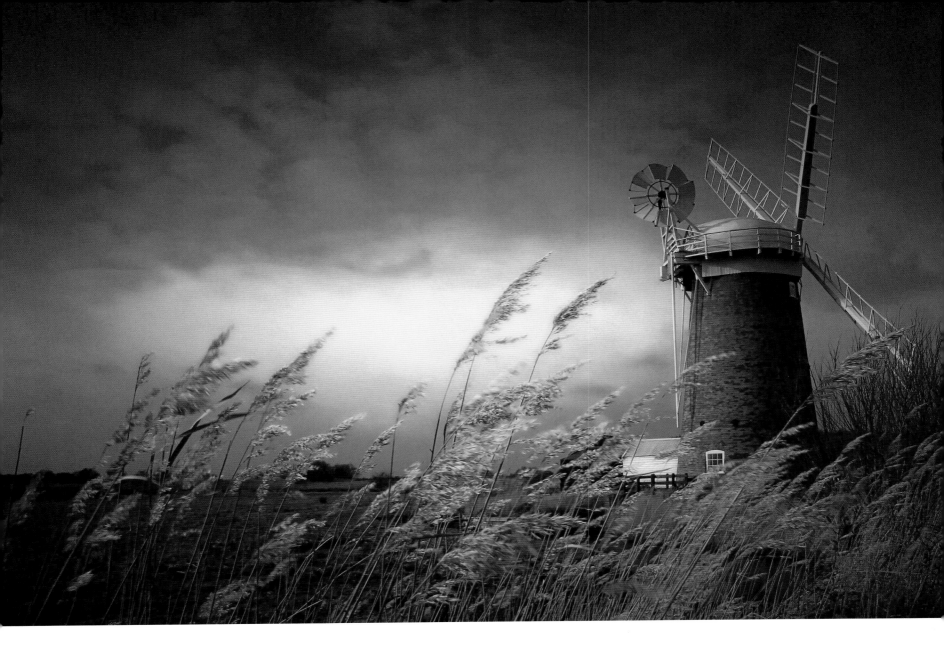

IAN FLINDT

Horsey Windpump, Norfolk, England

The mills of the Norfolk Broads are probably one of the region's best-known features. This image was composed to make the most of the reeds – another of the Broads' well-known attributes – as they swayed in the winter wind.

Right: Fisherman's Rope, Staithes, North Yorkshire, England

A little while before this shot was taken, a bank of sea fog had rolled in to occupy the village. The conditions provided an opportunity to photograph Staithes in a subdued light that helped to emphasize the mood of the place on that cold, fog-filled day.

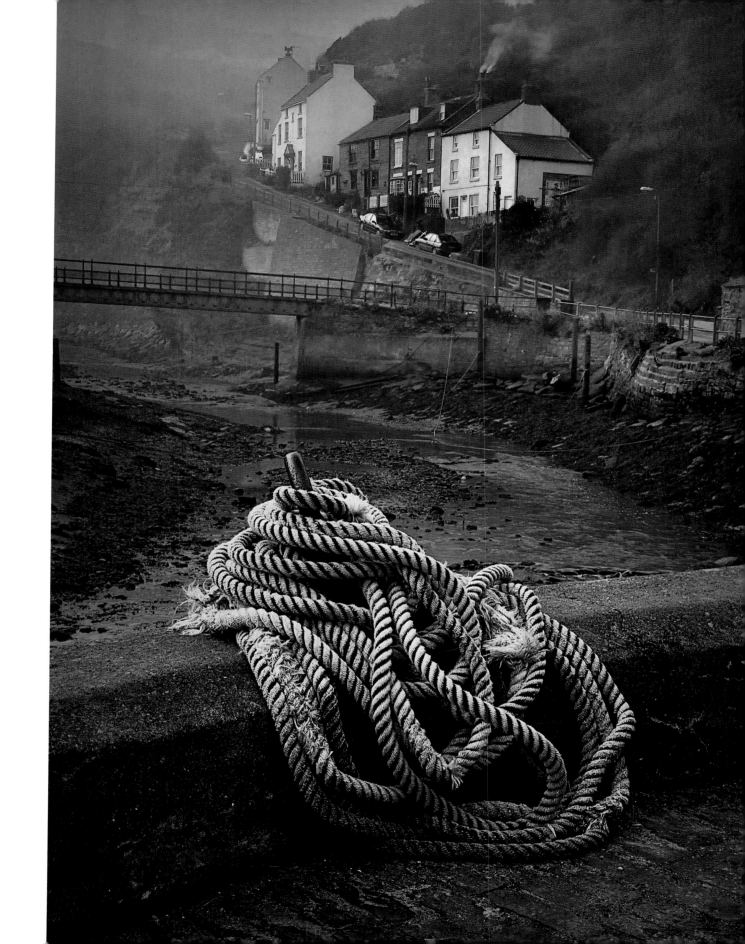

IAN FLINDT

Polders, East Mersea, Essex, England

The posts, or 'polders', extending in long straight lines across the mudflats, are all that remain of brushwood fences erected in the late 1980s in an attempt to protect the cliffs of Mersea Island from the insatiable appetite of the North Sea. Mersea Island may not be renowned as a photogenic location, but at the moment this image was captured, it was possible to believe that it was the most beautiful place on Earth.

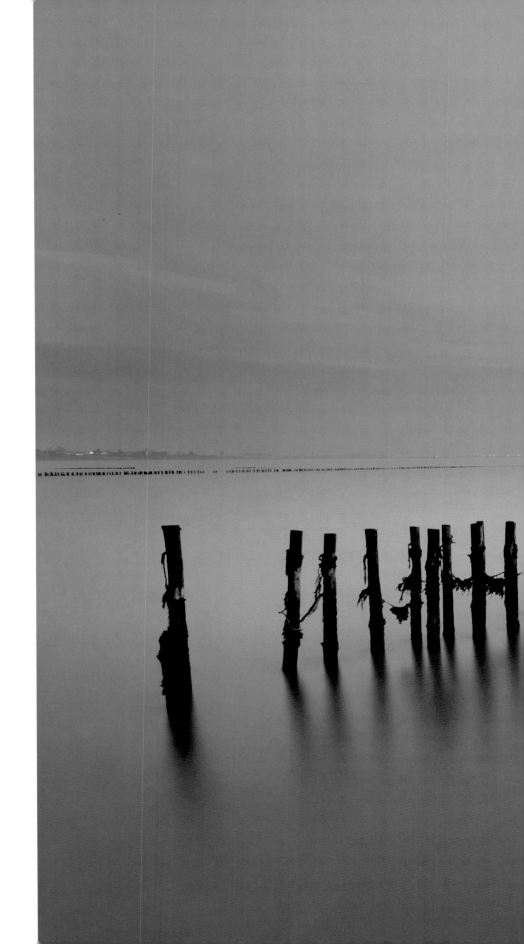

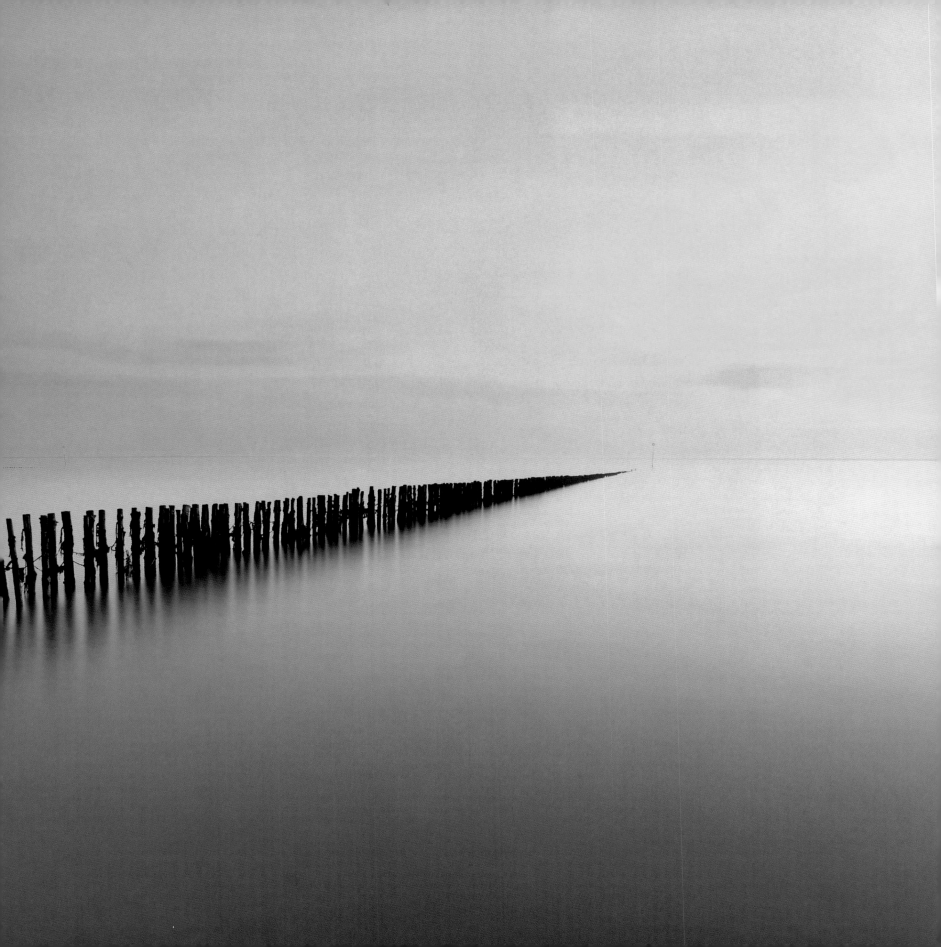

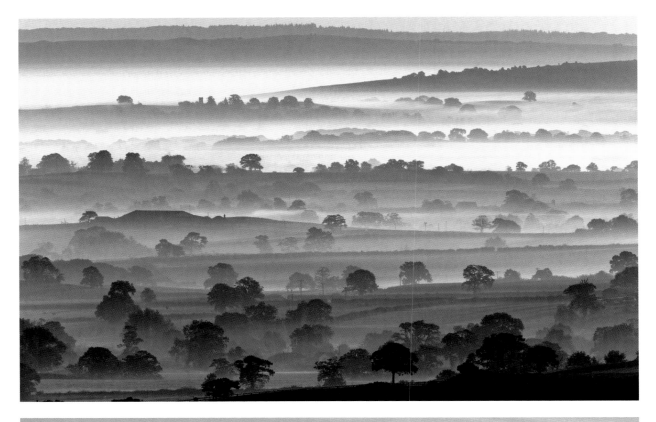

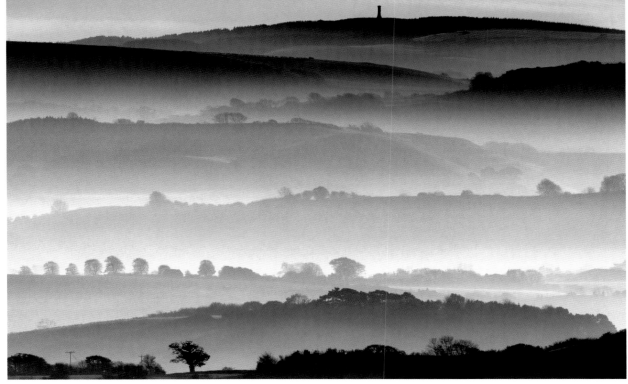

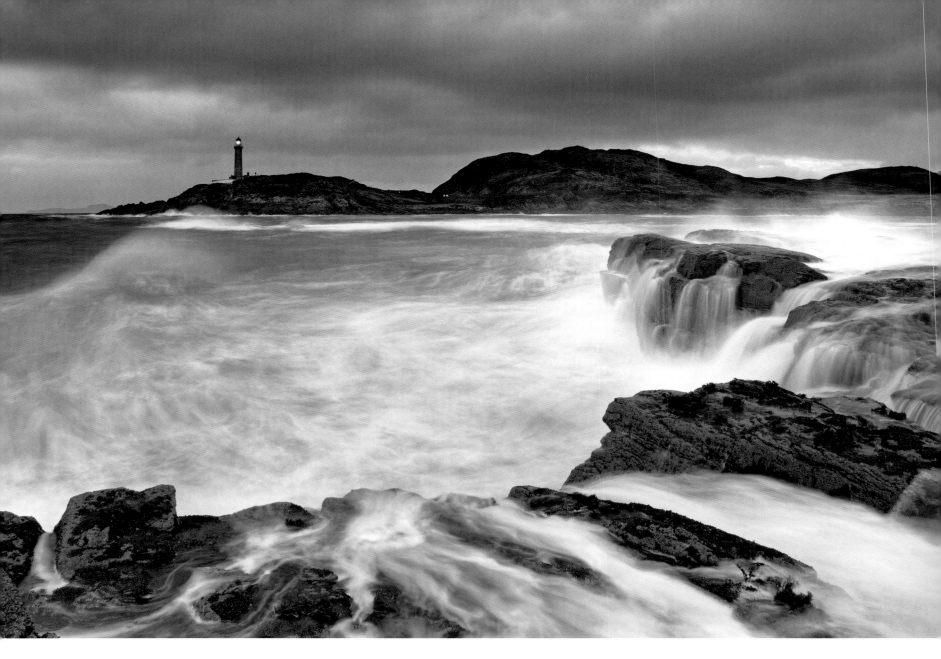

GUY EDWARDES

Top left: Layered hills near Yeovil, Somerset, England

This photograph was taken at dawn, using a very long 700mm lens to compress the layers on the mist-shrouded hills in the heart of Somerset.

Bottom left: The Marshwood Vale, Dorset, England

A distant view of the Marshwood Vale in Dorset. I used a very long 1000mm lens to give a 20x magnification of this tranquil, misty scene.

Ardnamurchan Lighthouse, Scotland

This was taken just as a storm was beginning to clear. I had to wait until dusk so that I could capture the light of the lighthouse to complete the shot.

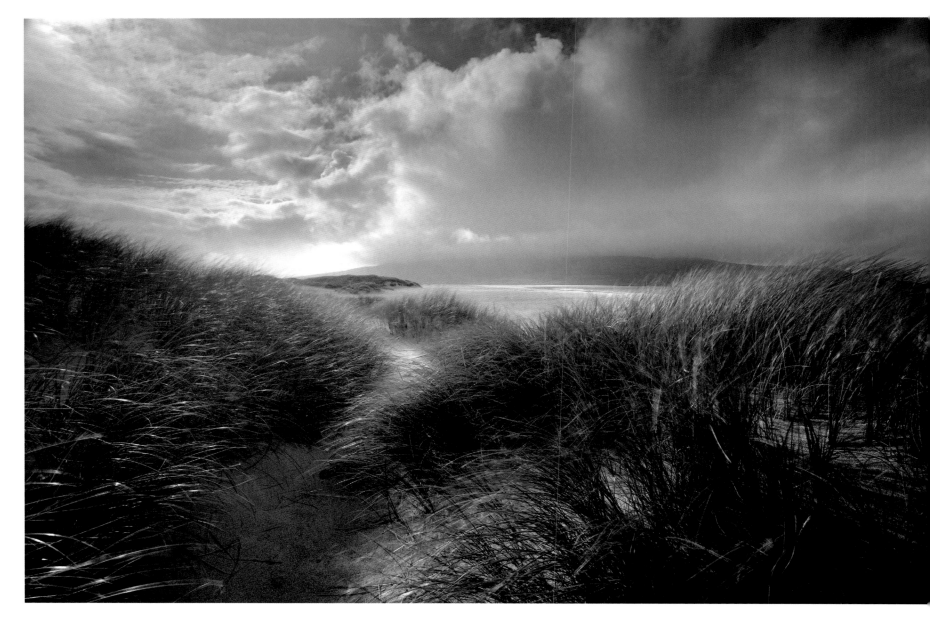

TRISTAN CAMPBELL

Scarista Bay, Isle of Harris, Scotland

This was taken during a stroll across the dunes as we paused for a break on a very blustery afternoon. I have to thank my six-month-old son for his patience as I composed the shot whilst he was being carried on my back.

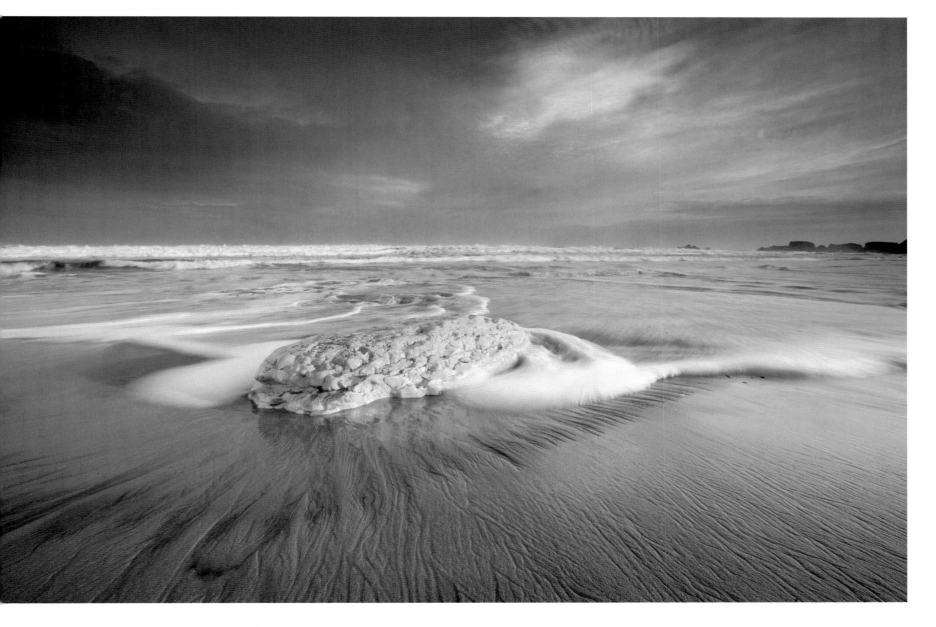

CLAIRE CARTER

Whitepark Bay, Antrim, Northern Ireland

This photo was taken early in the morning on a crisp day with no one yet out on the bay – bliss. The wind had been fierce for days and the waves were pounding the beach, making it necessary to run in and out in order to catch the swirling waters around this boulder that was turned golden by the light.

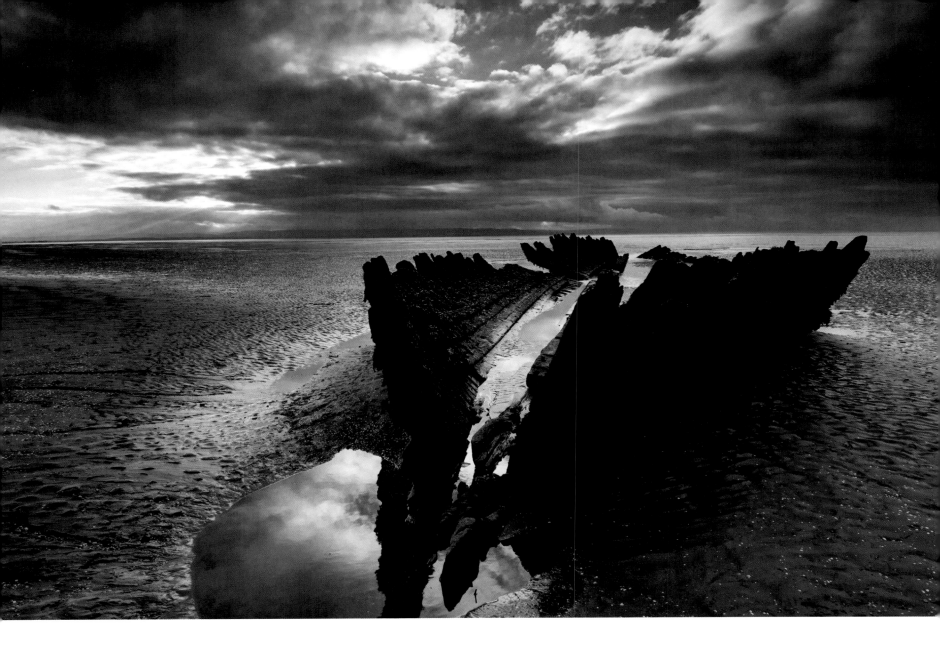

CRAIG JOINER

The wreck of SS Nornen, near Burnham-on-Sea, Somerset, England

While editing the images from this shoot, the overwhelming memory of desolation and loneliness, combined with the drab colours of this scene, led me initially to overlook this image. It lay forgotten in my archive for nearly a year until a friend asked for an image of a black and white coastal scene for his living room. The thumbnail immediately stood out as being perfect for the brief, and when I showed him there was no hesitation on his part. It has now become one of my favourite images and it strongly conveys the emotions I experienced when first setting up my camera that day.

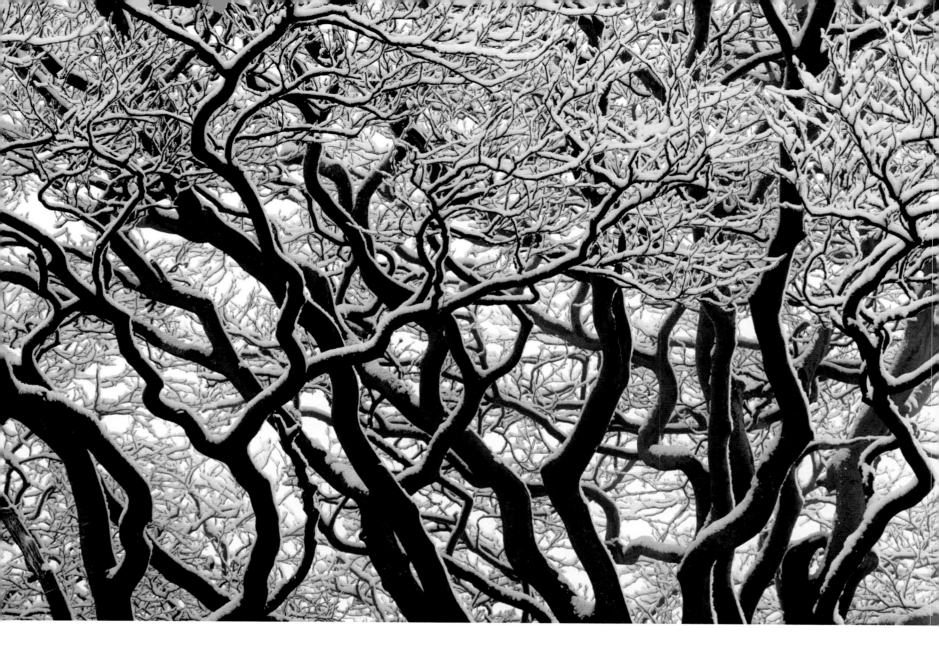

GUY EDWARDES

Snow-covered beech boughs near Beaminster, Dorset, England

This was taken looking directly up into the boughs of a beech tree after a heavy snow fall, with the white, cloudy sky providing the perfect backdrop.

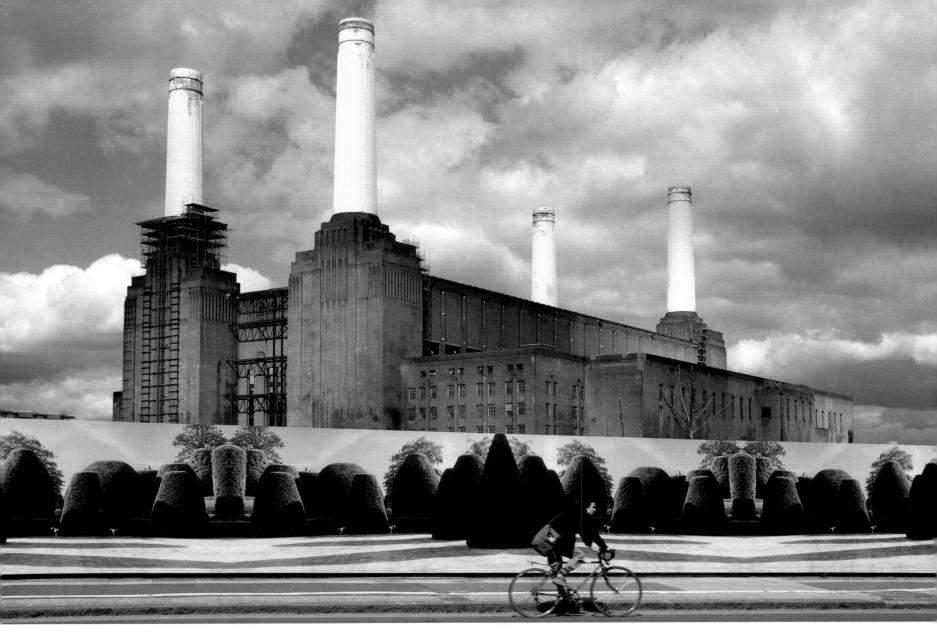

MATTHEW ALLAN

'The Gardens at Battersea Power Station', London, England

When I came across this scene, I was struck by the contrast between the industrial brick exterior of Battersea Power Station, the rather moody sky, and the tranquil garden setting painted on the hoarding. The passing cyclist completed the shot...

BOB AYLOTT

Right: Church at Rowland's Castle, Hampshire, England

While travelling to London by train on a Friday, I noticed this chapel surrounded by a field of rape seed. I went back to the location on the Saturday and spent the day photographing the scene. The next week the farmers moved in and cut down the crop.

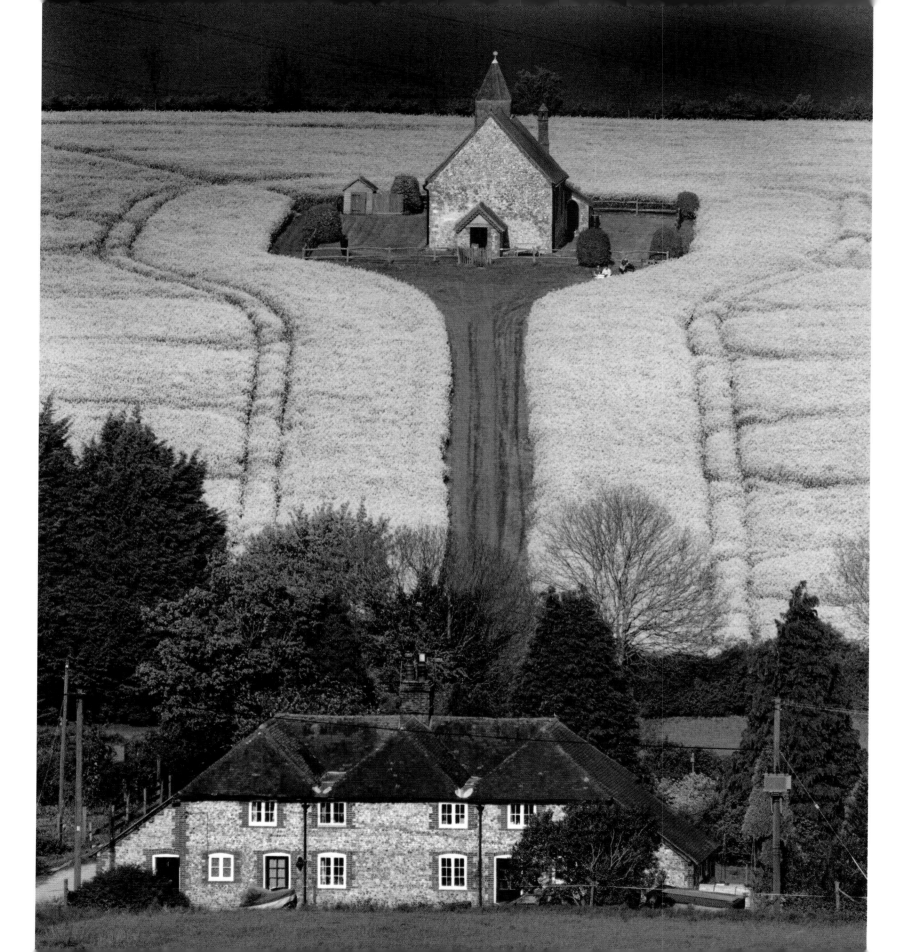

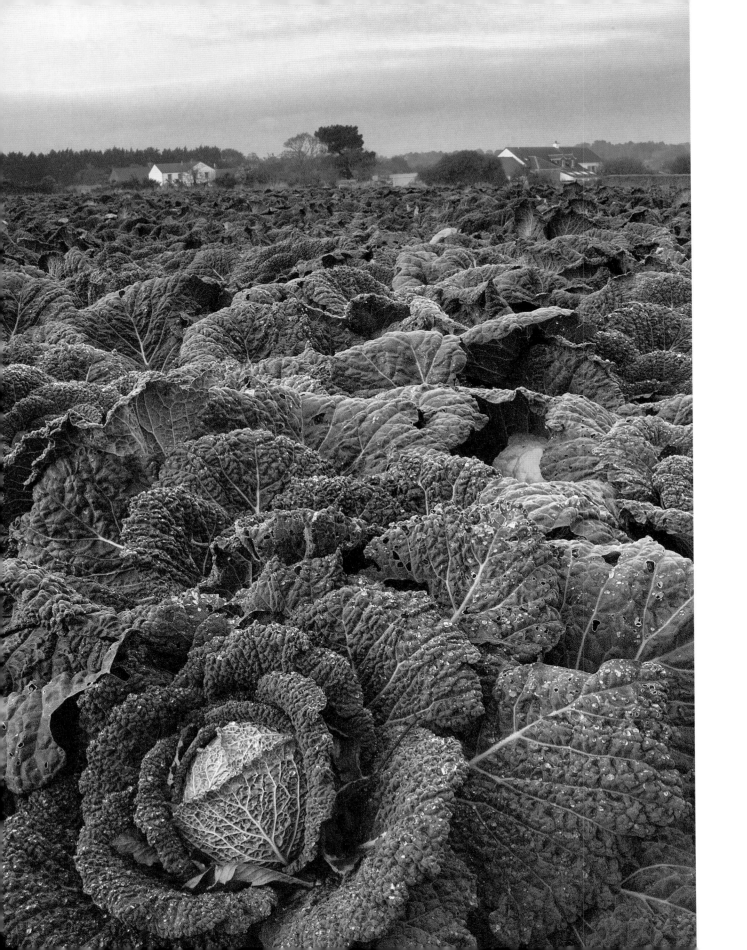

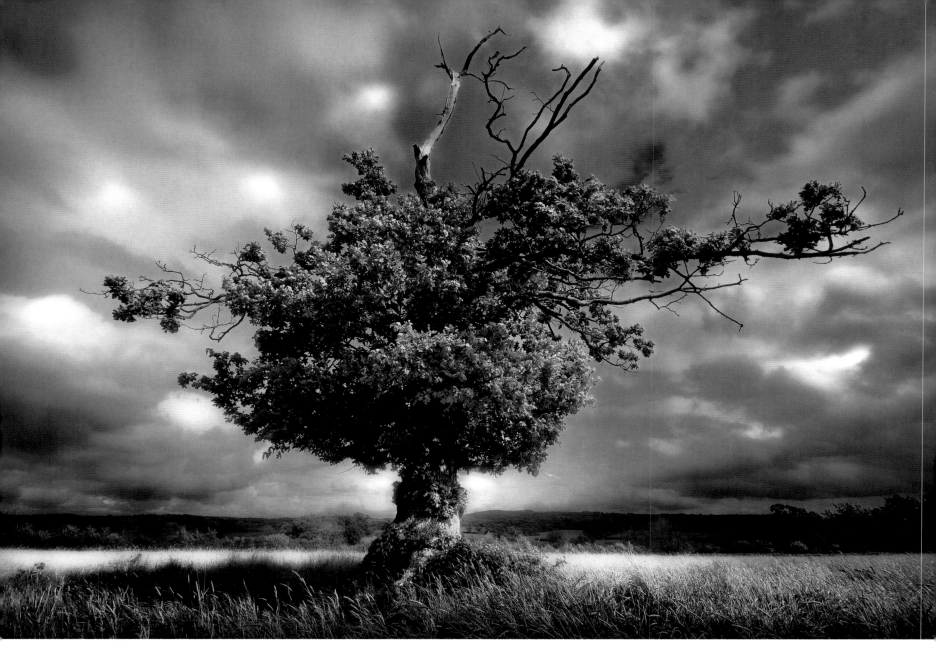

JAN ISON

Left: 'Autumn Crop', Le Couvent, St Lawrence, Jersey, Channel Islands

This image was taken in October whilst I was looking for some autumnal images of Jersey. I was standing at a corner of a field near my parents' house and turned round to find these glorious cabbages in full bloom asking for their picture to be taken! A common landscape in Jersey that often goes unnoticed.

BOB BRIANT

'Devil's tree', Gillingham, Dorset, England

I had driven past this tree many times before realising its potential as a subject. On this occasion, after a storm, the light and sky combined to great effect.

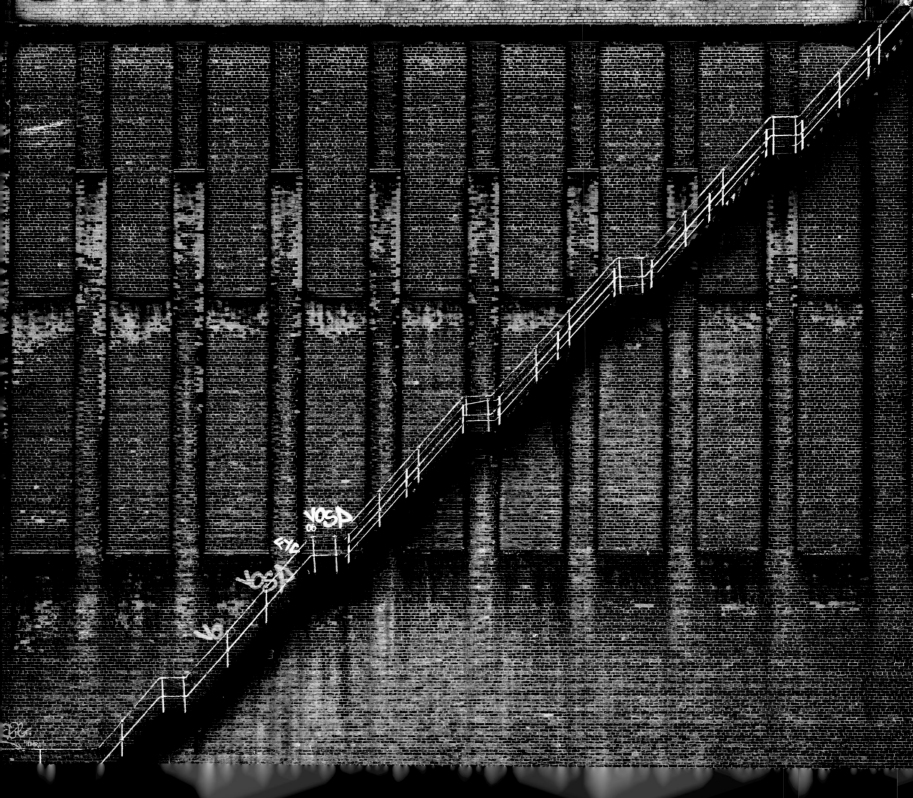

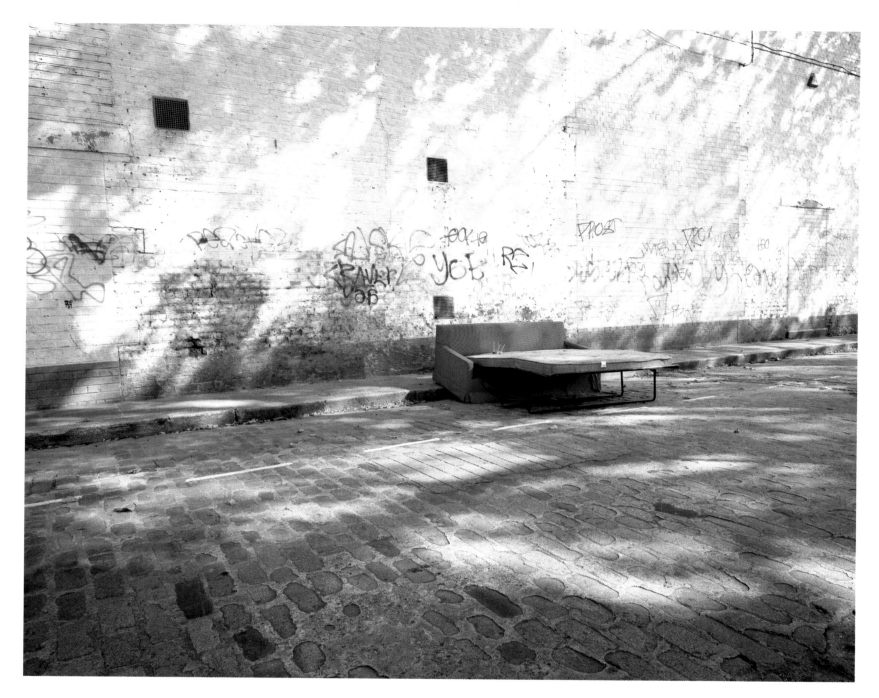

PETE BRIDGWOOD

Left: 'Extracted', Riverside, Hull, England

I was struck by the precarious nature of the rusty metal staircase on the vast outside wall of this derelict building by the riverside in Hull. It makes me shudder to think of the risks taken to spray the graffiti on the wall.

PAUL JEFFERIS

Deptford Green, London, England

This corner of Deptford Green, by the wall of a factory where steam-ship boilers were made, has a unique tranquility. I was struck by this sofa bed that looked paradoxically 'at home', and yet pitifully abandoned, in this sunlit corner.

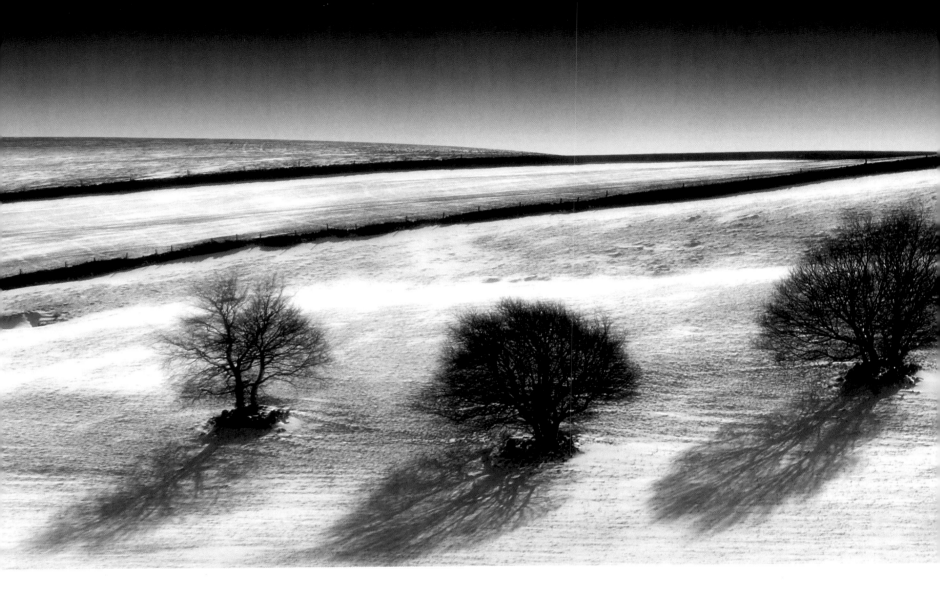

STEPHEN ASHMORE

Peak District, England

I was out on my own one Saturday morning looking for locations for winter scenes, making the most of our rare snow. Although I know the Peaks well, with snow on the ground everything looks different. As soon as I drove past the hillside, although the hill was criss-crossed with dark tracks and hedges, the line of trees stood out at the top and the shot could be seen immediately.

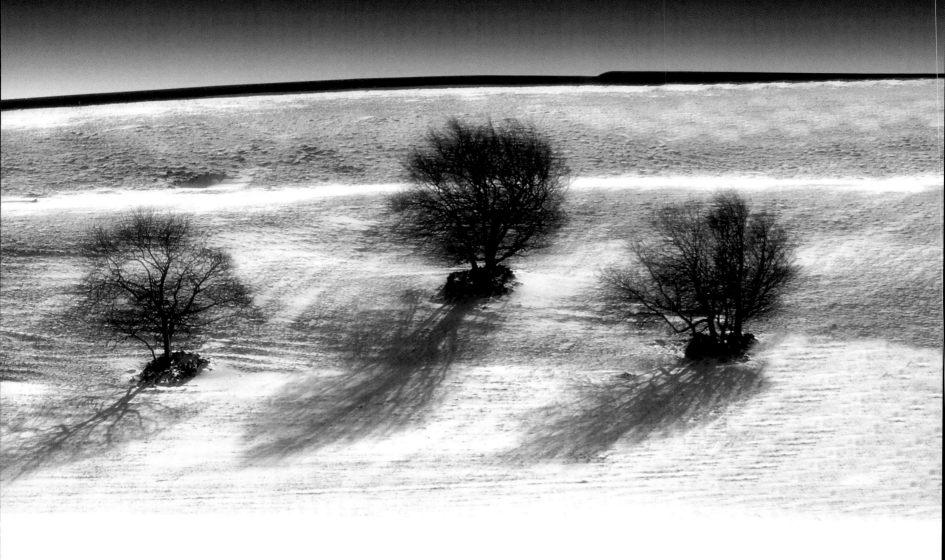

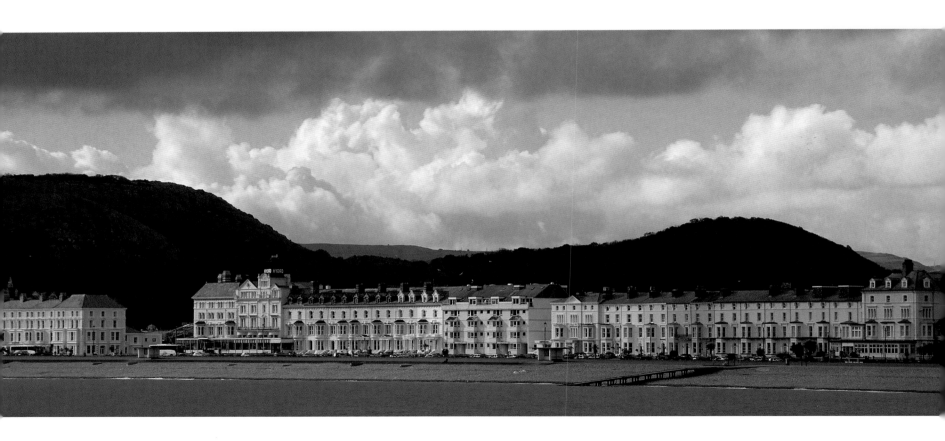

PATRICK KAYE

Early morning, Llandudno sea front, Wales

This image was taken early one morning in May. I was alone with the view and felt very nostalgic about my own childhood holidays. The whole scene, with its elegant Victorian buildings and the dark cloud forming above, is an allegory for the impending storm of World War I that was to engulf the occupants of these same buildings.

BRIAN MAHLER

Right: Merton Mill, River Tweed near St Boswell's, Scotland

Merton Mill on the River Tweed is a wonderfully peaceful place to sit, contemplate and watch the river flow. This shot was taken at dusk in early spring.

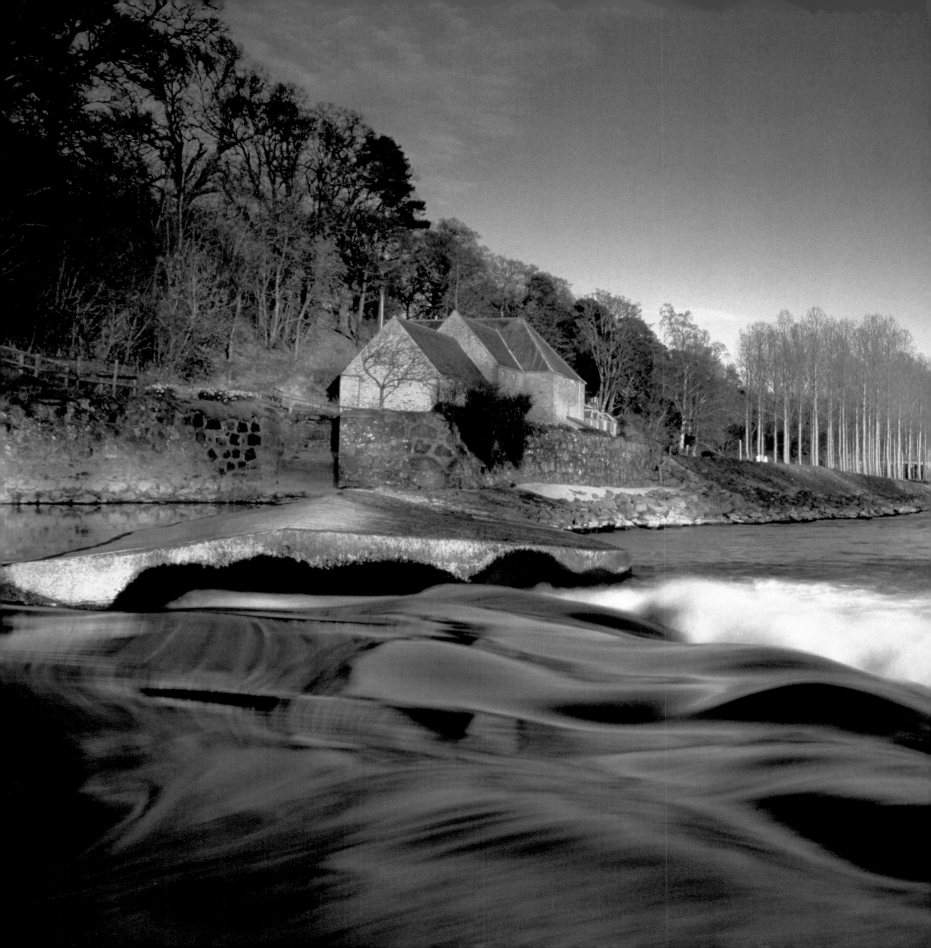

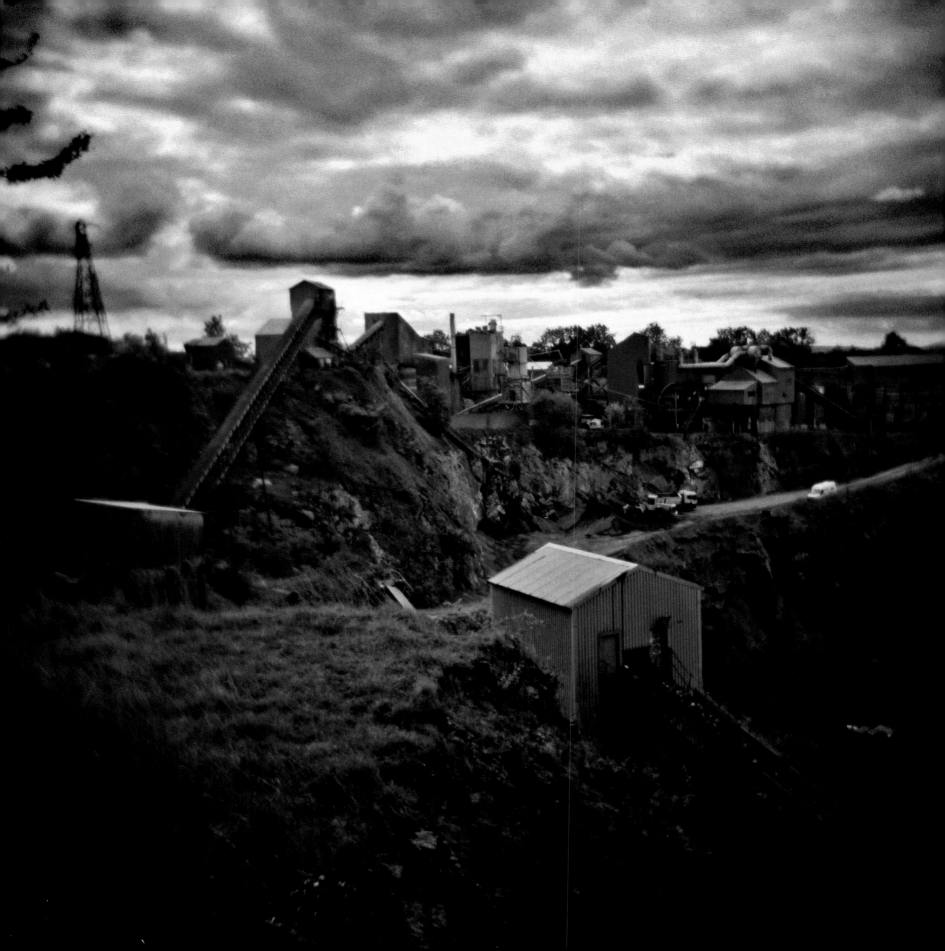

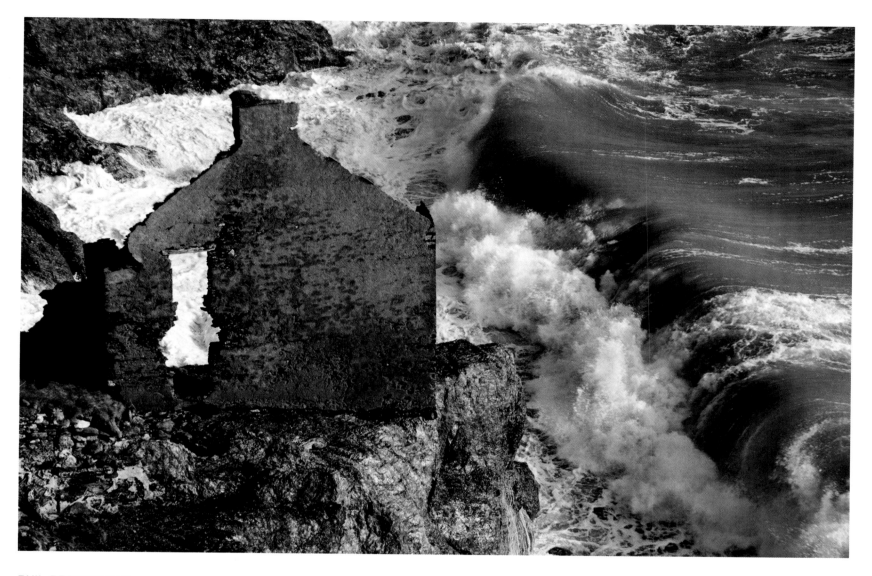

PHIL BEBBINGTON

Left: 'It's only a matter of time', Warwick Quarry, near Bristol, England

The inspiration of this shot is based on man's apparent destruction of the landscape; whether it really is destruction and the way that nature always has of taking it back in the end. Nature seems to adapt to whatever we do and makes it its own. This reflects how I feel about global warming... I don't see it as destruction, just change. Nature adapts, reclaims and adjusts. All we need to do is the same.

NICK SHEPHERD

Lost village of Hallsands, Devon, England

In January 1917, an exceptional storm surged over the pebble ridge that had protected the village of Hallsands from the sea – weakened after dredging of the seabed – and crashed into the houses beyond. In a single day, all the houses were destroyed bar one. When I took the photograph, I tried to imagine the terror of that night and the anguish felt. Above all, I tried to capture 'the story'. Although not of the same ferocity, the conditions were similar – high spring tides and gales had whipped up mountainous seas. I have tried to capture the eerie sight of the one remaining wall of the one remaining house with its one remaining doorway.

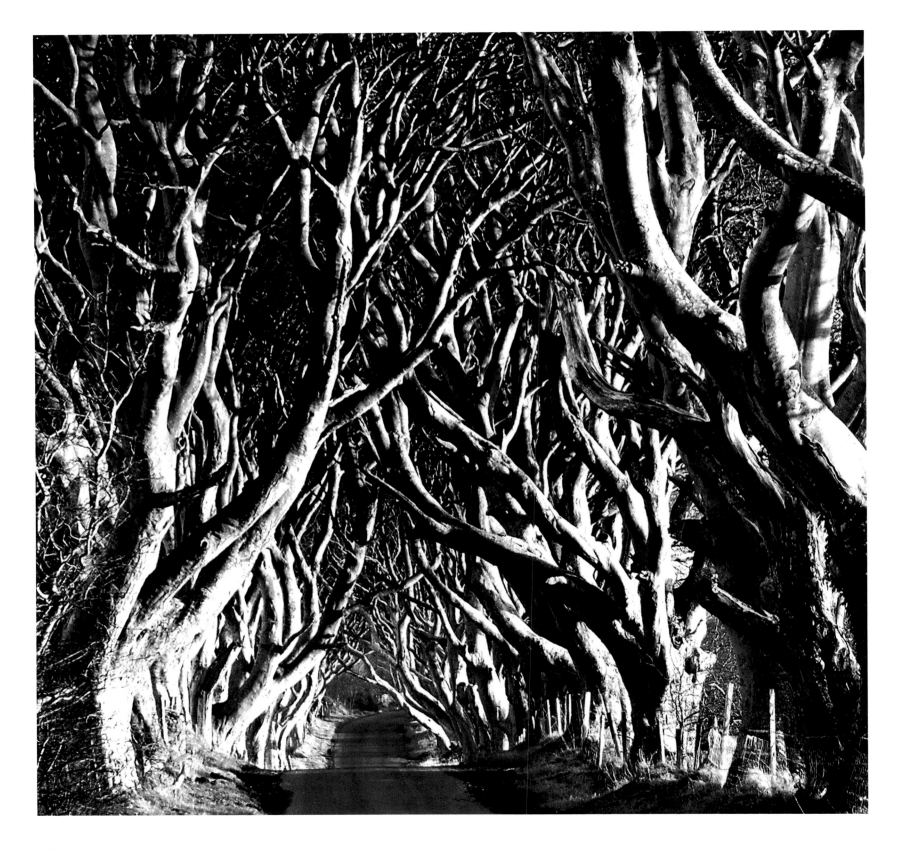

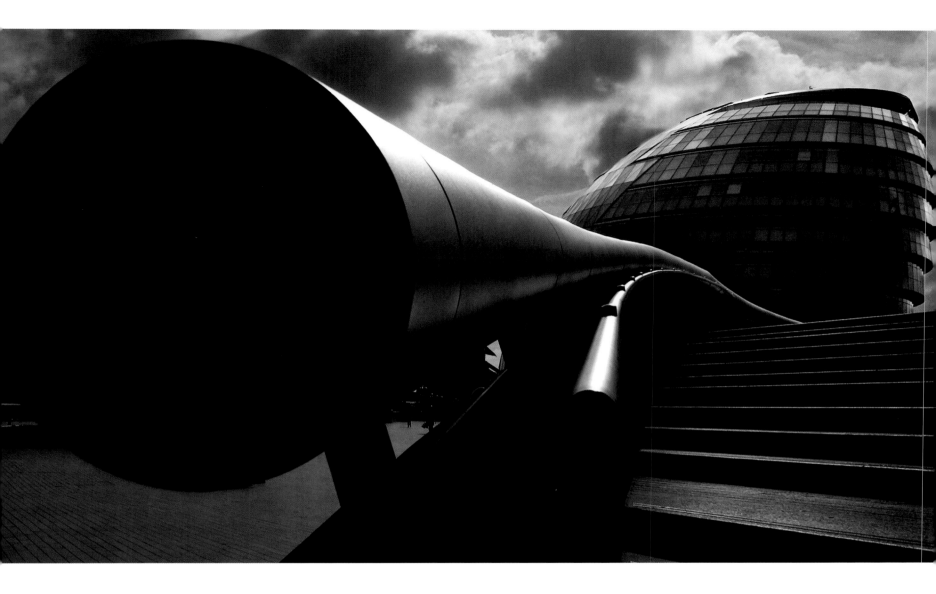

GLENN OWENS

Left: 'The Dark Hedges', Stranocum, Northern Ireland

These spectacular beech trees were planted around the 1750s, forming a tree-lined avenue which originally led to an estate. Over the centuries the trees have become intertwined to form a tunnel-like route – it is now a public road.

MICHAEL SILVE

City Hall, South Bank, London, England

City Hall, the Greater London Authority building, is an iconic feature on the South Bank, known locally as the 'helmet'. The oversized handrail made a perfect counterbalance to this imposing building, whilst adding strong foreground interest and striking graphic lines.

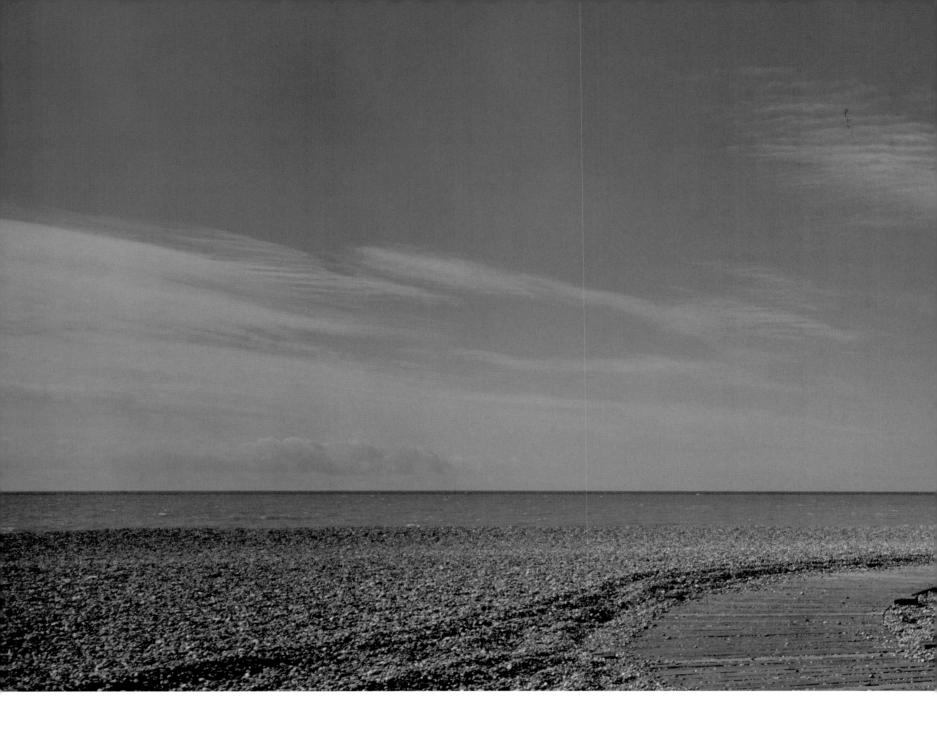

JONATHAN HORROCKS

Merry-go-round, Brighton Beach, East Sussex, England

A lot of thanks has to go to my wife for this image who, just out of shot, is trying to placate a rather hot and bothered toddler, while dad is slowly setting up his tripod and generally doing lots of other things that don't seem that much like fun.

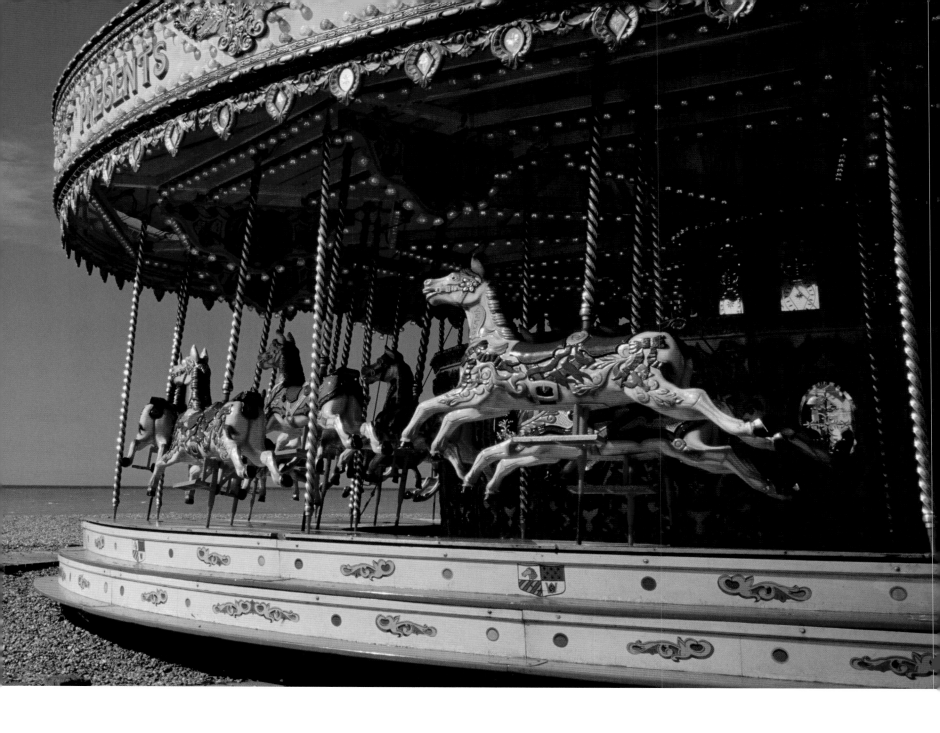

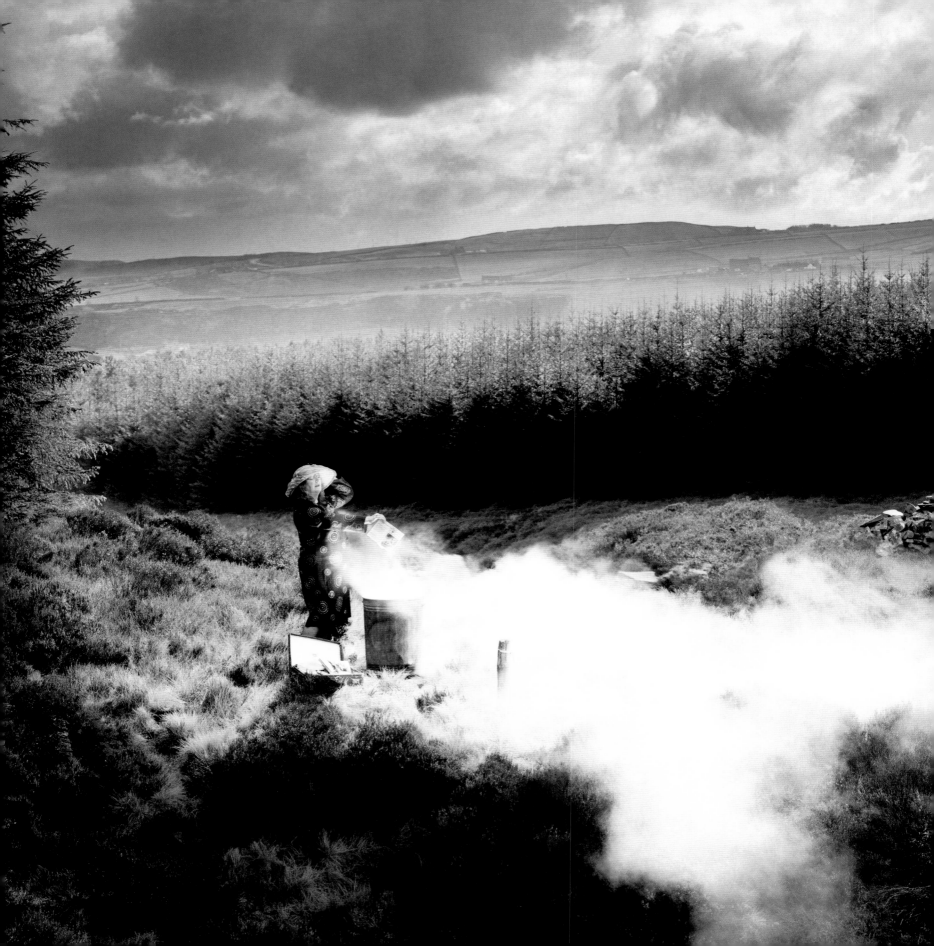

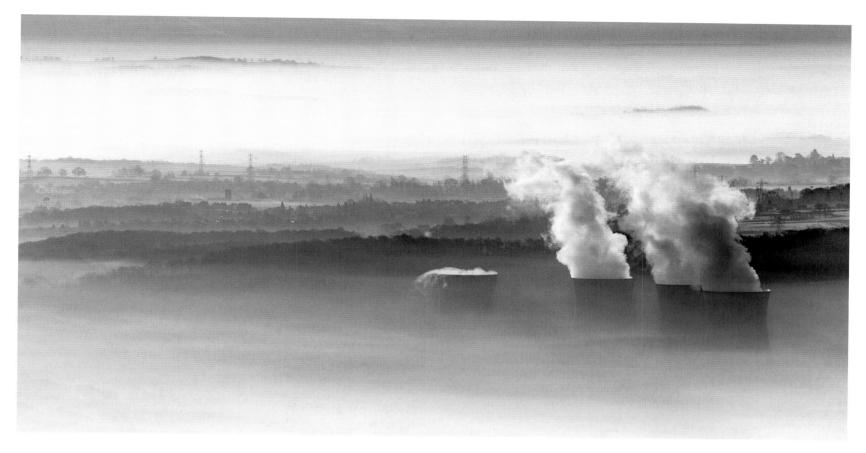

DYLAN COLLARD

Left: 'Anything goes', near Holmfirth, West Yorkshire, England

After 20 years in Holmfirth, I was still able to find and explore new places that were within two miles of my parent's house. That is part of the excitement of landscape photography. I love images that tell a story but have an ambiguity to them that demands the viewer's interpretation. The idea of this image was to use a landscape as a context in which to place an unusual event or happening. I wanted the viewer to feel like they had happened across a surreal scene and then had to try to work out what was going on. It was taken on the only bad weather day we had over a period of ten days. When the sun came out, for all of three minutes, the whole hillside started to steam as the sun hit the damp moorland. We got there in the end.

JON BAKER

Mist in the Severn Valley from the Wrekin, Shropshire, England

The Wrekin is the highest point in the Shropshire Hills above Telford. Even though the Power Station is in full flow, nature always manages to make all things beautiful.

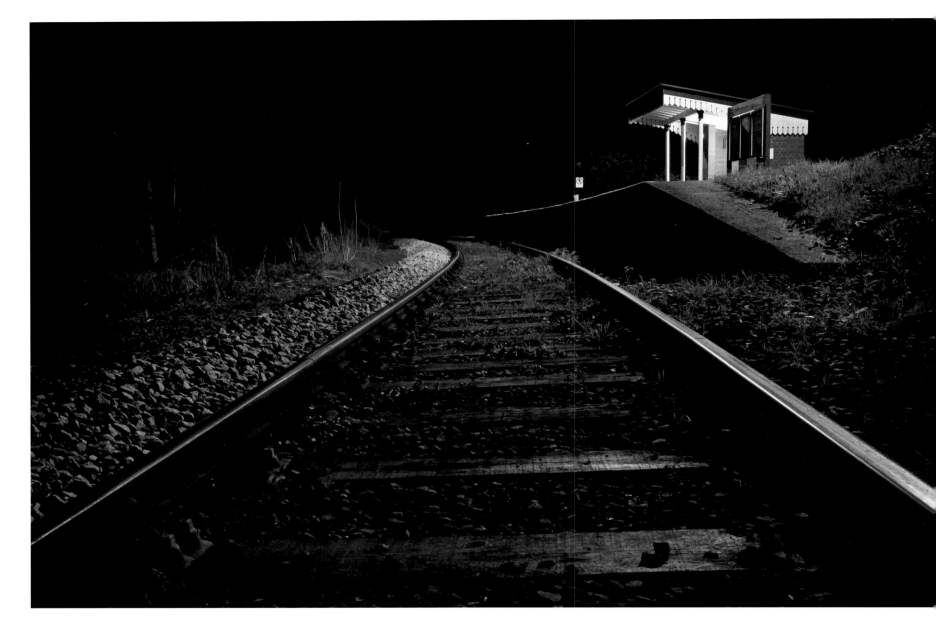

TIM GUNDRY

Sandplace Station, Looe Valley Line, Cornwall, England

This image was taken as part of a body of work exploring bereavement and grief following the death of my brother in 2006. He had a love of trains and we visited this place shortly before his death. It symbolises the journey from mourning and grief into remembrance.

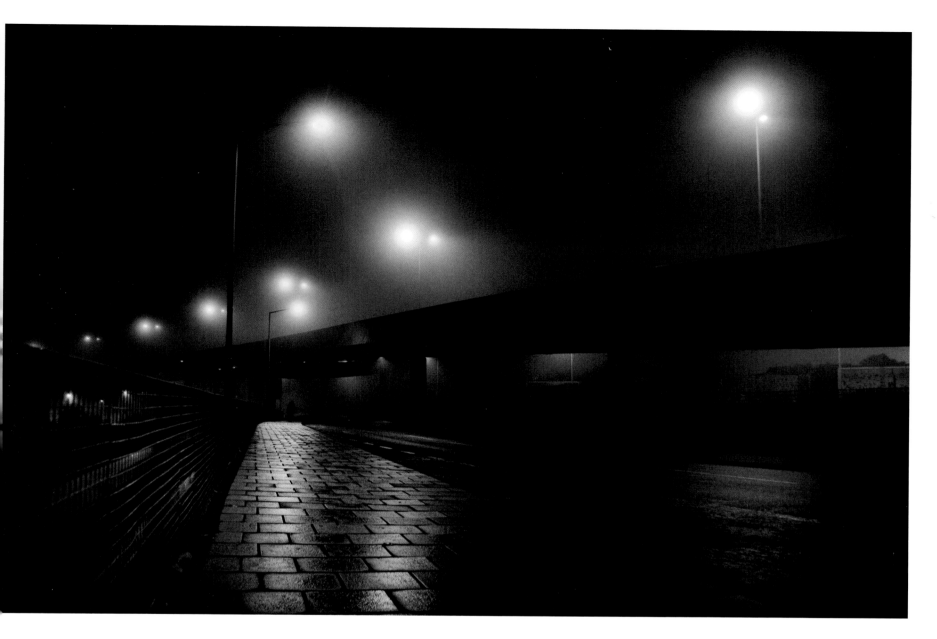

JONATHAN LUCAS

'Nightstalker', Edmonton, Enfield, England

Fog always tempts me to get out with my camera and this eerily still evening was particularly
quiet. I drove around looking for ideal opportunities and thought the dynamics of the A406
flyover near Edmonton offered a striking balance of form amidst some atmospheric light.
I set up my tripod and, after having waited for some time, a solitary figure appeared adding
the only element of life to an otherwise sterile scene.

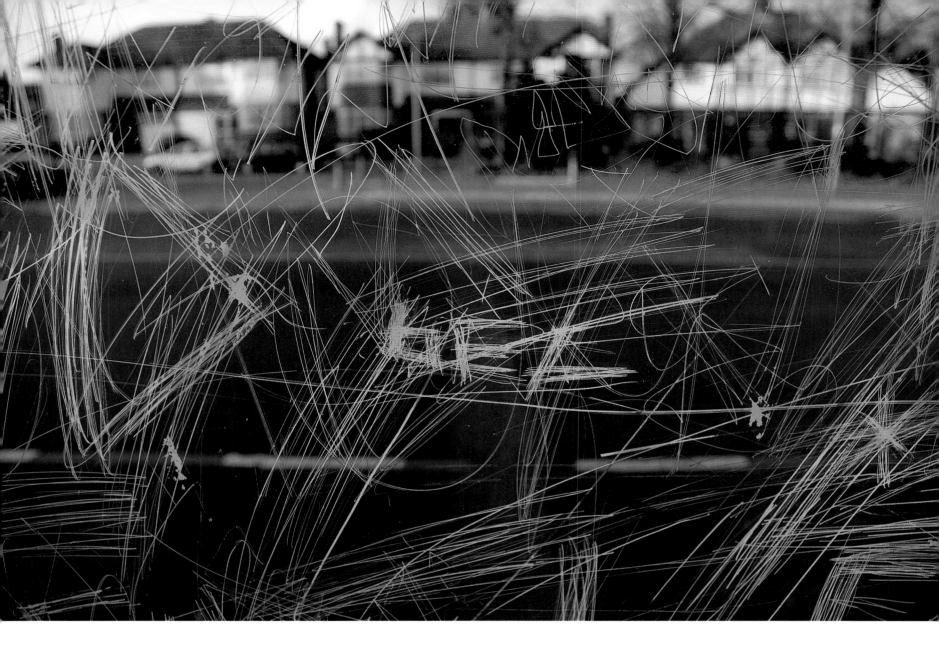

JOHN TAYLOR

Oakwood, North London, England

I decided to walk to a local bus stop that had been vandalised and photograph the very interesting results. I took a number of images trying to strike a balance between the environment and the graffiti and this was the best one. The light on the houses and verge across the road came to life with late evening sunshine, and this softness and warmth contrasted perfectly with the rather brutal scratches.

BOB AYLOTT

The London Eye, London, England

Finding an unusual view of the London Eye is something photographers are always looking for. This picture was only made possible by overnight rain.

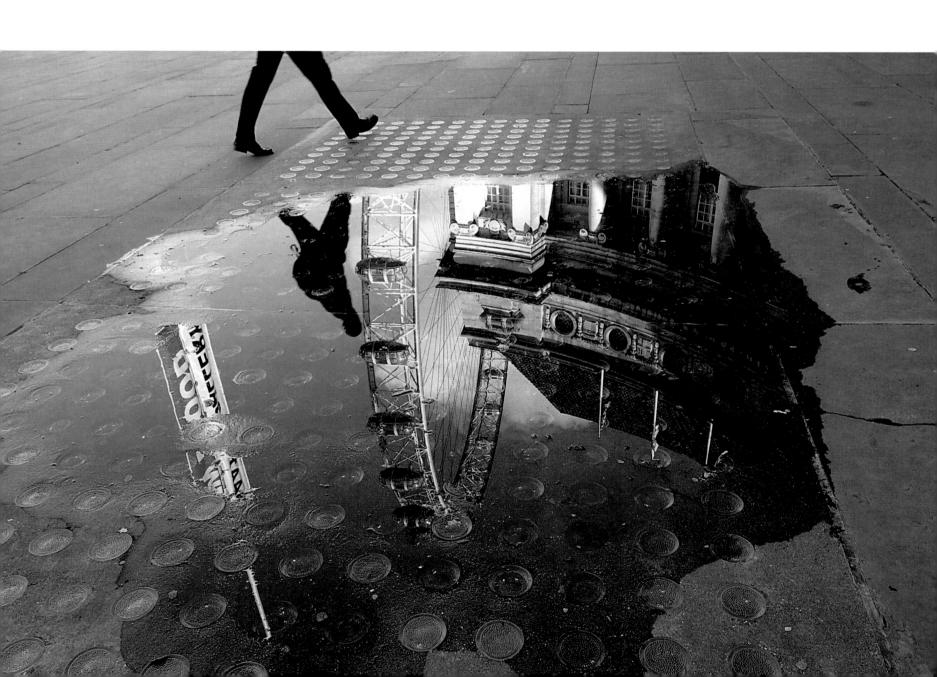

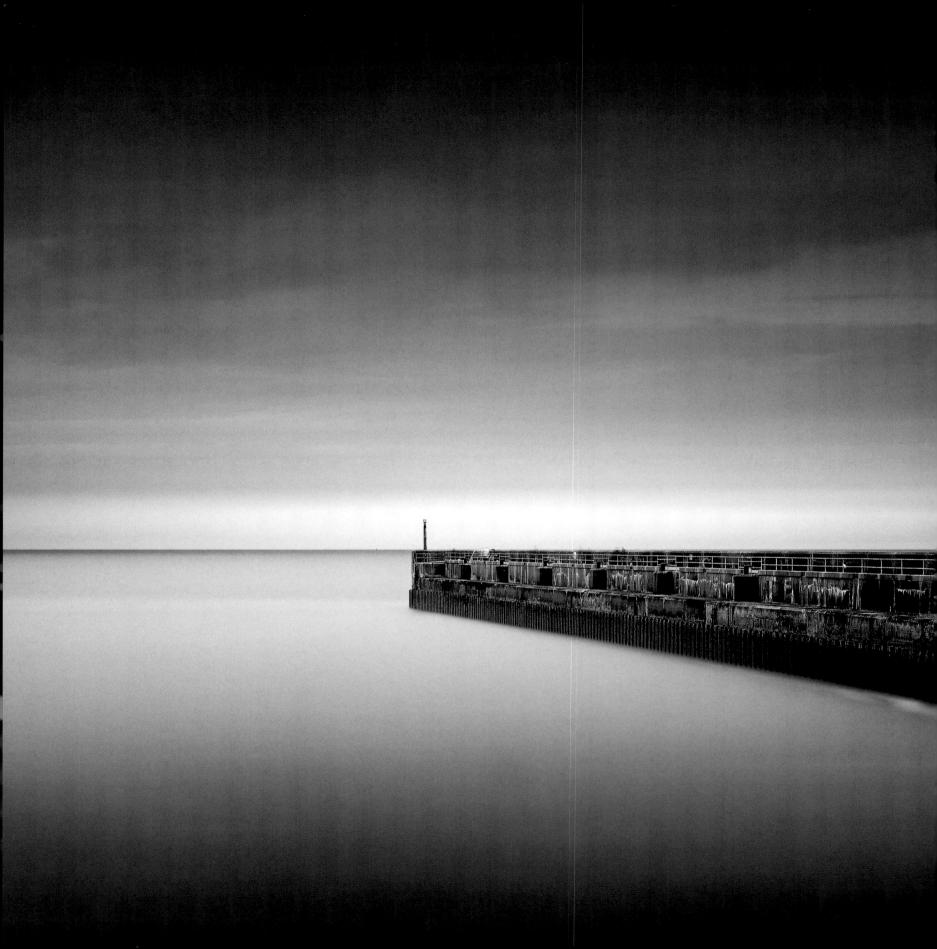

Left: West Pier, Shoreham-by-Sea, West Sussex, England

I had been studying the map for new areas that might hold potential and Shoreham-by-Sea was one of them. I started with Shoreham harbour, very early in the morning before sunrise, and this is part of the result of that trip. At low tide, it's possible to walk right down into the basin entrance between the East and West Piers. Both are huge, with South Pier being much smaller in between them and left to disintegrate. It's a very spooky place; like being on a science fiction movie set.

'Inertia study', Dinton Pastures Country Park, Berkshire, England

While this particular image was not premeditated, the feel and the atmosphere certainly were. This was a particularly eerie and magic autumn morning with thick fog covering Dinton Pastures Country Park. I arrived about an hour before sunrise, and spent the next couple of hours setting up and shooting several long exposures. This is one of the results.

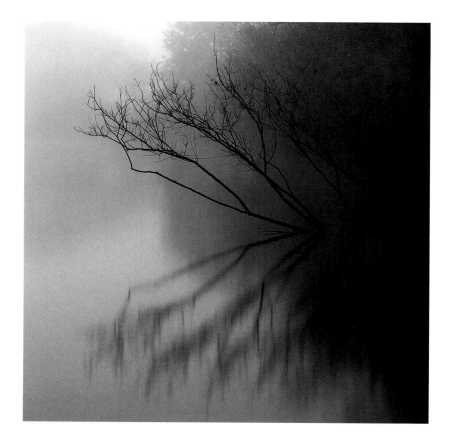

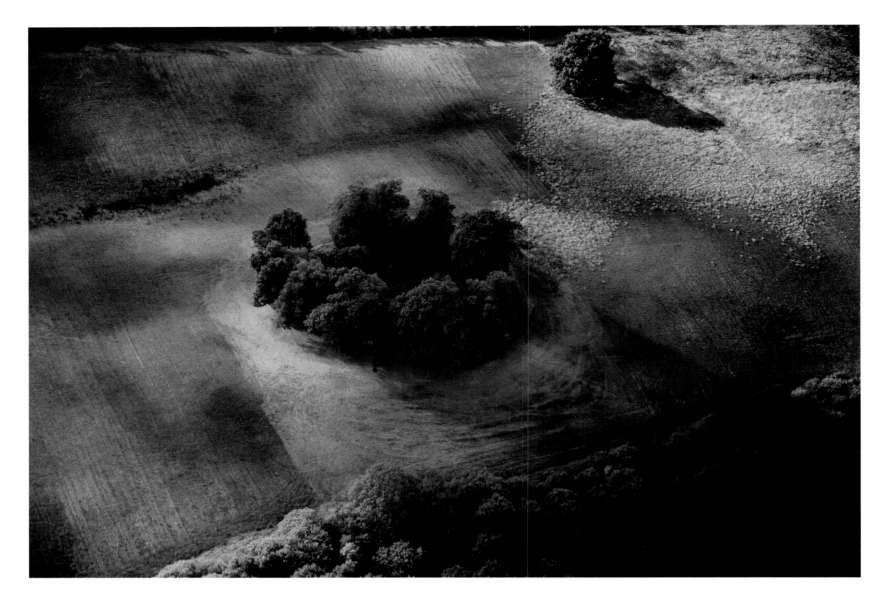

DAVID J WHITE

Evening Copse, Hampshire, England

I spent a day with a friend and his plane in August 2006 taking aerial photographs. Somewhere over Hampshire, I've no idea exactly where, the low slanting light picked out this scene as we flew over it. I took one frame before it disappeared behind us and thought no more about it – until I saw it on the computer the next day.

ADRIAN HOLLISTER

Right: Frosty sunrise in woodland, Crowthorne, Berkshire, England

This image was taken early on a frosty February morning in the woods at Crowthorne in Berkshire. The sun's rays were just rising above the thick forest foliage. I was attracted by the wonderful colours resulting from the yellow early morning sun reflecting off the frosty grasses and the light-facing side of the tree trunks.

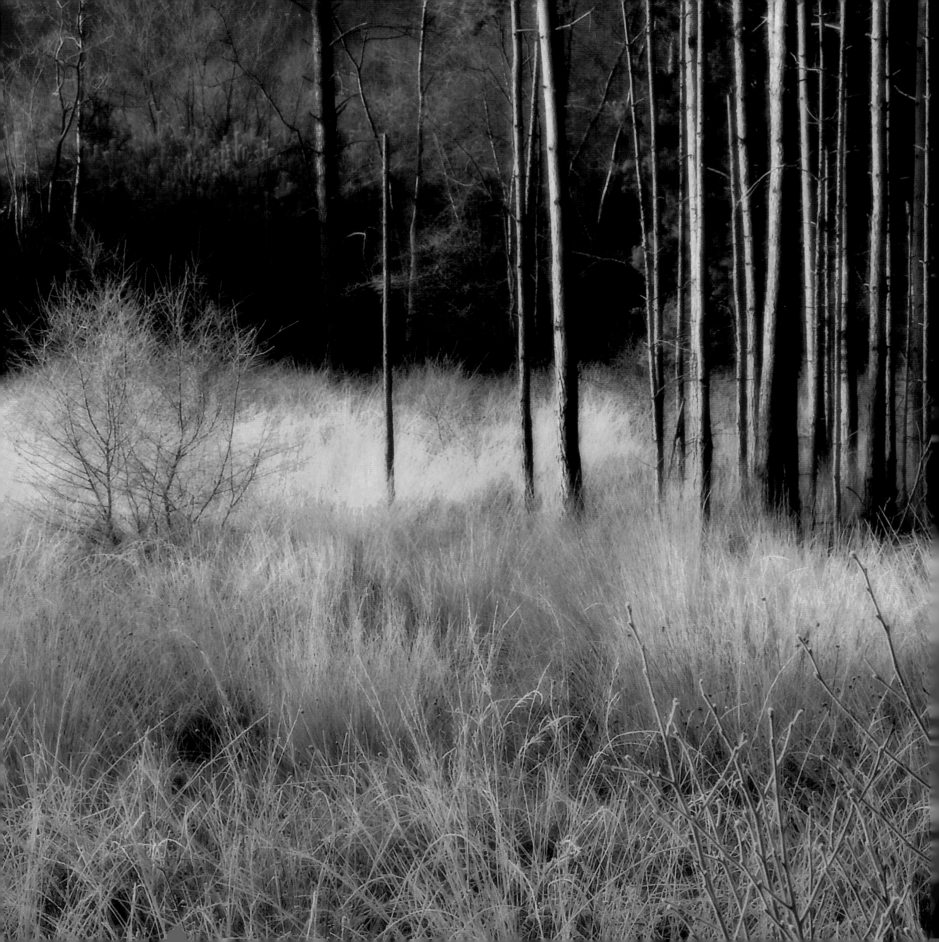

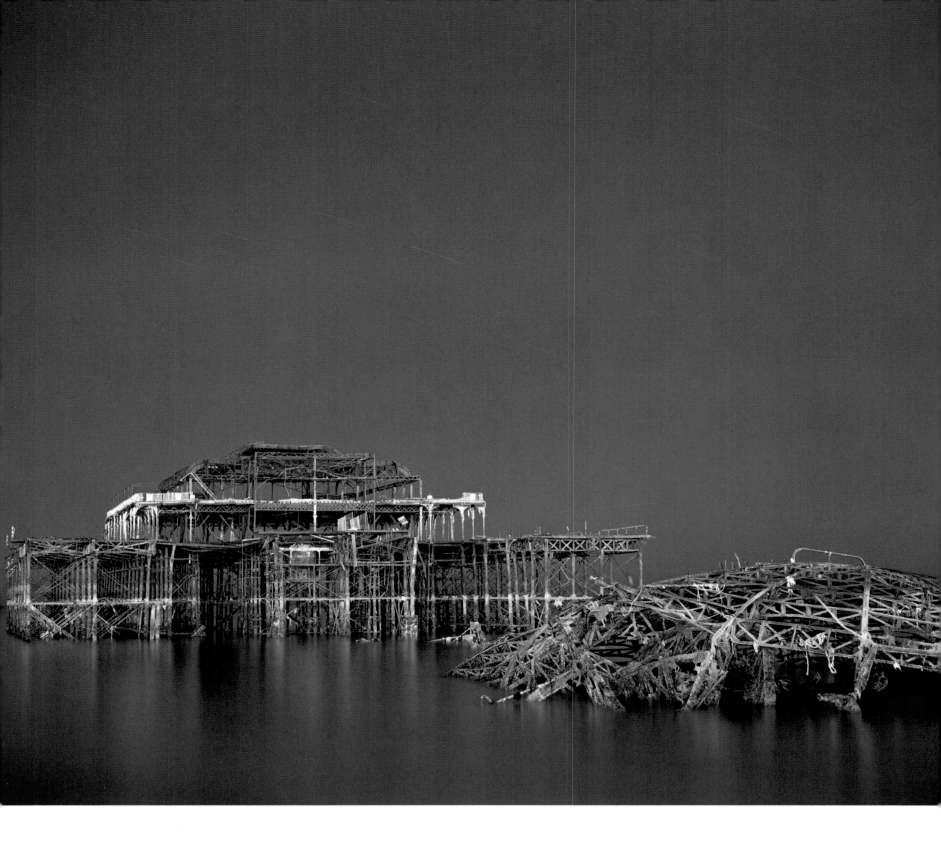

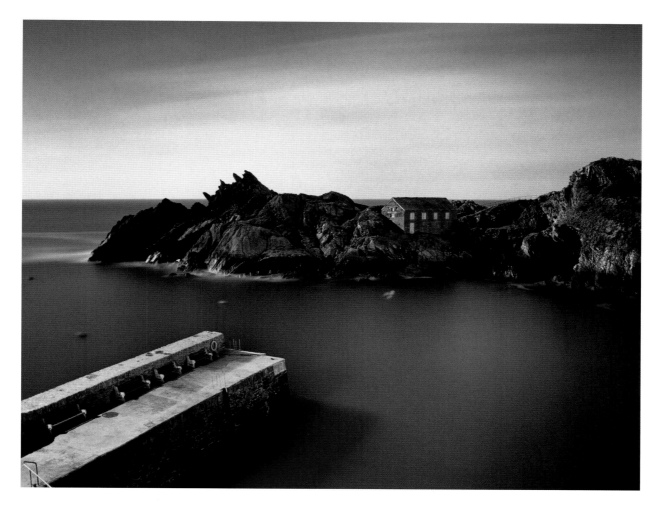

CHRISTOPHER HOPE-FITCH

Polperro Harbour by moonlight, Cornwall, England

Left: Brighton West Pier by moonlight, East Sussex, England

These images are part of a series exploring the effects of ambient man-made light pollution and moonlight on otherwise conventional landscapes, using long exposures and traditional film to capture the varying colour changes and light effects.

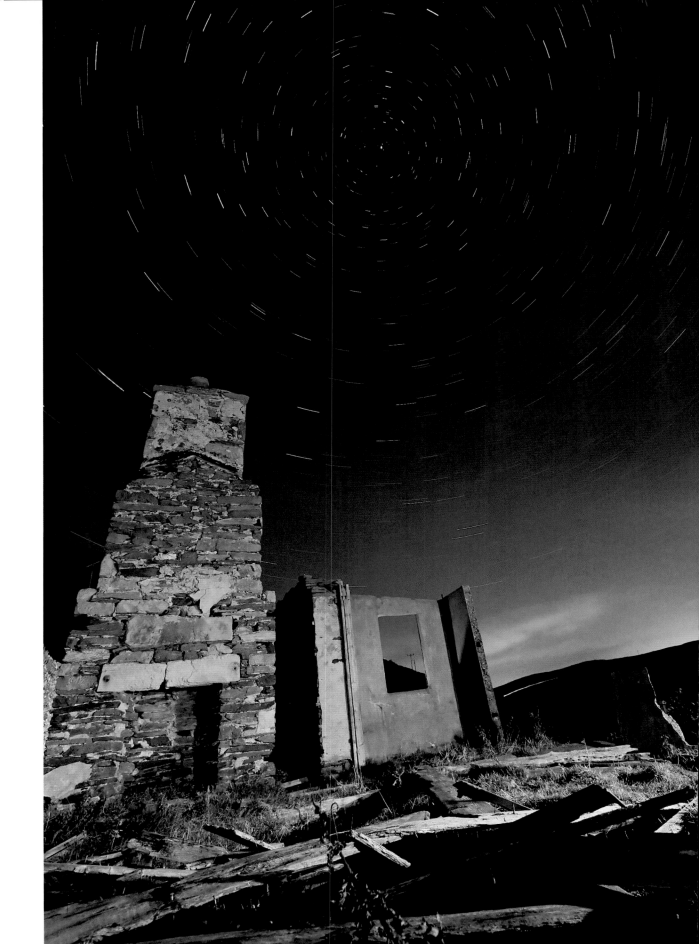

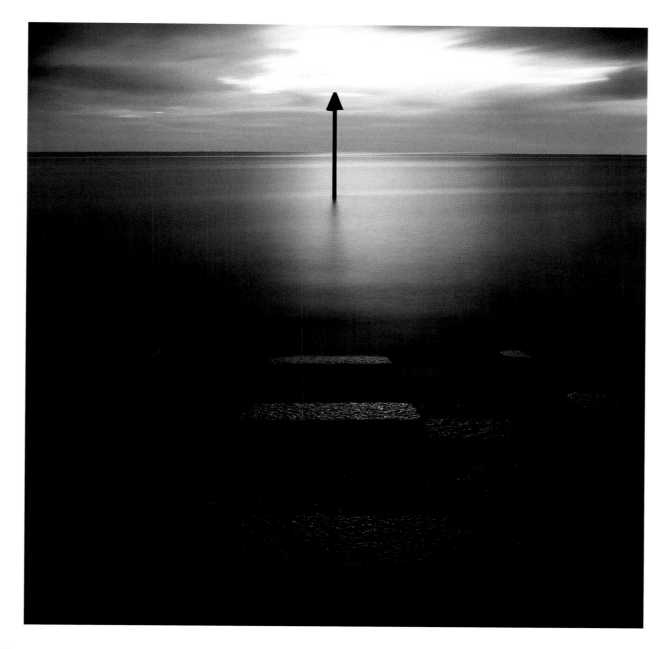

MARK SINCLAIR

Left: Star trails, Levenwick, Shetland Isles, Scotland

This shot took me several attempts as it was very hard to compose properly because of the darkness. The foreground was lit by several bursts of flash held at different points. The overall exposure is about 20 minutes allowing the star trails to form. The orange glow is caused by streetlights over the hill.

BARRIE WATTS

Llandudno at night, North Wales

I had passed this scene several times and visualised this image long before the conditions were right to photograph it. The state of the tide and height of the water never seemed to coincide with the strong moonlight that I wanted. My perseverance paid off after a wait of several months. It's one of my favourite images – I love the shadow detail and tones, and the sense of peace it gives me.

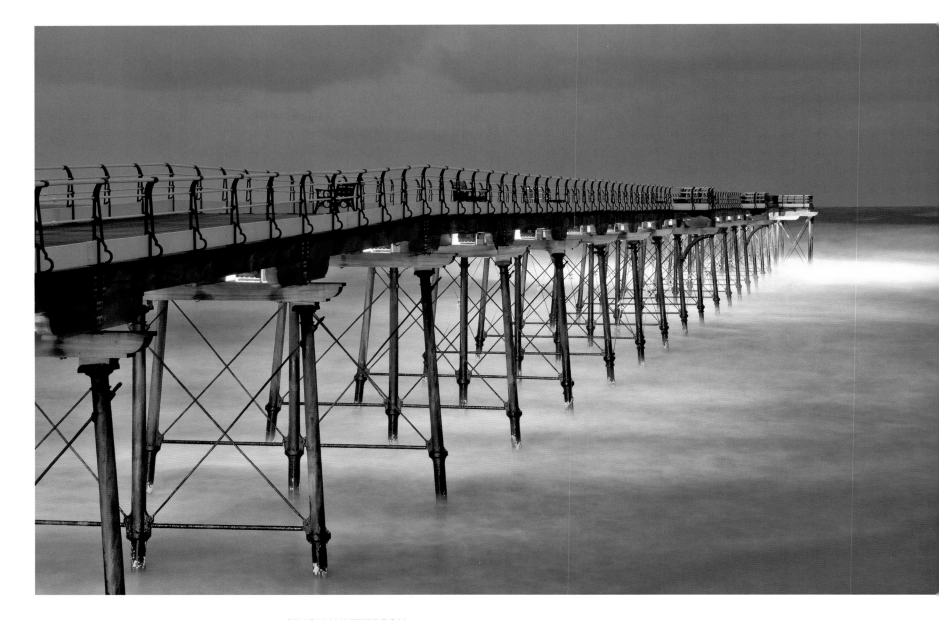

SIMON WATTERSON

Saltburn Pier at dusk in winter, North Yorkshire, England

Since it first opened in 1896, Saltburn Pier has been damaged and repaired many times, and it was during the most recent renovations that lights were installed on the underside of the pier. As the natural light fades, these lights give the water under the pier a unique appearance. This image was made at dusk in the middle of the winter.

PHILIP THOMAS

'It's the Big One', Blackpool, Lancashire, England

This image speaks to me of contrasts. The starkness of the blue and orange steelwork
against the velvet black of a November night. The static solidity of the structure's framework
against the organic speed-blurred movement of the coaster itself. And the unyielding metal
coldness contrasting with the unseen warm enjoyment of the coaster's human cargo.

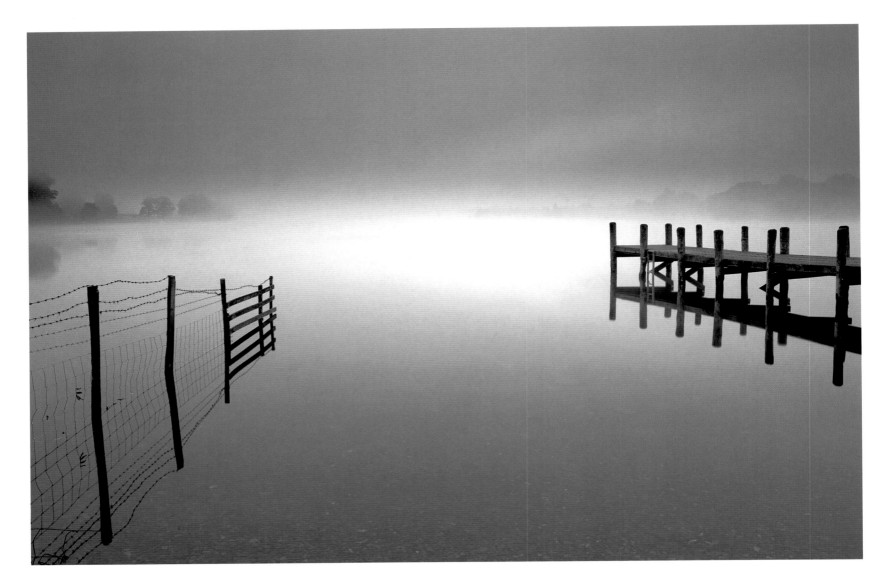

IAN CAMERON

4.30am at Coniston Water, Lake District, Cumbria, England

On my arrival at this jetty at the edge of Coniston Water early one morning, the vision I beheld was nothing short of magical. The water surface was mirror-smooth, a low mist hung wraith-like over its surface and the twilight of pre-dawn had a distinctly cool, blue edge to it. I set up my camera and chose a composition that forces the eye to use the jetty and wire-post fence as lead lines to an infinite and horizonless void.

LEONORA SAUNDERS

Craighouse Bay at dusk, Isle of Jura, Scotland

This photograph was taken just after sunset in Craighouse Bay on the Isle of Jura. We were in a small dinghy rowing back to our boat. It was dark and still with the subtle colours of the sky reflecting on the water. The only movement were the oars dipping into the water; the only sound, the gentle paddling. It was incredibly peaceful and calm with the only sign of human activity being some faraway lights on the peninsula.

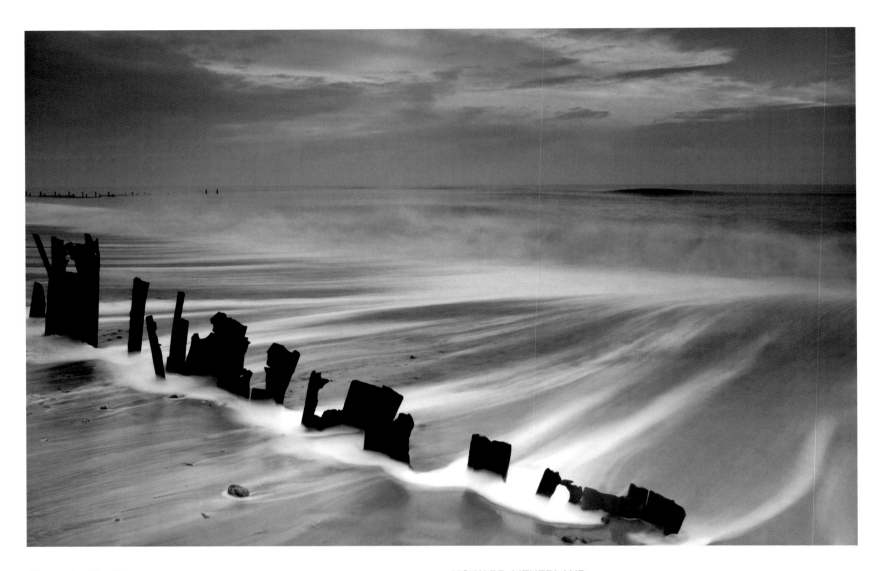

KATE BARCLAY

Disappearing coastline, Happisburgh, Norfolk, England

The coastline at many places along the Norfolk coast is disappearing into the sea. The sea defences are left to decay due to lack of finances and and an uphill struggle against the ravages of the sea. This will get worse as we suffer the effects of global warming. It is sad to see the broken and torn sea defences, but they make for dramatic photography.

HOWARD LITHERLAND

Right: Jetty at dusk, Llandudno, Wales

The wooden jetty at the end of the promenade is a favourite subject of mine, especially when half-covered by the tide. I set the camera up under an umbrella and took a few shots using a long exposure to blur the waves. While I was working, a gap appeared in the clouds, letting through a patch of beautiful orange light that reflected off the calm sea.

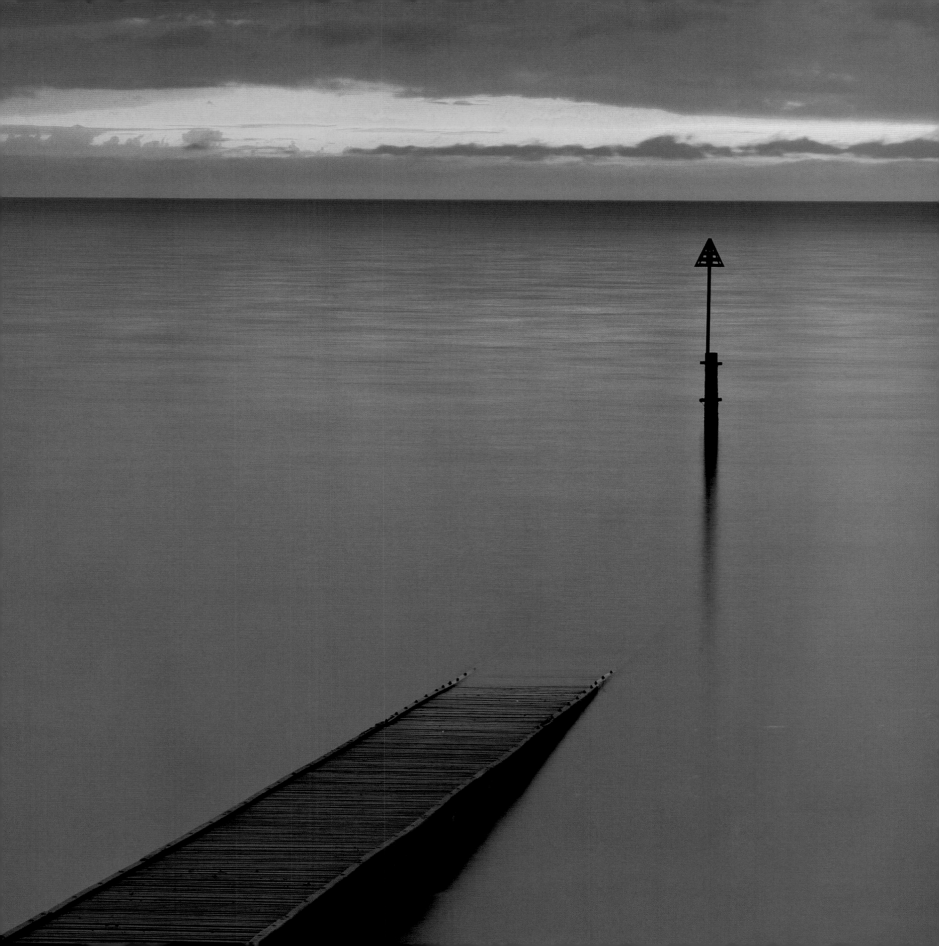

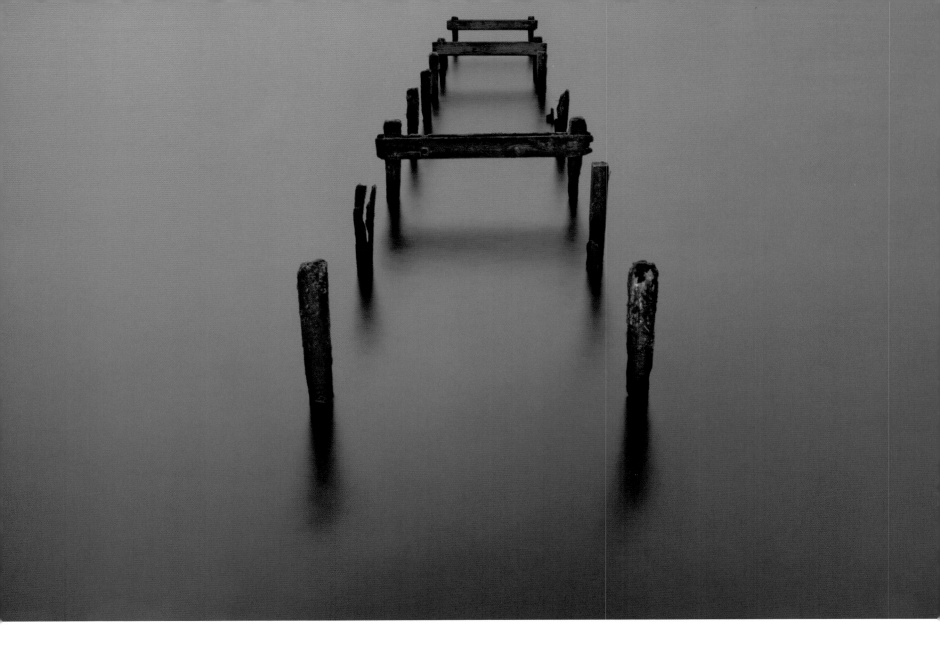

SIMON BROWN

Broken jetty at dawn, Oxford Island, Lough Neagh, Northern Ireland

I stumbled across this scene during an early morning trip to the Oxford Island Nature Reserve on the shores of Lough Neagh. My original hope had been to capture a few picturesque images of this peaceful place at sunrise. Unfortunately, however, a heavy dose of unpredicted cloud cover thwarted my plans. I was forced to look harder for photographic opportunities and it was this search that resulted in me choosing this composition as an idea for a photograph. For the first time ever I was happy not to capture a glorious sunrise on one of my early morning photographic jaunts!

Judges' Choice Bill Bryson

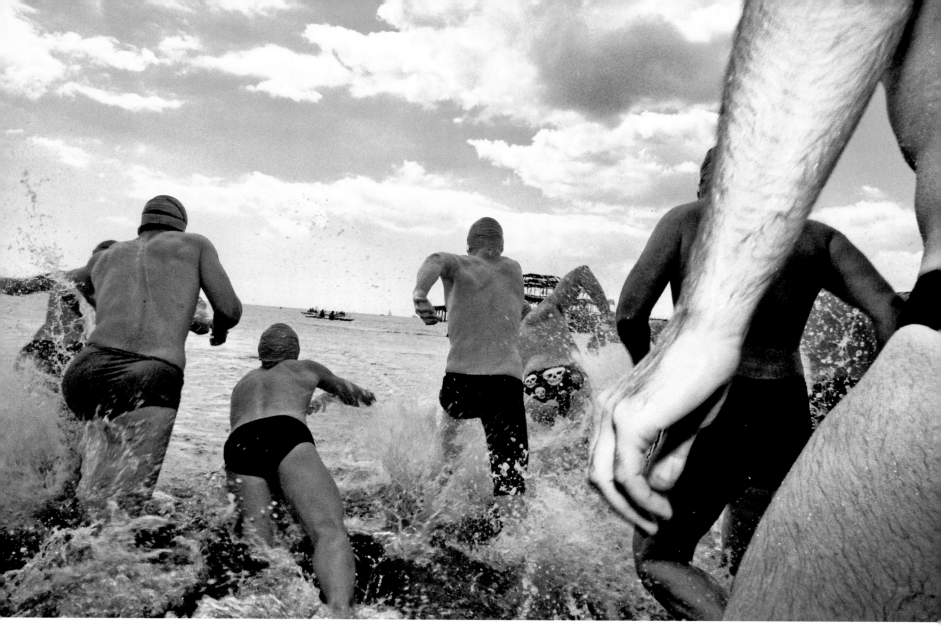

GUY TIMEWELL

Enjoying the seaside in Brighton, East Sussex, England

Every year hundreds of swimmers take part in the mile-long race between Brighton's two famous piers. I wanted to capture the thrill and excitement and thought the only way to really do that was to get right in amongst the action – in the water with the swimmers. As I took the shot many of the swimmers were barging me out of the way, so it really was quite exciting – and I was pretty pleased with the results.

YOUR VIEW
youth class

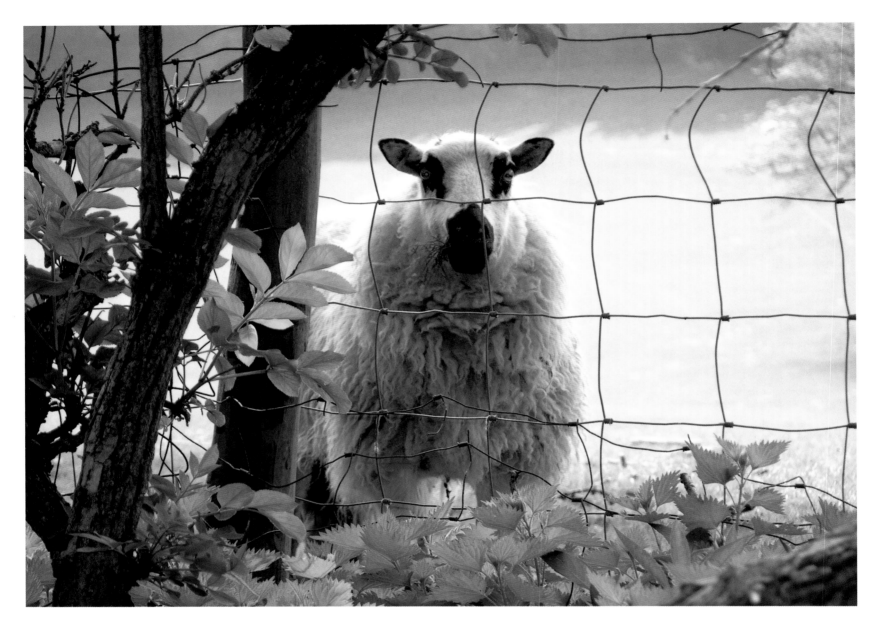

YOUR VIEW YOUTH CLASS WINNER

BENJAMIN TURNER

Sheep in Green Lane, Wenlock Edge, Shropshire, England

My Dad gave me his old camera and for my first 'photo shoot' we went for a walk near my home with my dog. We came a across a field full of sheep. This one was busy doing what they do best – eating, and as I switched on my camera it looked up and I took the picture. It looked so funny with grass in its mouth.

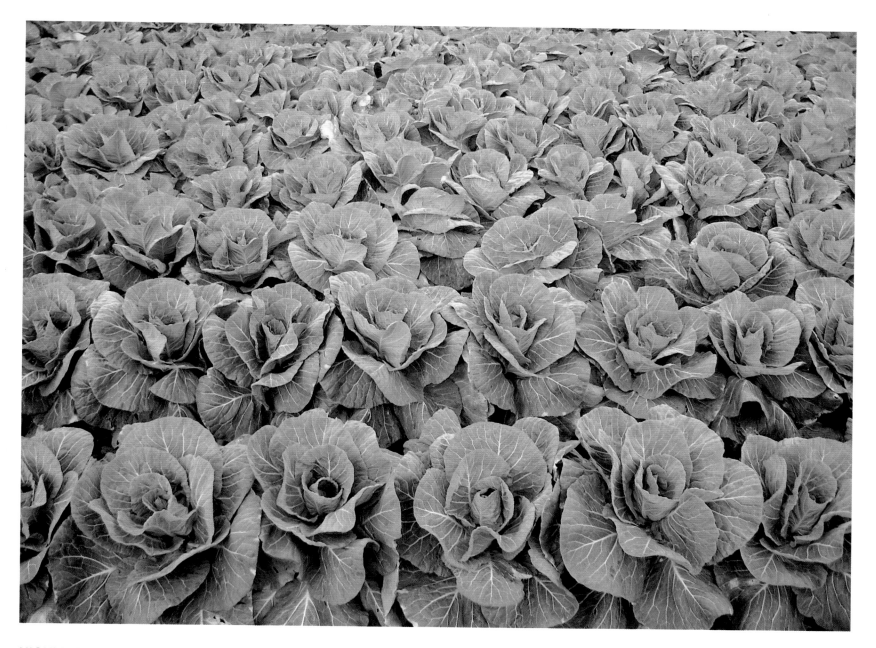

HIGHLY COMMENDED

JAMES SALDIVAR

Wallace's Field, Ludgvan, Cornwall, England

This shot was the last photo I took on this day in Cornwall, and, as I know the farmer, I can vouch that the crop is entirely organic!

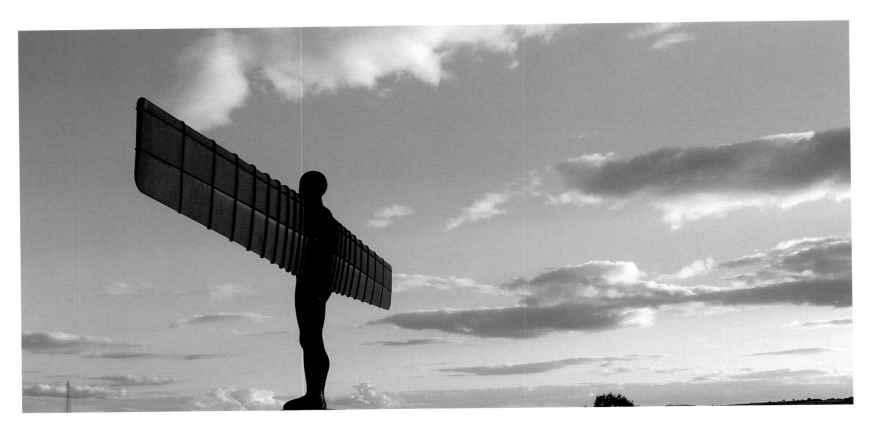

HIGHLY COMMENDED

HARRY TILSLEY

The Angel of the North, Gateshead, England

This photo was taken on a day in July when my dad and I stopped off to see The Angel of the North on the way to Gateshead. The skies were amazing.

WILLIAM BOWSER

Right: Cloudscape, Lincolnshire, England

I was out photographing in the flat Lincolnshire fields with my dad when I noticed the contrast of the dark and light in the evening sky. It was so appealing that I took the shot.

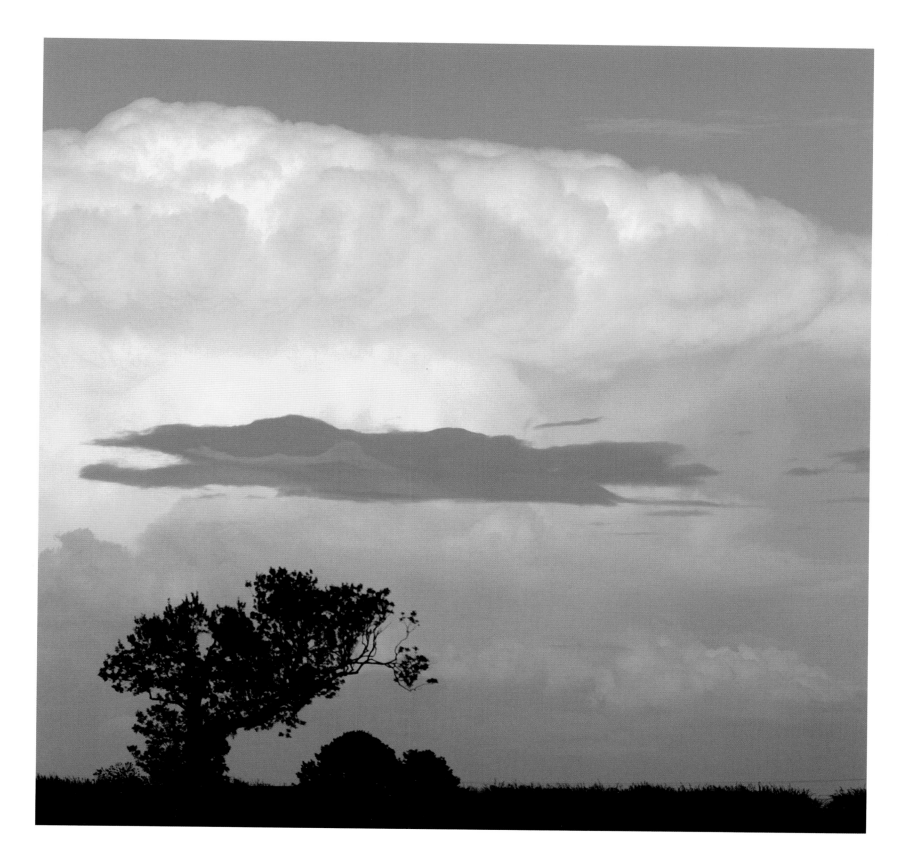

PHONE VIEW
adult class

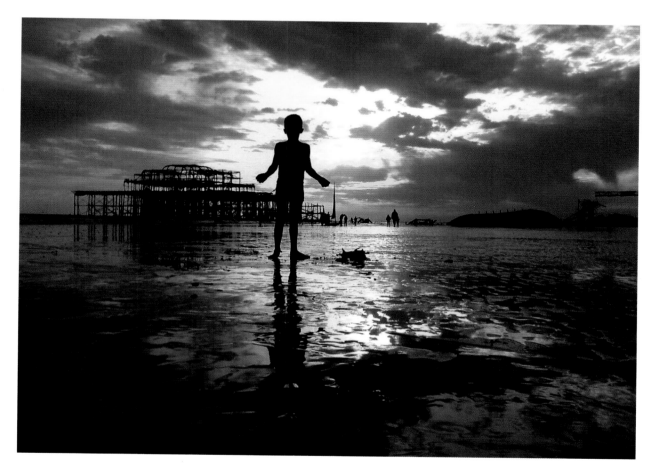

PHONE VIEW ADULT CLASS WINNER

UMIT YELSIDAG

My son and sunset, Brighton, East Sussex, England

My wife, son and I were on a day trip to Brighton. I'm always photographing Alexander and I have always loved taking photographs of sunsets. Watching him playing, it occurred to me I could have both in the same shot. I hadn't brought my proper camera along but my trusted mobile did the job well enough.

PHONE VIEW ADULT CLASS RUNNER-UP

CHRIS CAINE

Snowy road home, Codnor, Derbyshire, England

This image was taken during a snowstorm on a day in February while sitting in a traffic jam – on my way home on the A610 in Derbyshire.

HIGHLY COMMENDED

CHARLES PALMER

Silage fields with a sofa, Winchelsea, England

I took this shot because we had an old sofa and I thought it would create a very abstract image if I took a picture of it in a silage field.

KERRY WICKS

Shells, Tenby, Wales

This was taken on a gorgeous, sunny April day. The shells clustered together on a rock caught my eye; I loved the colours and texture and couldn't resist taking a close-up shot.

PAUL MARSCH

Decaying boat, Holy Island, Northumberland, England

I took this photo at the end of a morning's photography on Holy Island. I had packed away my large format film camera and then spotted this decaying fishing boat on the shore.

PHONE VIEW
youth class

PHONE VIEW YOUTH CATEGORY WINNER

ELLIE SCOTT

Thales End near Harpenden, Hertfordshire, England

Thales End is a very special and beautiful spot on the peak of the middle of the three valleys that run through Harpenden. It's one of the very few local places with unspoilt views and always offers magical landscape colours.

HIGHLY COMMENDED

JACK HEATH

Low tide, Robin Hood's Bay, North Yorkshire, England

Low tide at Robin Hood's Bay – I was on a trip, camping with the Scouts here. I had to take this shot in secret, without being seen, as we were not allowed to have mobile phones with us!

Allan, Matthew www.mattallan.com

Ashmore, Stephen www.stephenashmore.com

Baker, Jon www.thewrekingallery.com

Barclay, Kate www.katebarclay.co.uk

Bebbington, Phil www.terrorkitten.com/iblog

Berry, Bob www.bbphoto.net

Bridgwood, Pete www.petebridgwood.com

Brown, Simon www.myphotographyjourney.com

Burke, Christine Lynne www.clbphotography.co.uk

Burton, Adam www.adam-burton.co.uk

Caine, Chris www.chriscaine.co.uk

Callaghan, James www.jamescallaghan.co.uk

Cameron, Ian www.transientlight.co.uk

Campbell, Tristan www.absolutelynothing.co.uk

Cantrille, David www.cantrillephotography.co.uk

Carter, Claire www.carterart.co.uk

Cavalier, Adam www.adamcavalier.com

Chan, Chao-Yan www.photomediacom.com

Ciolli-Leach, Darren www.onebigsky.co.uk

Clapp, David www.photo.net/photos/DavidClapp

Collard, Dylan www.dylancollard.com

Czechowski, Piotr www.piotrczechowski.com

Davidson, John http://homepage.ntlworld.com/picstuff/

Deer, Steve http://stevedeer.gallery.artlimited.net/

Doessing, Steen www.steendoessing.com

Dunn, Andrew www.andrewdunnphoto.com

Edwardes, Guy www.guyedwardes.com

Faulkner, Joe www.blackpool-photography.org.uk/2009/joe_faulkner/index.htm

Flindt, Ian www.eastangliascenes.com

Fyfe, Andrew www.andrewfyfe.com

Gibbs, Jon www.jon-gibbs.co.uk

Goodwin, Geoff www.grgphotos.dsl.pipex.com

Graham, Paula www.wildlifeandphoto.net

Gundry, Tim www.timgundry.com

Hart-George, Rad www.eliotgeorge.com

Hendry, Rich www.richhendry.com

Hepburn, Tony www.creativeframe.co.uk

Hodson, Emma www.emmahodson.com

Hollister, Adrian www.hollisterimages.com

Hope-Fitch, Christopher www.christopherhopefitch.com

Horrocks, Jonathan www.jhorrocks.com

Ison, Jan www.janisonphotography.com

Jetstream, Johnny www.johnnyjetstream.com

Joiner, Craig www.craigjoiner.com

Keene, Christopher www.KeeneEyes.com

Kurn, Douglas www.douglaskurn.com

Lefebvre, Frédéric www.northernlandscapephotography.com

Lothian, David www.waveseven.co.uk

Lucas, Jonathan www.jonathanlucas.com

Marsch, Paul www.photoluma.com

McBride, Scott www.smcimages.co.uk

McFarlane, Mike www.mikemcfarlane.co.uk

Osmond, James www.jamesosmond.co.uk

Paterson, Peter www.peterpaterson.com

Plewes, Ben www.benplewes.com

Potter, John www.jpotter-landscape-photographer.com

Roberts, Colin www.colinrobertsphotography.com

Rogansky, Seymour www.roganskyphoto.co.uk

Roper, Ed www.edroper.co.uk

Rosen, Alex www.alex-rosen.com

Sansome, Paul www.paulsansome.com

Saunders, Leonora www.leonorasaunders.co.uk

Shepherd, Nick www.nickshepherd.com

Silve, Michael www.mikesilvephotography.co.uk

Sinclair, Mark www.photography.phatsheep.co.uk

Singleton, Tom www.flickr.com/photos/greenrunnerman

Spain, Andy www.asvisual.co.uk

Sterratt, David www.davidsterratt.co.uk

Stevens, Peter www.peterstevensphotography.co.uk

Streater, Colin www.colinstreater.com

Tancock, Chris www.christancock.com

Taylor, John www.johntaylorphotography.com

Thomas, Philip www.philipthomasphotography.com

Waite, Richard www.richardwaite.com

Wallace, Alex www.alexwallace.co.uk

Ward, Patrick www.patrickwardphoto.com

Watterson, Simon www.northern-focus.com

Watts, Barrie www.barriewatts.co.uk

Whalley, Robin www.lenscraft.co.uk

White, David J www.davidjwhitephotography.co.uk